Simplifying Perspective

Bound to Create

You are a creator.

Whatever your form of expression — photography, filmmaking, animation, games, audio, media communication, web design, or theatre — you simply want to create without limitation. Bound by nothing except your own creativity and determination.

Focal Press can help.

For over 75 years Focal has published books that support your creative goals. Our founder, Andor Kraszna-Krausz, established Focal in 1938 so you could have access to leading-edge expert knowledge, techniques, and tools that allow you to create without constraint. We strive to create exceptional, engaging, and practical content that helps you master your passion.

Focal Press and you.

Bound to create.

We'd love to hear how we've helped
you create. Share your experience:
www.focalpress.com/boundtocreate

Focal Press
Taylor & Francis Group

Simplifying Perspective

A Step-by-Step Guide for Visual Artists

Robert Pastrana

Focal Press
Taylor & Francis Group

NEW YORK AND LONDON

First published 2015
by Focal Press
70 Blanchard Road, Suite 402, Burlington, MA 01803

and by Focal Press
2 Park Square, Milton Park, Abingdon, Oxon OX14 4RN

Focal Press is an imprint of the Taylor & Francis Group, an informa business

© 2015 Taylor & Francis

The right of Robert Pastrana to be identified as the author of this work has been asserted by him in accordance with sections 77 and 78 of the Copyright, Designs and Patents Act 1988.

Notices
Knowledge and best practice in this field are constantly changing. As new research and experience broaden our understanding, changes in research methods, professional practices, or medical treatment may become necessary.

Practitioners and researchers must always rely on their own experience and knowledge in evaluating and using any information, methods, compounds, or experiments described herein. In using such information or methods they should be mindful of their own safety and the safety of others, including parties for whom they have a professional responsibility.

Product or corporate names may be trademarks or registered trademarks, and are used only for identification and explanation without intent to infringe.

Library of Congress Cataloging in Publication Data
Pastrana, Robert.
 Simplifying perspective: a step-by-step guide for artists/
 Robert Pastrana.
 pages cm
 1. Perspective. I. Title.
 NC750.P345 2015
 742—dc23
 2014026328

ISBN: 978-0-415-84011-8 (pbk)
ISBN: 978-0-203-76880-8 (ebk)

Typeset in Myriad Pro
By Florence Production Ltd, Stoodleigh, Devon, UK

Printed and bound in the United States of America by Sheridan Books, Inc. (a Sheridan Group Company).

Contents

Acknowledgments

I would first like to thank three of the most helpful and supportive people at Focal Press — Editor Lauren Mattos, Editorial Project Manager Caitlin Murphy and Production Editor Emma Elder. It's much easier to work in perspective than it is to write about it; Lauren, Caitlin and Emma nimbly supported my efforts throughout the entire process.

This book wouldn't have been possible without the guidance and enthusiastic support from my friends and colleagues at both Art Center College of Design and Gnomon School of Visual Effects. I'm fortunate to have such an amazing group of people to rely on. I'd like to thank Stan Kong and Richard Pietruska for serving as reviewers for my initial book proposal, and Krystina Castella for answering all of my questions about the publishing industry. Whenever I felt the weight of having to design and simplify the hundreds of diagrams in this book, I was able to rely heavily on the collective expertise of Scot Moss, Dario Di Claudio, Carla Barr, and Annie Huang Luck. I learned a lot! When some of the diagrams needed a little more attention, it was Casilda Montgomery and Steven Worley to the rescue. I'd like to thank Brian Bradford at Gnomon and Dana Walker at Art Center for their encouragement and support throughout.

A very special thank you to the estimable Gary Meyer. Gary served as technical editor for this book. If you don't know Gary, having him as technical editor is like having Einstein review your algebra homework — I couldn't have been in better hands. Gary was my instructor 25 years ago and, for all practical purposes, still is. I already miss our weekly meetings.

My family has been waiting, for the better part of a year, for me to come out of my office. As I finish these last words, I can't help but think how grateful I am to have you in my life, Andillon. Love isn't supposed to be this easy. Olivia Lane, you're my joy and I am officially done 'drawing boxes.' To finally answer your question, yes! Let's . . . play hide and seek, go to the park, go the beach, play fort, jump on the bed, and catch up on My Little Pony. First, though, I think Daisy really wants to go for a nice long walk.

This book is dedicated to the memory of my parents, Robert and Nilda Pastrana. They gave me the best perspective of all. I love and miss you both very much.

Robert Pastrana

Introduction

The Approach of This Book

Understanding perspective is a great way to quickly improve general drawing ability. Your drawings will become much more believable and you'll be able to tackle things that at one time seemed far too complicated or challenging.

The goal of this book is to simplify the ideas of perspective without compromise. I want you to be well armed so you can successfully get back to doing what you love – drawing and painting. To the uninitiated, sometimes the material can seem a little intimidating. Busy diagrams with their confusing clutter of lines and points can sometimes seem indecipherable. You may instead be worried that the mechanical process may sap the life and spirit out of your work. These appearances are wholly deceiving. Once you start to understand perspective, you'll soon discover that you have a faithful ally at your side – one that helps you convincingly translate the ideas and pictures in your head to paper, pixels, or canvas. Knowing basic perspective lets your sketching and drawing catch up with your imagination.

Who This Book Is For

This book is written under the assumption that you are relatively new to perspective or that you find it confusing or intimidating. We'll start at the beginning – laying a solid foundation not only with perspective but also with the ideas of drawing that perspective relies on. From there, we'll move into more intermediate and some advanced ideas of perspective drawing so you can take on a wide range of more challenging subjects with greater confidence and ease.

This book is intended to help visual artists. If you're interested in painting, illustration, concept design, comics, video games, or animation, you'll find the material presented with your needs in mind. Fields such as architecture, engineering, and technical illustration sometimes rely on a more diagrammatic way of presenting images, so the information in this book will be somewhat incomplete to those concentrating in these areas. Our interests lie in making great images, from a simple still life to an imaginary space colony a million light years away.

Some Advice

Start slowly. Don't just look at the pictures! There are some really important ideas that, once learned, will make all the work that follows much easier to understand. While you can skip around, if you

want to get the most out of the material, make sure you at least feel comfortable with the information presented in Chapters 1 through 5. These chapters set you up to more fully understand the ideas and techniques presented later in the book. With the later chapters, you'll learn more if you go through and copy some of the process diagrams step by step. This will help you learn the actions necessary to get through the principles at hand. Then, try it again – this time substituting your own subject matter in place of the simpler ones presented here. Soon, you'll have these methods down and you'll quickly be able to work out almost any drawing problem that comes up when doing your own work.

Chapter 1
Before We Start

Before we dive into perspective, we first need to address what it does and where it fits into the creative process. We'll then talk about the inherent but minor pitfalls of working in perspective and the best ways to manage the drawing process. We'll end by going over the traditional and digital tools necessary to work in perspective.

What Perspective Can and Can't Do for You

Perspective has a singular mission. It helps you draw your subject matter accurately as you place it in believable space. That's it – it won't make your idea a good one and it doesn't compose your picture for you. A general composition needs to be roughed out before you can put it in perspective. If you don't first spend enough time coming up with a great idea and then doing enough sketches to find the best composition for that idea, then you'll only be using perspective to clearly and accurately present weak concepts and poor compositions. By doing the right things in the right order, you can avoid this very common problem. With that in mind, let's quickly review some ideas about the creative process.

The Creative Process – Getting from A to Z

Some people approach their work as if they are being led by the wind – moving back and forth, making major decisions and changes all the way until the very end. This only makes sense if you don't have a specific goal in mind. That's how you should work if you're exploring in a sketchbook or experimenting on a personal project without any specific deadline. On the other hand, anytime you do work for someone else – a class assignment, a freelance commission, or as an employee, there's an expectation that the work will be complete (and wonderful) by a specific due date. This is where having a rock-solid working process is a great help. The process outlined below will get you from an initial assignment to a finished painting. It has nothing to do with technique – whether you're working with paint, pixels, or pencils, here's how the pros handle their work.

Clarify Your Goals

There's something really important that needs to happen before you start – even before you go looking for ideas. You have to be completely clear on what you need to communicate to your audience. A picture is so much more than its subject matter. How you convey your idea is as important as the idea itself. It helps to think of a picture as a visual record of every decision you made in order to express your idea. If you start with the end in mind – that is, deciding what you need to get across to your audience, you'll have both an easier time assessing your ideas and you'll establish a specific visual direction for your work.

Getting Ideas

Now it's time to find specific ideas that will help you visually express what you hope to communicate. A common mistake is to immediately start drawing. Visuals are always representations of ideas – a better way to start would be to spend some time just thinking and writing down words or phrases related to your problem. Write down anything that comes to mind. Don't edit; that's best saved for later. It's too difficult to try to judge your ideas while you're trying to come up with them. You'll discover that you'll have a greater number of better and more diverse ideas if you separate the act of finding them from the act of evaluating. The more you write and think, the more chances you create for your best ideas to show up.

This can also be a place for research. A word of caution – try not to do too much visual research yet. Sometimes, when you look at images too early in the process, it ends up stifling your own creativity and problem solving. It's the visual equivalent of getting a song stuck in your head. You won't have a lot of room left to find your own ideas when your mind is crowded with someone else's. If you value creativity, try looking for inspiration only when you've decided on a direction for your work – that is, after getting some viable ideas. Visual reference should mostly support your ideas, not be a stand-in for them.

Sketching

Now that you've defined the content of your image, that is, identified the specific things that will be in your picture, it's time to explore how you want to present them. This is where we start to create visuals. It's always a good idea to sketch before you draw. Here's the difference between the two: the goal of drawing is to aesthetically convey, with all necessary detail, the information that visually describes your idea. Before you commit to a drawing, some basic decisions of size, shape, and placement need to be made. That's what sketching is all about. A good sketch is the compositional foundation of a good drawing. When sketching, you should do many – and then do more after that. Make them small and do them quickly. Don't be distracted by detail. Sketching can quickly help you identify potential problems with your approach. It's best to catch them before you start working on your finished piece. Since you're working simply, you should be able to do a lot of exploring in a short amount of time. When people draw when they instead should be sketching, they don't typically get to explore enough compositionally. Save the act of drawing for a composition that's worth your time and effort. There's another problem with drawing without first sketching – it's harder to be objective about a composition when you've drawn something successfully. For example, you may be happy with the way you've drawn a pair of hands, or maybe you finally found some success with drawing a likeness. That success can blind you to the fact that those wonderful hands or that amazing likeness may be the stars of a very poor composition. Sketching helps you to quickly find the best composition for your subject matter. It doesn't take long, it supports your work and makes it easier to do. Find what you feel are your best few sketches and decide which one would make the best image.

Perspective

The job of perspective is to transform your sketch into a believable drawing that mimics the specific way we see. Here is where you give the very informal but important decisions you made in the sketch stage believable dimension and space. Later in this book, we'll discuss some perspective sketching ideas that you can use as a transition between rough initial sketches and your final drawing. It's an important step. If you're creating a busy, complicated drawing and you gloss over this part of the process, the mechanics of perspective will lead you away from your intended composition. Only leap into perspective when you're ready.

Line Drawing

It's finally time to draw. This is probably the part that you've been itching to get to, but because of your patience and discipline, something great will happen – you've made it a lot easier for that drawing to be successful. The work that you've already done was devoted to resolving some really big decisions about your picture. It's going to be a lot easier – and faster – to do your drawing because of that. This is where you do the bulk of your visual research. Surround yourself with all the reference material you need to help you flesh out the details of your image and get to work. Know how far you want to go with detail and get your subject matter looking the way you want it to.

Value Studies

If you need to go beyond a refined line drawing, then you'll have another group of very important decisions to make. You'll need to establish your lights and darks, and, if your final project will be in color, you'll eventually need to make those decisions as well. Think through your values first. Value (how light or dark something is) has three important functions. It helps to create mood, it directs the eye through contrast, and it describes form. Approach your value studies the way you approached sketching. Explore your options and keep things simple. Don't worry so much about details and subtle gradations. Concentrate on large, important shapes and paint them simply. Decide what general value something is. Is it light, more of a middle value, or is it dark? Your goal here is to make sure, through contrast, that the more important parts of your picture stand out first and that secondary elements remain so. If you can already direct the eye to your center of interest without relying on detail and lighting effects, you can be sure that you'll have an amazing picture once you include that information in your final.

Color Studies

If you're going to work in color, you have one last set of key decisions to make. The good news is, if you've already done some value studies, the hard work is mostly over. Value choices are functional while color, by comparison, is more decorative. Having a great value study means you'll have a lot of freedom with color – but only if you hold onto the specific tones from your value study. The success of your color is largely related to the *values* of your color, so work hard on your values and you're almost there. Once you've gained some experience and are comfortable managing both value and color, you can skip the value study and instead establish your values while working out your color study. To gain that experience more quickly, you're better off separating the ideas of value and color when you do your work.

Final Image

If you look back and analyze the previous steps, you'll see they were all geared to help you make solid decisions about every important part of your picture. This process is meant to focus your efforts, in a specific and prioritized way, so you can develop a clear idea of what

your picture will look like before you start to make it. This makes creating the picture much easier and faster to do. If you've made good choices along the way, the only thing left to worry about is technique. Sharpen your pencils, mix your paint, launch your software; you're fully prepared to enter the most rewarding part of the whole process. You can now devote all of your energy to making your image. On the other hand, if you haven't managed the process properly – if, for instance, you didn't spend enough time sketching, or if your color studies never made it out of your head, then you've instead made your work much more difficult to do successfully. There's really no skipping any of these steps – if you didn't make these decisions when you were supposed to, you'll instead be making them now, when you should be trying to paint. Working just got a whole lot harder.

Getting the Most out of Perspective

It's All About Looks

Sometimes, your work can look wrong, even though it's technically accurate. Let's examine the image below.

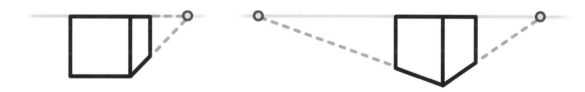

Both images are technically correct. They're wrong, though, when you consider the goals of drawing. When we draw representationally, we translate the three-dimensional world into a two-dimensional one. This process has many limitations and it's our job to successfully compensate for them. You can avoid some of these problems by remembering to give your viewer enough visual information so they can easily tell what your object is and what it's doing. Specifically, think about the general form of your object. Whether it's organic or geometric, make sure you show enough of the front, side, and either top or bottom planes. When you lose or minimize any of these major planes you've hindered the readability of the form. In the real world, it's less of an issue. When we look at a three-dimensional object with our eyes, each eye has a slightly different vantage point. This gives concrete dimensional information to our brains in ways that a two-dimensional drawing can't. That, coupled with the fact that we move in space relative to what we're looking at, means that in the dimensional world, this kind of visual misinterpretation is an extremely rare occurrence.

Since our goals are more creative and artistic, we need to be more concerned with things looking right as opposed to being right. Being right is never enough if our results can't be understood clearly. Initially, you may only have a vague sense if something looks correct or not. As you gain more experience with perspective and drawing, you'll develop a visual vocabulary and a frame of reference of what right and wrong look like. With a little patience, you'll get there!

Approaching Your Work

As you start to draw in perspective, there are some simple things you can do to make the process more manageable. First, draw through your forms. It's always a good idea to know where your planes are. Doing so will help you more clearly establish your object in space. Next, think about constructing things in color. This makes it easier to follow your work if you're tackling a complicated idea. Consider using different colors to represent different objects.

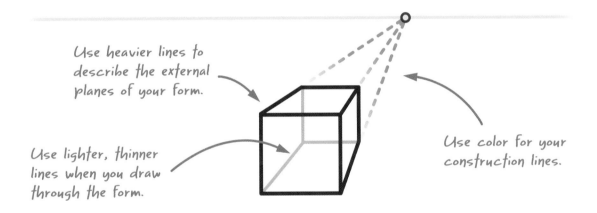

Use heavier lines to describe the external planes of your form.

Use lighter, thinner lines when you draw through the form.

Use color for your construction lines.

Lastly, use dark or heavy lines to describe the outside of your form. If your lines are all the same, you may start to misinterpret your own work. Below are three versions of the same box. The only difference between them is how the line weights are drawn. When you control your line weight, it keeps your work from becoming dimensionally ambiguous.

Below, the lines are all the same, making it easy to misinterpret the form.

Line weights, used properly, make this last box look like the intended cube.

This box doesn't read as a cube; it looks like it's tapered. We're also looking up at it.

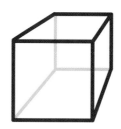

Materials

Working Digitally

You'll need a few basic supplies to get started. If you want to work digitally, choose software that allows you to zoom in to your work, vary your line weight, and work in color. As long as you have a decent command of the program, you should be fine. On the other hand, if you're still learning the program and you can't easily get it to do the things you want it to, then you're better off using some of the traditional art supplies outlined below.

Working Traditionally

In perspective, the larger you work, the easier it is to draw accurately. While there are many ways to approach working traditionally, the following supplies will make your workflow easier and faster.

Drawing Board (with a metal edge) – 24 x 30 inches

While you may have a large table to work on, you'll find that also using a hollow-core drawing board along with a T-square will speed your work up considerably. Make sure the drawing board has a metal edge on the side. That edge makes it easier to keep the T-square accurately positioned.

T-Square – 24 to 30 inches

As already mentioned, we'll use a T-square along with a drawing board to draw our horizontal parallel lines. When we need to draw angled or vertical lines, we'll use the triangles mentioned below in conjunction with our T-square.

30/60/90° Triangle

Larger is better. Get one that's tinted plastic if you can. Tinted ones are easier to see against the paper you're working on.

45° Triangle

Again, as above. Larger and tinted are most helpful.

C-Thru Ruler, 2 x 18 inches

This is a very handy ruler – it's clear plastic and has a red grid printed on it. The grid is a helpful guide for making parallel lines anywhere on the page.

Paper – 18 x 24 inches or larger

Large white drawing paper is your best choice. If you hope to work out large environments, you'll need lots of room to draw accurately. You'll want something that's easy to erase, so you'll have to get something nicer than newsprint. A large pad of smooth quality bond paper will go a long way.

Drafting Dots/Drafting Tape

To keep your drawing from moving around while you work, you'll need to tape your drawing paper to the board. Drafting dots are circular pieces of drafting tape and are a convenient way to keep a drawing in place. Both drafting tape and its circular cousin use a lower-tack glue – it's formulated to be sticky enough to secure your paper but not so sticky that it rips your work when you try to remove it. Tape or dots work equally well.

Graphite Pencils

While not mandatory, mechanical pencils help you to keep consistent line weights without having to worry about sharpening. Mechanical pencils come in these standard sizes – 0.3, 0.5, 0.7, and 0.9mm. You'll find the 0.5mm pencil to be the most versatile. It's fine without being so fine that it's hard to see your work. Softer leads (HB, B, 2B, and so on) are darker and easier to erase but smear more. Harder leads (H, 2H, etc.) are lighter, smear less but don't erase well. Having both a B and a 2H will come in handy.

Col-Erase Pencils

These are the colored pencils mentioned earlier. Most colored pencils don't erase well, but these are specifically formulated to do just that. Have a few different colors on hand so you can keep track of things when working on a complicated piece.

Erasers

White vinyl erasers won't stain your paper the way a pink eraser can. A kneaded eraser can lighten a line without completely removing it. An ArtGum eraser can remove a lot quickly.

Erasing Shield

Typically found with drafting supplies, this handy little piece of perforated metal will help you to accurately erase small mistakes without disturbing the rest of the drawing.

Protractors

While not mandatory, a simple protractor can help you divide circles into specific angles.

Since we're more interested in drawings as opposed to mechanical diagrams, I've left things like French curves, circle and ellipse guides, and compasses off our list. If you feel they can help you with your drawing, feel free to bring them aboard.

Chapter 2
Creating Space

Perspective is all about accurate form and believable space, but it's not the only player in town. There are many ways of showing depth – from how you arrange your shapes to how you use value. In this chapter, we'll discuss and analyze the different ways we make and interpret space and form, building up to linear perspective.

Create Space Any Way You Can

As discussed in the previous chapter, perspective is just one of the many players used in the context of making a picture. It helps you show form accurately while unifying everything you draw from one particular viewpoint. In other words, perspective makes everything you draw look the way it's supposed to when seen from a specific place. Still, while perspective can solve many drawing problems, it's not the only way to show space in an image.

Remember, the goal is to have a great picture – one that emotionally communicates your subject matter in the clearest, most effective way. Drawing and painting each take considerable time, effort, and skill. Because of that, it's wise to entertain any idea that will help you create the best image possible. While linear perspective is the focus of this book, it makes sense to quickly review the other ways of showing depth and dimension.

Creating Space through Shape

Space can be conveyed simply, even before giving things dimension. What follows are ideas about using shape to direct how we see and perceive visual information.

Size

Even with a flat, simple shape we can convey a sense of depth. Drawing on the idea that things visually appear smaller to you as they (or you) move away from them, we can use scale to indicate proximity. Size, when coupled with placement, clearly describes an object in space. It's a simple tool that, when properly applied, can be used to great effect.

The size of a shape can help indicate space. Here, these four rectangles are the same shape, yet as they get smaller, they seem to be further away from the viewer.

While size is a decent indicator of space, it never works alone. Because the shapes above line up through the center of each side, a horizon is implied. This helps us interpret each box's scale a certain way. Here, they all look to be the same size box, just at different distances from the viewer. If we don't show or clearly imply a horizon, we get a different effect, as shown below.

Above are the same boxes, but instead of being aligned through the middle they're aligned at the bottom. Doing so changes how we interpret the space. Here, the boxes seem to be the same distance from the viewer but different sizes — an effect that's opposite our first diagram. This reinterpretation of space was solely caused by a change of alignment.

Overlap

As powerful as size can be, showing one object overlap another is the strongest way to indicate space. Overlapping shapes unmistakably show different levels of depth. It does so regardless of size, shape, and dimension.

Overlapping forms is a powerful and easy way to indicate space. Below, we can see how it trumps scale...

...no one interprets the example to the left to be like the one above; our brains strive to interpret a two-dimensional picture the same way they interpret the three-dimensional world.

Placement Relative to a Perceived Horizon

We've already talked a bit about placement, but there's more to it beyond its relationship with size. This method relies on the viewer's ability to sense where the horizon line is. If it isn't clearly understood, then the effect isn't apparent to the viewer. Below, we again have flat graphic shapes as our example.

Here, both squares seem to rest on the ground. The right square seems to be a bit closer to the viewer because it's further away from the horizon.

The effect doesn't translate well above the horizon – it's hard to tell which box seems closer to the viewer.

The image on the left more clearly demonstrates this idea. Again, the viewer has to interpret the horizontal division near the middle of the image as the horizon line. If this happens, it's then easy to believe that the dark blue box on the right is closer to the viewer. We understand it this way because it's farther away from the perceived horizon, making it closer to the viewer. This example relies solely on placement. The squares are the same size and aren't overlapping each other.

Why doesn't the version on the right communicate the principle with the same degree of clarity? If we understand the division to represent the horizon, then it follows that below it is the ground and above it the sky. Objects placed on the ground are limited in where they can be; while they can move forward, back, left, or right, they can only do so within the confines of the plane they're physically on. Objects that float above the ground plane do the same but can also move up or down in space. The added ability to move in that dimension makes the space they're in seem somewhat ambiguous when compared to objects that seem to be resting firmly on the ground.

Creating Space through Value

Value is an extremely powerful picture-making tool. We use it to establish the lights and darks that represent our subject matter. Again, value does three important things – it helps establish mood, define form, and create focus by prioritizing content through varying levels of contrast. Note that if you're working digitally, many software programs use the word 'brightness' to label and control value. Some people prefer to use the word 'tone' instead, and others describe the idea by talking specifically about black, white, and grays. It's all the same idea – we're controlling contrast by making things lighter or darker.

There are two ways to define space through value. Essentially, both ideas are about controlling contrast, but one method is specifically used to describe what happens when depicting an outdoor environment.

Value Contrast

High contrast attracts the eye and pushes things forward in space. In the first of the three examples below, strong contrast makes the dark square seem closer than the white one. The specific value that surrounds both squares is responsible for how we interpret the space. Because there's more contrast between the dark square and the surrounding light gray than there is between the gray and the white square, the white square effectively 'groups' or merges with the surrounding value. Think of it as a kind of camouflage, causing the less-contrasting shape to, by comparison, blend into the value that surrounds it.

A dark background makes the white square come forward, making it look closer to the viewer.

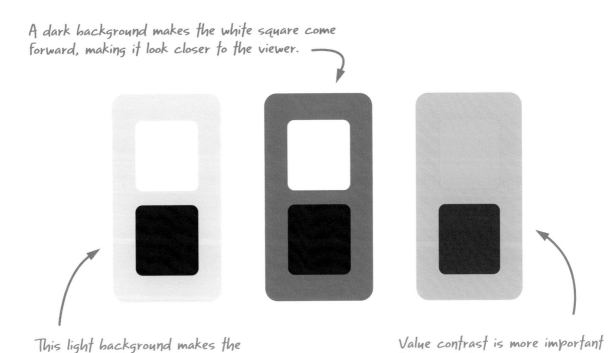

This light background makes the dark square stand out the most.

Value contrast is more important than color for implying space.

Changing the background value to a much darker one redefines the spatial order accordingly. In the middle example, notice how the white square now stands prominently out while the dark one gets lost inside its surrounding environment. Squinting your eyes makes the effect even more pronounced by blurring the subtle difference between the two closer values. The last example repeats the principle in color. It's important to understand that this effect is mostly dependent on the value of the colors used and not the colors themselves. In the last example, even though the dark square and the surrounding shape are both different values of the same color, they have more contrast than the pale green square and the blue that surrounds it.

Aerial or Atmospheric Perspective

This method builds upon the idea of value contrast. It's meant to help show long distances in an outdoor environment. When you look at something that's far away, you're looking through miles and miles of air. As you do this, the tiny particulates in the air add up, causing things in the distance to both lose value contrast and to have softer, more diffused edges. The more air you look through, the softer your edges get and the closer your values become. The more particulates in the air, the stronger the effect.

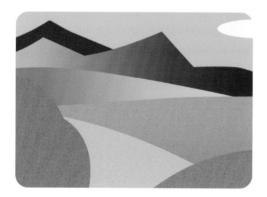

Here's a quick landscape study done in a flat, graphic style. Even with all of the overlapping forms, the space looks condensed and flat. The sharp edges and high value contrast throughout come forward and flatten the intended space.

Here's the same image, this time redrawn with the ideas of atmospheric perspective in mind. As you move back in space, hard edges grow softer and there's less value contrast. Both ideas help create a more believable illusion of space.

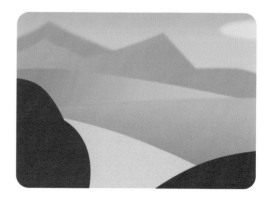

Compare the two images on the previous page. Even though the subject matter is graphically simple and shown without dimension, each portrays space differently. The first image relies mostly on scale and overlap to show depth. The second adds in the two effects that define atmospheric perspective – less value contrast and softer edges as you move back in space. These ideas work together to accurately describe the distance between foreground and background.

Creating Space through Form

We've finally arrived at three-dimensional form, and with that comes perspective. The two kinds of drawing that establish dimension are called paraline perspective and linear perspective.

Paraline drawings look diagrammatic because most or all of the parallel lines in an object remain parallel in the drawing. These drawings have more to do with showing dimension in a visually consistent way than with creating images that reflect how we see. Paraline drawings rarely look natural – that's not the intent. Engineers and architects use these types of drawings on blueprints and diagrams. While this type of perspective is useful in their domains, if your goal is to create an image that reflects how we see, you'll want to use linear perspective.

Paraline Drawings

To show the difference between the two main kinds of perspective, here's a simple house presented in four common types of paraline projections.

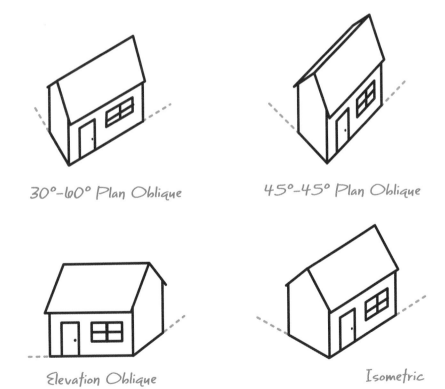

30°–60° Plan Oblique 45°–45° Plan Oblique

Elevation Oblique Isometric

Linear Perspective – A Quick Introduction

Linear perspective is the primary focus of this book. Linear perspective organizes your artwork's space and dimension into a cohesive, believable image. The ideas, rules, and methods of perspective are designed to help convey visual information the same way our eyes take in the world.

There are three types of perspective that mimic the way we see. Each presents visual information differently, and they will all be covered throughout this book. Let's first identify the three primary types of linear perspective and discuss their main characteristics.

One-Point Perspective

A box in one-point perspective looks like the one below. Notice how the front of the box looks like it's completely facing the viewer. In one-point perspective, there are two sets of parallel lines: the verticals and horizontals. The lines that move back recede to a singular vanishing point, which sits on the horizon line.

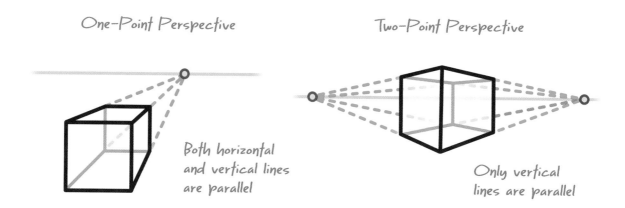

One-Point Perspective

Two-Point Perspective

Both horizontal and vertical lines are parallel

Only vertical lines are parallel

Two-Point Perspective

Next to our one-point box is one drawn in two-point perspective. When you compare the two, this one has turned away from the viewer. While the front of the box is no longer facing us, the front edge is. There are two sets of lines that move back toward the horizon line. Each group moves to its own vanishing point. In two-point perspective, only vertical lines are parallel to each other.

Three-Point Perspective

Here is our last box, this time drawn in three-point perspective.

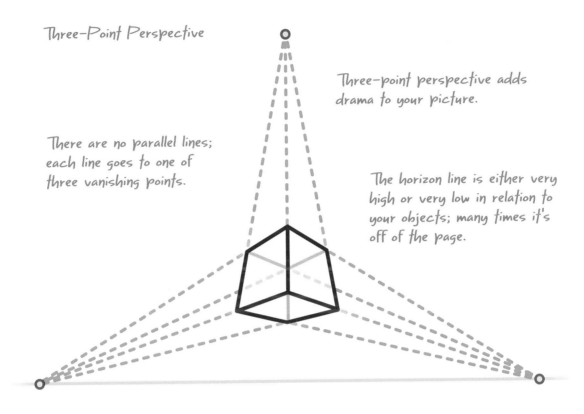

Three-Point Perspective

Three-point perspective adds drama to your picture.

There are no parallel lines; each line goes to one of three vanishing points.

The horizon line is either very high or very low in relation to your objects; many times it's off of the page.

Images constructed in three-point look more dynamic than ones set up in one- or two-point. In three-point perspective, all lines move away from the viewer, leaving us with no parallel lines.

Chapter 3
Setting It All Up

Perspective is designed to help you imagine and control how someone, a viewer, is looking at something. It helps you determine what they see and how they see it – and therefore how we draw it. We'll go into detail about how this works. Once you understand the underlying ideas that govern perspective, the mechanics of it all become straightforward and almost elementary.

To make the most of what follows, we should first agree on some general terminology.

Plane – A flat, even surface used to describe a specific direction in space.

Parallel – Lines or planes that, even when infinitely extended, remain the same distance from each other. When things are parallel to each other, they never meet.

Perpendicular – Lines or planes that meet at a right angle.

90° – The numerical representation of a right angle.

Vertical – A line or plane at a right angle to the horizon.

Horizontal – A line or plane that runs parallel to the horizon.

Diagonal – A line or plane that runs at an angle between a vertical and horizontal plane.

The Three Rules of Perspective

Perspective helps us recreate the specific way we see. Whenever we look at a three-dimensional object, you can be sure the following three rules apply.

Rule One: Convergence

All parallel lines that move back in space will always seem to converge at a point on the horizon.

The key word is seem, and it's an important one. Parallel lines never truly converge, but as they move away from us they *look* like they do. It's essential that you understand this idea as it exists beyond the specific object you're drawing. All receding parallel lines, anywhere on the page, from any object, will always seem to meet at the same place on the horizon line.

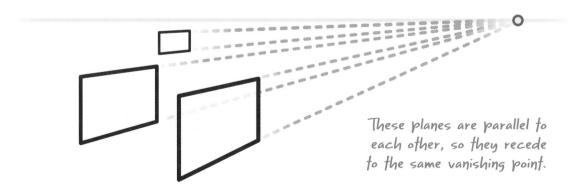

These planes are parallel to each other, so they recede to the same vanishing point.

Rule Two: Diminution

Objects of equal size appear smaller as they move away from the viewer.

We've seen this rule play out in Chapter 2, when we were talking about space. As things move away from us, they get smaller on the page yet still represent their particular size anywhere in your picture.

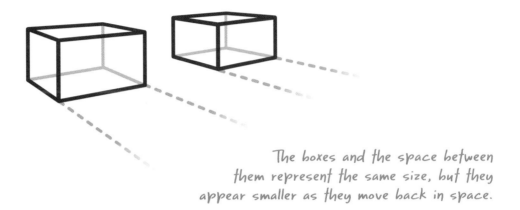

The boxes and the space between them represent the same size, but they appear smaller as they move back in space.

Rule Three: Foreshortening

When an object that's perpendicular to the viewer's line of sight changes angle, the shape of the object seems more condensed.

When a form leans back, the part of the object that has moved forward starts to obscure what's now behind it. Foreshortening effectively compresses how an object is represented. The more it leans back, the more foreshortened and condensed it appears.

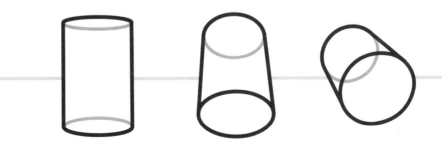

The height of these cylinders seems more condensed as they lean back in space, away from the viewer.

How Perspective Works

Whenever we draw something representationally, we're drawing what something would look like from a particular location. It's a lot like using a camera – whenever I take a picture, what I get is determined by where I am in relation to what I'm looking at. If I move or aim my camera at a different location, I get a different picture. Representational artists create with the same intention – our work is always a portrayal of what things looks like from a particular viewpoint. When you look at a photo, you are essentially placing yourself in the photographer's shoes – seeing exactly what they saw when they took the picture. Drawing serves the same purpose – what we draw and how we draw it effectively places our audience at the scene. The sole purpose of perspective is to help you do this accurately. To start, we need to define the three things that help us position our viewer in space: how high our viewer's eyes are off the ground, how far away they are from our subject matter, and the direction or angle that they are looking in. The vocabulary of perspective is devoted to explaining how our viewer specifically relates to what he's looking at. Once you understand the following ideas, you'll have a much easier time navigating what's to come.

The Vocabulary of Perspective

Viewer

It all starts with an imaginary viewer. Just as a photo documents what something looks like from the specific vantage point of the photographer, our drawings record what we want our audience to see from where we want them to see it. This is true of any representational image, whether it's a photo, drawing, painting, or movie. We start with the viewer in mind, because, when we finish our work, that imaginary viewer becomes our very real audience. As we learn how to set up and construct images in perspective, keep in mind that the viewer ultimately represents our audience looking at our work. When working in perspective, deciding where we place the viewer is our first order of business.

Ground Plane

Everything we draw is either above, below, or on the ground. The ground plane represents an infinite horizontal plane that serves as our starting point for measuring height. It's easiest to think of it as the ground itself.

Eye Level

Eye level represents the height of the viewer's eyes off of the ground plane. It helps to determine what the viewer is able to see. Eye level isn't tied to the specific physical stature of the viewer but rather to the height of their eyes in any given situation. Whether the viewer is standing, sitting, lying down on the ground or on the roof of a 10-story building, the distance from the ground plane to their eyes will always represent eye level.

When things are below eye level, you can see the tops of them.

Here's what a one-point and two-point box look like below the horizon line:

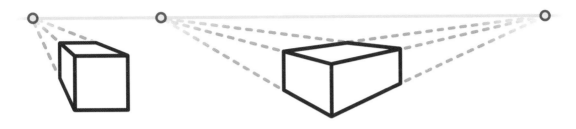

Below the horizon line, you're able to see the top of the form.

When things are at eye level, you can neither see their top nor bottom. Remember, when you place a receding plane close to eye level, it can be confusing to the viewer – the drawing isn't showing enough information to accurately describe the form. While it may be technically accurate, it will likely look awkward or be spatially confusing. When something is correct but still looks wrong, you'll probably need to change it. The image below avoids this problem because eye level runs through the middle of the object.

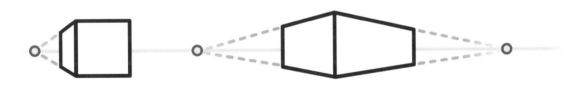

Here, they overlap the horizon line – you can't see the top or bottom.

If things are above eye level, we can only see them from the bottom.

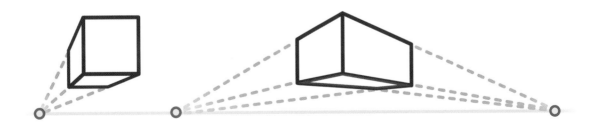

Now they're both above the horizon line – you can only see the bottoms.

Horizon/Horizon Line

When we think of the horizon, we see it as a faraway place where the sky meets the earth's surface. However, in perspective, the horizon line represents the specific height of our viewer's eyes, however high they happen to be, as far as the eye can see. In other words, it's what eye level looks like in the distance. It certainly doesn't seem that way; the horizon always looks like it's the dividing line between the earth's surface and the atmosphere. To understand why the horizon line isn't really on the ground, let's follow a simple plane as it moves back in space.

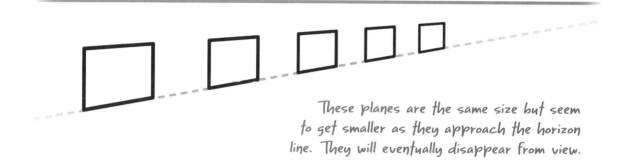

These planes are the same size but seem to get smaller as they approach the horizon line. They will eventually disappear from view.

Let's imagine the plane is three feet tall. As it moves away from us, we see it getting smaller and smaller. If it keeps going, it will eventually disappear into the horizon. The plane could just as easily have been a 16-story building. If you get far enough away from it, it too disappears into the horizon. Given enough distance, everything disappears. Yet when you're far away from something, when it's just a speck on the horizon, it's still the same size it always was. It makes sense that it will take more distance for the building to disappear than the plane because it's bigger. Instead of thinking of the horizon line as an actual line – it's not – it's best to interpret it as the edge of a plane that's always aimed at your viewer's line of sight. Here's why it shows up as a line in our work:

Four views of the same plane leaning back in space:

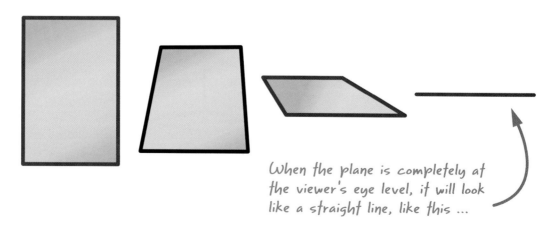

When the plane is completely at the viewer's eye level, it will look like a straight line, like this ...

Since the plane is perfectly foreshortened in the eyes of the viewer, it shows up as a line. Because it always meets the eye head on, we use it to represent eye level. It only looks like it's laying on the ground, separating the earth from the sky, because it's very far away. It may be useful to think of eye level and the horizon line as being on opposite ends of a perfectly foreshortened horizontal plane. Seeing 'starts' with the viewer's eyes and 'ends' at the distant horizon, with the line of sight traveling parallel to the ground plane as it makes its way from one end to the other. Because of this relationship, the terms horizon line and eye level are sometimes used interchangeably. Both terms help us specify height as it relates to the viewer.

Practical Considerations for Eye Level/Horizon Line

Look at the two chairs below, paying attention to how high the horizon line is in each picture. Notice that when the horizon line is high on the page, the more floor, or ground plane, you see. The eye level is high, meaning that your viewer will be looking down on most things. When the horizon line is low on the page, more space is dedicated to what happens above it. This means the viewer is low to the ground and will be looking up at most things. These are important considerations that deserve to be explored while sketching. The eye level that you choose for your viewer will help determine how your audience connects with your work.

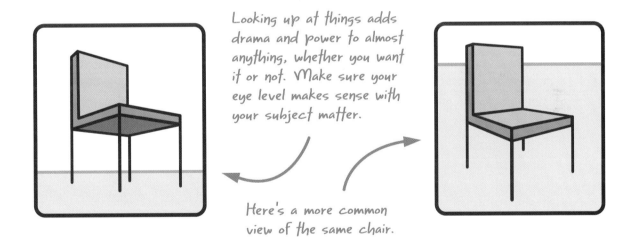

Looking up at things adds drama and power to almost anything, whether you want it or not. Make sure your eye level makes sense with your subject matter.

Here's a more common view of the same chair.

Picture Plane

Imagine our viewer, standing on the ground, looking straight ahead at something. In this scenario, we've identified the ground plane and, because we have a viewer, the eye level and horizon line. Going back to the idea of using a camera, the picture plane represents an imaginary vertical plane that the viewer looks through to see their subject matter. It's useful to think of the picture plane as an imaginary piece of glass that's always perpendicular to the viewer's line of sight. It acts as the place where we record what our viewer sees from their particular point of view. It's where we 'collect' the information that becomes our drawing.

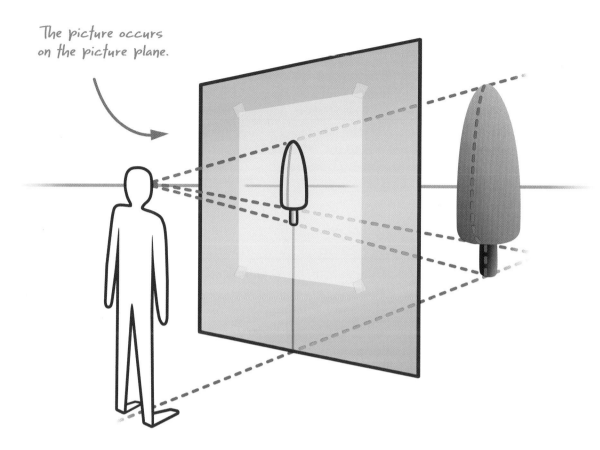

The picture occurs on the picture plane.

It's important to know that in one- and two-point perspective, we always assume the viewer to be looking straight ahead. This means the picture plane will always be perpendicular to the ground plane. Three-point perspective is the exception. The picture plane moves with the line of sight and is no longer 90° to the ground plane. Three-point will be covered in detail in a later chapter.

Ground Line/Horizontal Measuring Line

The ground line is the imaginary line which shows where the picture plane intersects the ground plane. If we need to measure things as they move back in space, we do so by using the ground line. For that reason it's sometimes called the horizontal measuring line.

Station Point

The station point is another way of representing the eyes of our viewer. We use eye level to define how high the viewer's eyes are relative to the ground plane. We use the term station point to determine how *far* the viewer is from the picture plane. In essence, we are taking two different measurements from the same location. With our viewer's eyes as a starting point, when we measure down to the ground plane we are determining height. When we move from the eyes to the picture plane, we're measuring distance. Both measurements determine the specific placement of our viewer. That placement determines what our picture will ultimately look like.

Line of Sight/Distance Line

Think of the line of sight as the direction of the gaze of our viewer. We already know that it starts at the station point and travels through the picture plane at a 90° angle. In one- and two-point perspective, the viewer is looking straight ahead, making the line of sight parallel to the ground plane. Because the line of sight starts at the station point and goes through the picture plane, it's used to measure distance, hence its alternative name.

Center of Vision

The spot where our line of sight crosses through the picture plane is called the center of vision. In one- and two-point perspective, the center of vision will always be on the horizon line. In one-point perspective, it does double duty as our vanishing point. If seeing 'starts' at the station point and moves through space following the line of sight, it 'ends' at the center of vision. Interestingly, the center of vision is the only place on our drawing where our work is completely accurate. As we move away from it, our work remains believable but isn't precise enough to perfectly recreate what we're drawing. There's eventually a point where we start to lose the believability of what we draw – that is, even while following the rules of perspective, our work will start to look distorted. To separate the area where our work gets distorted, we need to find the cone of vision.

Cone of Vision

While the next chapter is fully devoted to the cone of vision, the idea deserves attention as we try to understand how to set things up for perspective. The cone of vision defines the physical boundaries of human sight. We use it to precisely determine what's able to show up in our viewer's field of vision. While we can certainly draw outside of this area, the further our subject matter moves away from it, the more distorted things become. We'll talk about how to set up the cone of vision in the next chapter.

True Height Line/Vertical Measuring Line

The true height line is a vertical line that runs parallel to the picture plane. It's the measuring line for our vertical dimensions. Once everything's set up, we can repurpose the line of sight as a true height line. If that location ends up being impractical, you can draw a vertical line elsewhere. Just make sure it intersects the ground line.

Seeing It All Together

Here's what everything looks like so far.

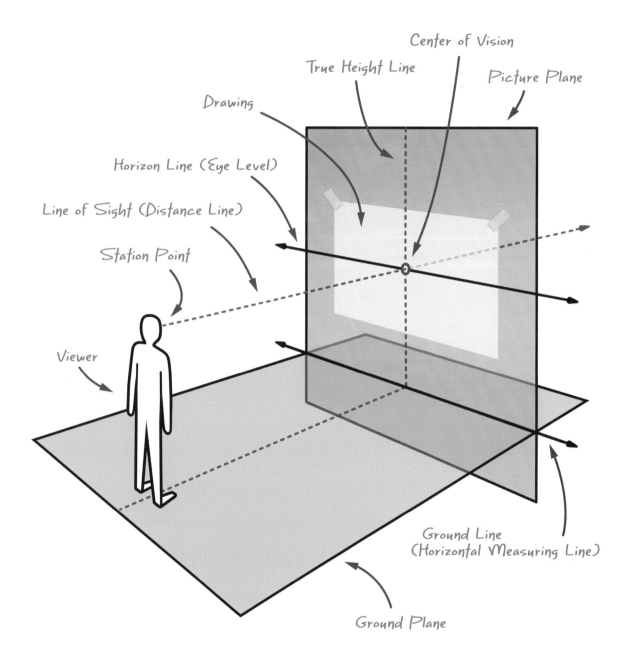

Center of Vision

True Height Line

Picture Plane

Drawing

Horizon Line (Eye Level)

Line of Sight (Distance Line)

Station Point

Viewer

Ground Line
(Horizontal Measuring Line)

Ground Plane

While the preceding image presents a clear picture of how everything is set up, it's shown from a different vantage point than that of the viewer. Here's a different point of view:

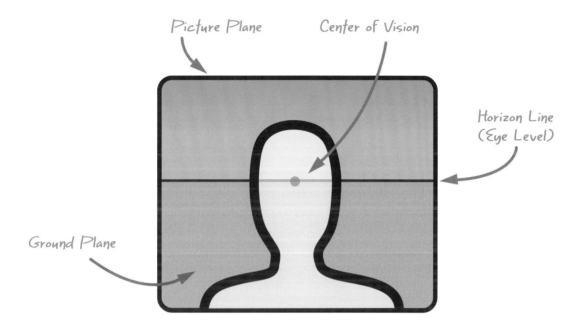

Here, we see the viewer looking straight through the picture plane. Both the eye level and the ground plane are represented. Outside of including the viewer, this is what our drawing would look like. This particular arrangement leaves us with a problem – we have no way to describe the specific distance the viewer is from the picture plane. That's because the station point, line of sight, and center of vision line up perfectly – they're all represented by a single point on the horizon. Seemingly, the only way to see how far the viewer is from the picture plane is to look at things from above. We can solve this problem by taking both the station point and line of sight and dropping it down from the center of vision until it hits the picture plane, as shown on page 32.

To begin working in perspective, we need to transfer
the distance the viewer is from the picture
plane onto our drawing.

Picture Plane

Center of Vision

Line of Sight

Station Point

To see how this works,
pretend the line of sight is
made out of string. Imagine the viewer
is standing 10 feet away from the picture
plane. That makes the line of sight 10 foot
long. If you were to cut the string at the station
point and let it fall, it would land on the picture
plane, effectively transferring the viewer's distance
away from the picture plane onto it.

We now have the viewer's specific distance represented on the picture plane. To work in perspective, we take the relevant information from the top view (which shows distance) and the necessary information from the front view (which shows height) and bring them together. This is all we need to create believable form and space as seen from our viewer's specific location. When we drop the line of sight down onto the picture plane, it does double duty. When imagined from above, it shows the distance from the station point to the center of vision. When imagined from the vantage point of the viewer, it's a vertical line that we can use to measure height.

While it's now easier to visualize how a station point makes its way onto the picture plane, it's not immediately apparent how to show the viewer's specific distance from the picture plane when drawing. Let's go through the process step by step. We can take any given value for eye level and use it to place our viewer a specific distance away from the picture plane.

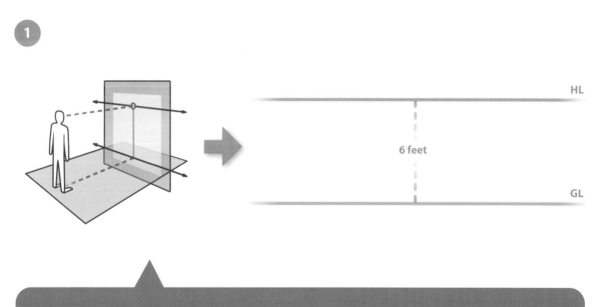

We can already create very specific points of view. Here's how to set up a viewer who is 10 feet away from the picture plane with an eye level of 6 feet.

Start by establishing the horizon line and ground line. Remember, the distance between the two, no matter how far apart the two lines actually are, will always represent 6 feet. This is an arbitrary value, based on the desired eye level.

2

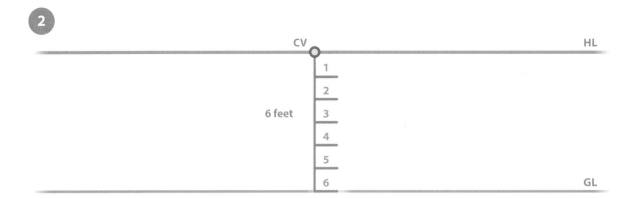

Place the center of vision on the horizon line. Draw a perpendicular line from the center of vision through the ground line. This is the vertical measuring line.

Next, divide the VML into 6 equal pieces. Each segment represents 1 foot.

3

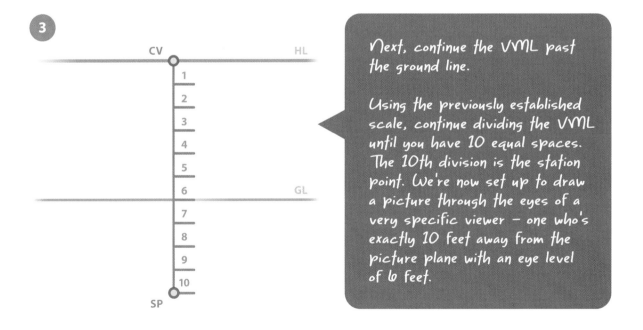

Next, continue the VML past the ground line.

Using the previously established scale, continue dividing the VML until you have 10 equal spaces. The 10th division is the station point. We're now set up to draw a picture through the eyes of a very specific viewer — one who's exactly 10 feet away from the picture plane with an eye level of 6 feet.

We can now place the viewer in a particular location. We defined eye level by establishing the ground plane and the horizon line. Next, we determined the line of sight by placing the center of vision on the horizon line and dropping a vertical line from the center of vision down to the ground line. Because this puts the line of sight on the picture plane, we were able to divide it into equal pieces that represent a specific unit of measure. Finally, we took that unit of measure and used it to place the station point the desired distance away from the picture plane.

Together, these decisions determine what your image will look like. Once we're done talking about the cone of vision, we'll talk about what happens on the other side of the picture plane.

After that, we're ready to draw.

Chapter 4
The Cone of Vision

If you've ever drawn something in perspective that ended up looking unnaturally distorted, you're not alone. This happens when you draw outside of the viewer's field of vision. In this chapter, we'll discuss the limitations of human sight and introduce the cone of vision – the tool that creates the necessary boundaries that tell us what the viewer is able to see.

How We See

Human vision has specific limitations. When we look out toward the horizon, the depth of our vision ends, somewhere in the distance. It's not as apparent, but we have limitations of height and width as well – if I stretch my arms out on each side and look straight ahead, I can't see them. If I hold my arms straight up, again I can't see them. Obviously, I can't see what's behind me. We don't notice these limitations, because we easily compensate for them. First, our eyes dart around very quickly. If that's not enough, we use our necks to aim our eyes in the right direction. When even that isn't enough, we'll use our bodies to turn around to see what we couldn't see otherwise. So, while there's a specific boundary to seeing, it's not something we're particularly conscious of.

In the last chapter, we discussed the perspective setup and how it helps us manage our work as we try to show depth accurately. Now, we need to talk about how to correctly determine what's able to show up in our viewer's field of vision. When we try to draw things that would exist outside of what the viewer can physically see, distortion creeps in, making our drawings look awkward and wrong. The information in this chapter will help you avoid this common problem.

Try this – while looking straight ahead, take your open hand, palm facing you, and place it horizontally over your eyes. Touch the spot between the base of your pinky and ring finger to the tip of your nose. As you try to look straight ahead, your hand will mostly fill up your field of vision.

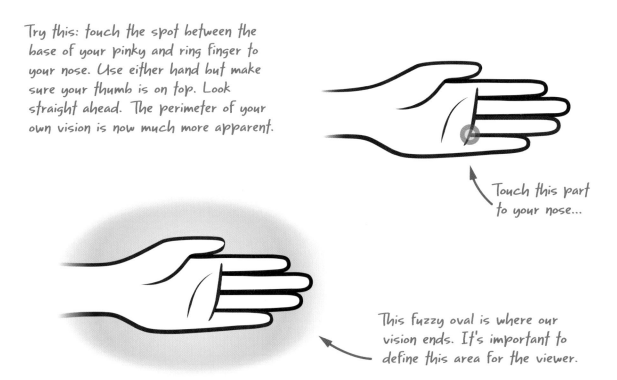

Try this: touch the spot between the base of your pinky and ring finger to your nose. Use either hand but make sure your thumb is on top. Look straight ahead. The perimeter of your own vision is now much more apparent.

Touch this part to your nose...

This fuzzy oval is where our vision ends. It's important to define this area for the viewer.

Clearly your hand is blocking out what's in front of you, but by doing this you've drawn attention to where the *edges* of sight are. You should have very little room on either side of your hand to see, and if you're still looking straight ahead, then what you can see is nondescript and general. There are a couple of lessons here. First, if you're really close to something, it crowds out your ability to see other things. While that's obvious, we need to remember that the same will hold true for our fictional viewer as we set up a drawing. Distance matters. Second, the periphery of human sight is imprecise. It's solely devoted to seeing general color, value contrast, and motion. Again, this isn't that apparent to us since we automatically move our eyes, neck, and body to see what we need to see. While we won't need to blur the edges of our work, we still need to know where our viewer's field of vision ends before we start to draw.

The Cone of Vision

In perspective, the cone of vision is our way of defining the edges of sight for our viewer.

If we draw without paying attention to the cone of vision, we run the risk of having parts of our drawing look distorted. This happens when we use perspective to draw things outside of what the viewer would naturally be able to see.

Drawing Outside of the Cone of Vision

If you start drawing without knowing where the cone of vision is, you'll discover that if you get too far away from the center of vision, there's a point where your work will start to look stretched and unnatural. You're probably drawing just beyond the periphery of sight. A little distortion isn't necessarily a bad thing; when it's done with control, we call it exaggeration.

Here's what a simple box looks like when drawn in the cone of vision – it looks normal and believable.

Here's a box that's completely out of the cone of vision – it exists beyond the 'edge' of human sight. Because it's so distorted, it doesn't do a very good job at representing reality.

Here's the same box, but this time it's starting to extend out beyond the cone of vision. Note that the front bottom corner looks a bit stretched.

Used properly, it can add drama and visual energy to your work. Exaggeration, though, should be on purpose, and it shouldn't be distracting. Know that if you draw much past this point, things will quickly devolve into a contorted and deformed mess.

Placing the Cone of Vision in the Setup

In perspective, the accepted standard is to use a 60° angle to define the cone of vision. This angle is really two 30° angles – one on each side of the center of vision. To start the cone, we need our viewer, the line of sight, center of vision, and the horizon line. Here's what it looks like in the setup:

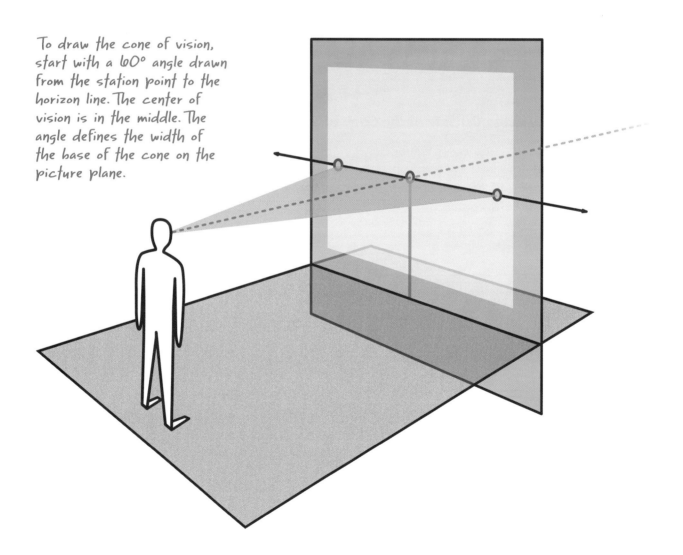

To draw the cone of vision, start with a 60° angle drawn from the station point to the horizon line. The center of vision is in the middle. The angle defines the width of the base of the cone on the picture plane.

Here's the same view with the cone of vision in place:

Here's the cone of vision — we used the 60° angle to determine the cone's width on the picture plane. From there, we can finish off the cone.

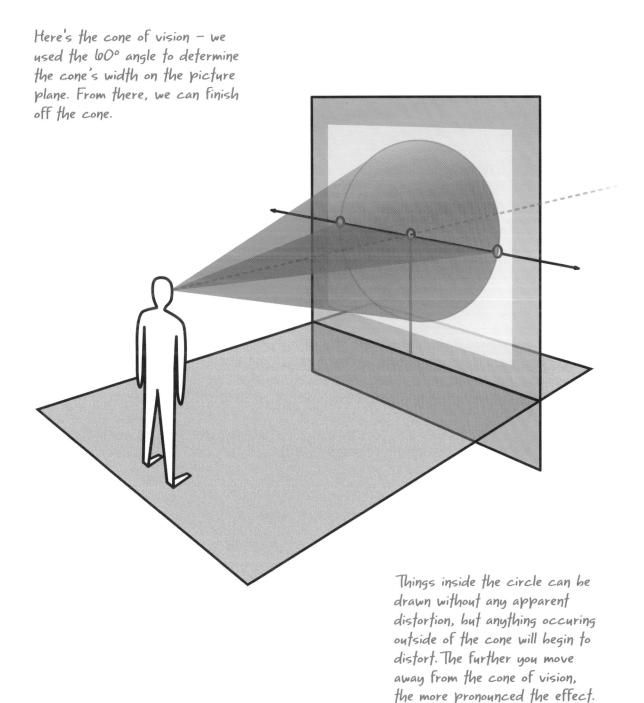

Things inside the circle can be drawn without any apparent distortion, but anything occuring outside of the cone will begin to distort. The further you move away from the cone of vision, the more pronounced the effect.

Here's what the cone of vision looks like from above. The base of the cone sits on the picture plane and the tip starts at the station point. It's the same for one- and two-point perspective.

In this top view of the cone of vision, we can see the 60° angle more clearly. Remember, it's made up of two 30° angles on each side of the center of vision.

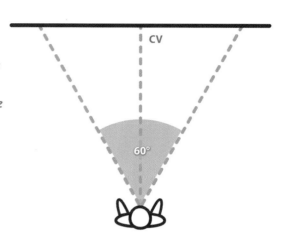

In your drawing it's represented by a large circle – that's the base of the cone resting on the picture plane. Again, only things drawn inside the circle look believable. Our imaginary viewer can only see things that are inside this area.

Here's the cone of vision as our viewer sees it. The viewer is only capable of seeing inside the large red circle – everything that's outside of that is outside the limits of vision. Note that the center of vision (the small red dot) is always in the center of the cone of vision.

Station Point, Cone of Vision, and Picture Plane

The perspective in a drawing is created by the relationship between how far away the viewer is to the picture plane, the size of the subject matter, and where the picture plane is placed between the two. As the picture plane moves away from the viewer, the cone of vision increases in size, allowing the viewer to take in more visual information. On the other hand, moving the picture plane closer to the viewer limits what's able to be represented.

In the image below, notice the two different picture planes and their different cones of vision.

Here we have the same cone of vision extended to two different picture planes. Notice how the cone gets bigger as the picture plane moves back away from the viewer. That means you'll have more room in your picture to draw without distortion.

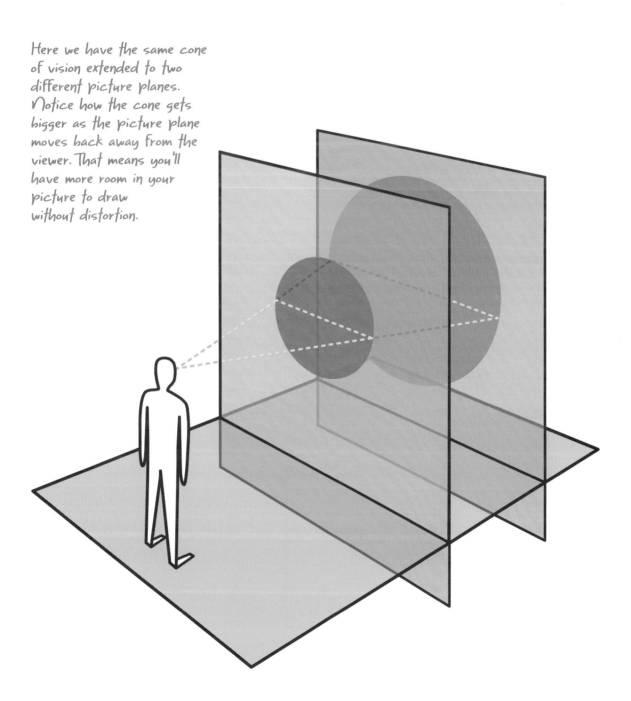

Finding the Cone of Vision Based on Your Image Area

It's best to start out with the cone of vision in place before you begin your work. You can quickly add it to your setup when drawing. Make sure to keep your work mostly inside the cone of vision and you'll be fine.

As always, start with a sketch. If you're happy with your basic composition, enlarge the specific frame (the box you did your sketch in) on your paper at the size you want to do your drawing. We'll set things up so our entire image area is inside the cone of vision. Using this method, we won't need to know exactly where our viewer is in relation to the picture plane. We're instead defining, based on how large we intend to draw, the *closest* our viewer can be without causing distortion. There are two different approaches to this, based on the kind of work that you're doing.

Working for Film, Animation, and Photography

If you're doing storyboarding for film or animation, or if you're a photographer planning out a challenging shoot, you'll need to treat the cone of vision in a particular way. When you look straight ahead through any kind of camera (film, video, or still), the center of vision is always in the exact center of your frame. Remember, looking straight ahead is the convention for drawing in one- or two-point perspective, though it's not necessarily how we hold a camera. The following shows your two options for camera-based work.

When a camera is looking straight ahead, the center of vision is in the exact center of the frame, resting comfortably on the horizon line.

Unfortunately, it's not how we always hold a camera. If you're sketching for film and don't want the horizon line to divide your picture in half, at least make sure the center of vision is somewhere along the vertical center.

The center of vision can be anywhere on this path and still represent a camera.

For this example, we'll assume the viewer is looking straight ahead. That puts the center of vision in the exact center of the frame – X marks the spot.

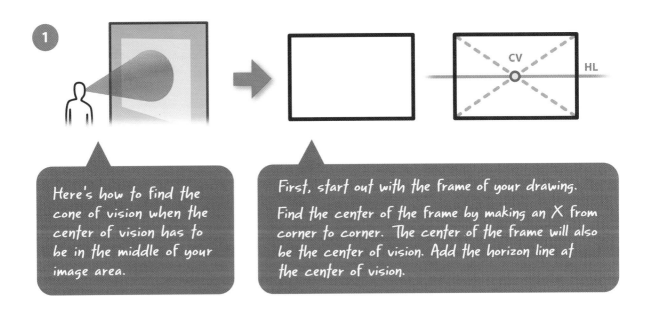

1

Here's how to find the cone of vision when the center of vision has to be in the middle of your image area.

First, start out with the frame of your drawing.

Find the center of the frame by making an X from corner to corner. The center of the frame will also be the center of vision. Add the horizon line at the center of vision.

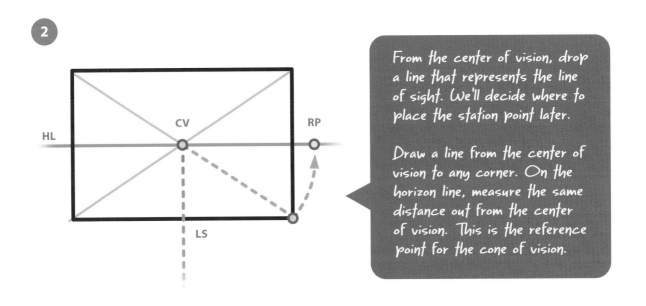

2

From the center of vision, drop a line that represents the line of sight. We'll decide where to place the station point later.

Draw a line from the center of vision to any corner. On the horizon line, measure the same distance out from the center of vision. This is the reference point for the cone of vision.

3

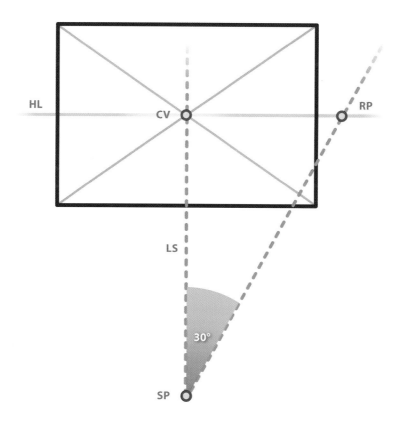

Next, use a 30/60/90° triangle find the station point, lining it up so the 90° angle runs through the center of vision while the 60° angle runs through the reference point. The 30° angle represents the station point. This is the closest the viewer can be if you're trying to keep the entire page in the cone of vision.

4

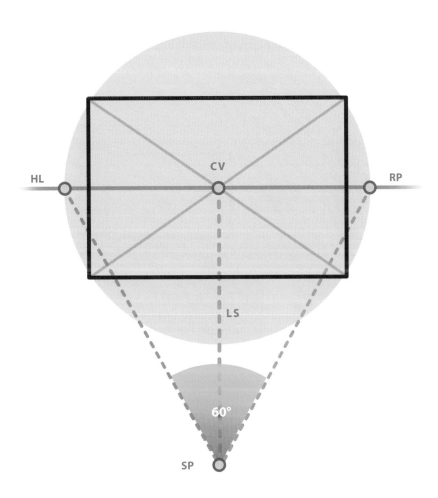

We don't need to measure the other 30° angle — simply draw a circle using the distance between the center of vision and the reference point as the radius.

Here, you can see the cone of vision cover up the entire drawing area. If we moved the station point closer to the frame, the angle from the station point wouldn't be able to cover up the entire picture area.

Making a Drawing or Painting

The only difference here is that our center of vision doesn't have to be anywhere near the center of our picture. If it's not, we need to choose the longest of the four lines that go from the center of vision out to the corners. That's the measurement we'll place on the horizon line to define the cone of vision.

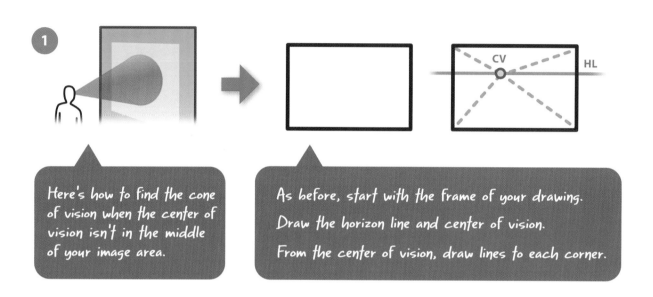

Here's how to find the cone of vision when the center of vision isn't in the middle of your image area.

As before, start with the frame of your drawing.

Draw the horizon line and center of vision.

From the center of vision, draw lines to each corner.

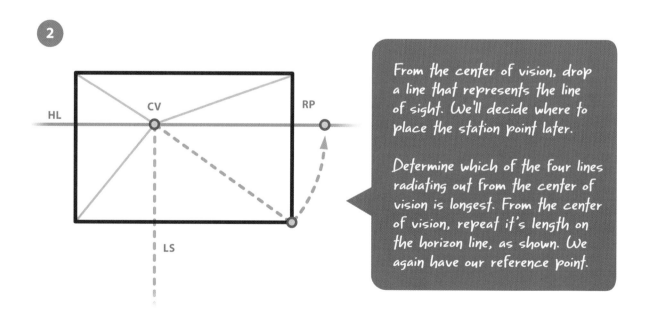

From the center of vision, drop a line that represents the line of sight. We'll decide where to place the station point later.

Determine which of the four lines radiating out from the center of vision is longest. From the center of vision, repeat it's length on the horizon line, as shown. We again have our reference point.

3

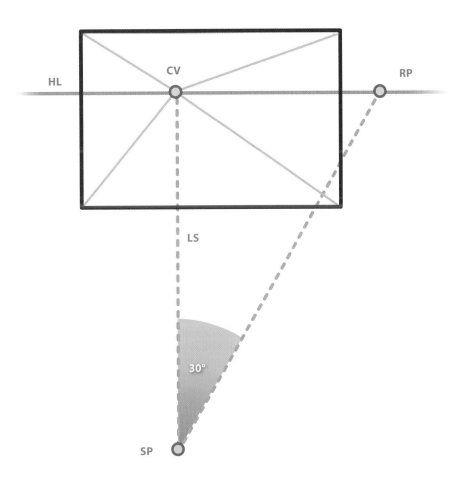

Next, measure a 30° angle from the reference point (RP) to the line of sight as shown. Based on the frame of our picture, we've again defined how close the viewer can be by the placement of the station point. Any closer and the cone of vision gets smaller, leaving the outer edges of the frame open to distortion.

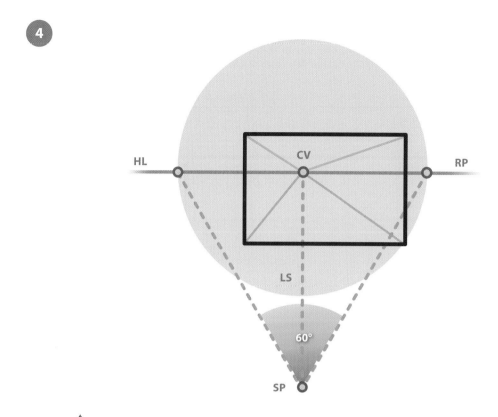

Using the line from the center of vision to the reference point as a radius, draw a circle to create the cone of vision. The cone of vision is offset and larger than the frame. This compensates for the center of vision not being in the middle of the page.

Both approaches will define the closest your viewer can be to your subject without creating distortion. Now it's time to think about how close your viewer should be to your subject matter. If you decide to move the viewer back (creating a longer line of sight), you'll be placing a greater distance between viewer and subject. This makes sense if you want to show a cityscape, but it may not be a great choice if your viewer's inside a room. Remember, the distance your viewer is from the picture plane ultimately depends on what you wish to show in your drawing.

Chapter 5
The Setup in Action

We're almost there. So far, we've been concentrating on the viewer, but now it's time to talk about what happens on the other side of the picture plane. When we're done, we'll have enough information to begin drawing in perspective. In this chapter, we'll go over the remaining vocabulary, complete the perspective setup, and go through the drawing process step by step.

More Vocabulary

Now that we've discussed how the setup relates to the viewer, we need to talk about how it relates to your subject matter. We have a few more things to review before we start to draw in perspective.

Vanishing Point – Vanishing points represent the spot on the horizon where the parallel lines of our forms seem to converge. Remember, they don't truly converge (they wouldn't be parallel if they did) but they always look like they do. We use vanishing points to establish precisely where on the horizon line this happens, as it relates to the specific location of the viewer.

Measuring Point – Measuring points live on the horizon line and help us measure scale as things move back in space. Once you've decided where your station point and vanishing points are, you can easily find your measuring points. Each vanishing point will have a measuring point associated with it. The measuring point is as far away from the vanishing point as the station point is.

Reference Line – Think of reference lines as lines that help show how planes travel back to the vanishing point. These lines serve to define our forms in the early stages of drawing.

Setting Up Your Forms

The things we draw are always turned in a specific direction when compared to the picture plane. How your objects sit in relation to the picture plane defines the perspective for your viewer and tells you where your vanishing points go. We'll use a simple box to see how this works in one-, two-, and three-point perspective.

One-Point Perspective

If an object is on or parallel to the ground plane and its front is parallel to the picture plane, it's presenting itself in one-point perspective. This gives us one set of parallel lines that move back in space toward the horizon line, creating our one vanishing point. If we were to move a box forward until it touches the picture plane, the entire front plane of the box would be flush with our imaginary piece of glass.

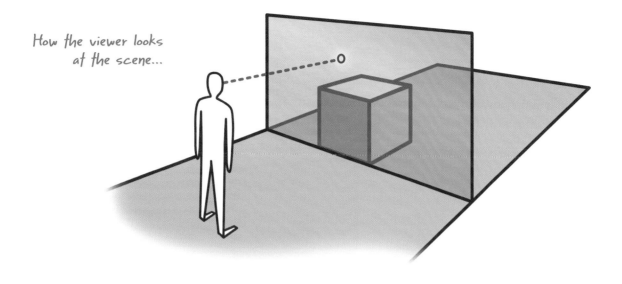

How the viewer looks
at the scene...

From above...

What the viewer sees.

Two-Point Perspective

When an object has the same relationship to the ground plane but is turned at an angle, it's in two-point perspective. If you take a simple box, turn it in place so its front isn't parallel to the picture plane, you'll end up with two different sets of lines that move back toward the horizon. Only the vertical edges of the box will be parallel to the picture plane. Moving the box to the picture plane would place only its leading edge flush against it.

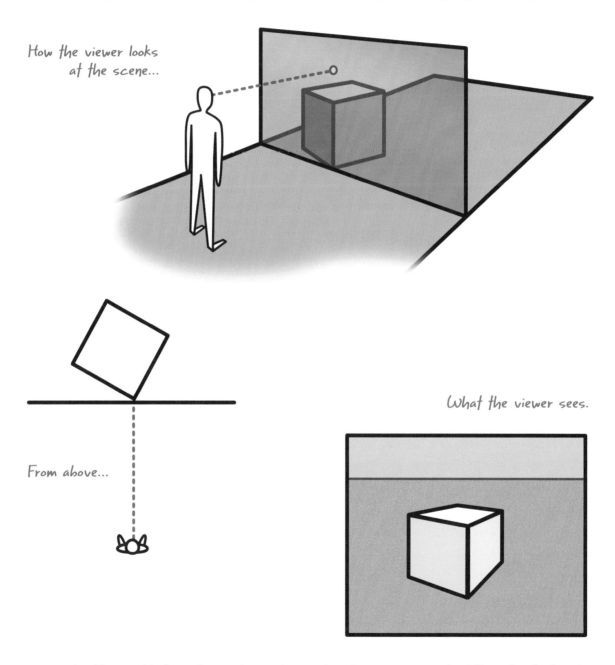

Looking at this from the top is very instructive. As you can see, the 90° angle of a box is repeated from the station point. The lines that define the receding planes of our object are parallel to the lines that go from the station point to the vanishing points.

Vanishing points are found by drawing
a 90° angle from the station point.
The arms of the angle run parallel to
the viewer's subject matter.

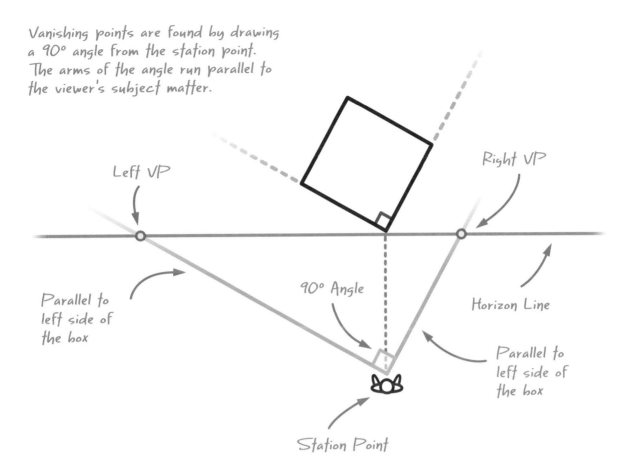

Left VP

Right VP

Parallel to
left side of
the box

90° Angle

Horizon Line

Parallel to
left side of
the box

Station Point

Vanishing points represent the interaction
between an object and its viewer.

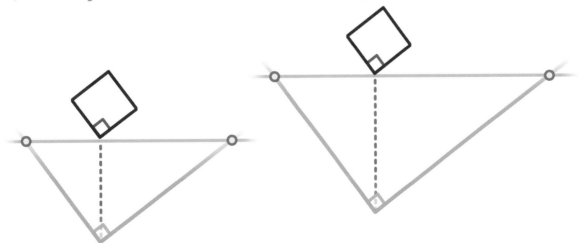

Rotate the box, and the
vanishing points move with it.

Increase the distance between the
viewer and the horizon line, and
the vanishing points spread out.

With two-point perspective, we have three things to remember:

- Our box is always turned at a specific angle when compared to the picture plane

- The station point is always the origin of a 90° angle, and . . .

- We repeat the same angle from the station point to find the vanishing points.

Three-Point Perspective

We use three-point perspective to draw things that are well below or above the viewer. With one- and two-point perspective we assume our viewer to be looking straight ahead, with a line of sight parallel to the ground plane. That's not the case with three-point perspective. Here, we allow the viewer to use his neck. He has to; because of his placement relative to the scene, he's either high up and looking down, or low to the ground and looking up. Wherever the viewer looks, the picture plane follows. In three-point perspective, that means it's no longer parallel to the vertical lines of our form, or perpendicular to the ground plane. This adds a third vanishing point to take into account how the vertical lines move back in space when compared to the picture plane. Staying with the example of our box, if you were to slide the box forward to touch our newly angled picture plane, only the leading corner is able to touch the imaginary piece of glass.

In this example, only the bottom front corner of the box is touching the picture plane.

In three-point perspective, the viewer is looking either strongly up or down, but no matter what, the picture plane will always be 90° to the line of sight.

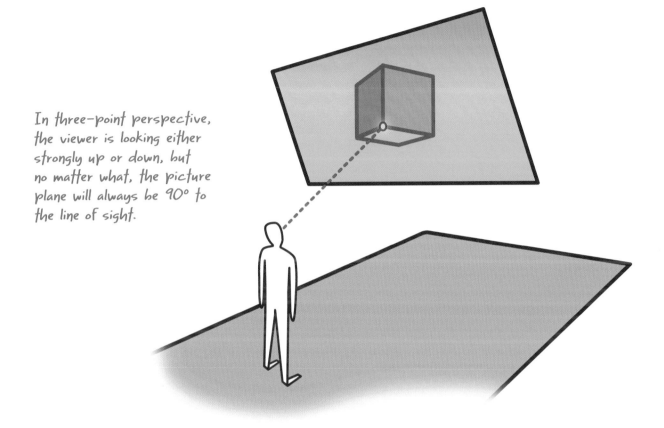

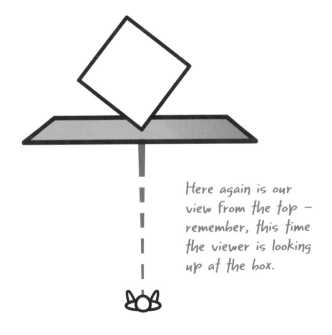

Here again is our view from the top — remember, this time the viewer is looking up at the box.

Here, the viewer sees the box in the air, above eye level — in this extreme view there are no parallel lines.

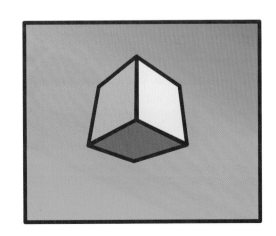

Drawing In Perspective

We're finally ready to put everything we talked about into practice. You should be quite comfortable with the information presented in the last few chapters, as they are the foundation of everything that's to come. What follows are the basic moves of perspective. We'll first set up a drawing for a simple cube in one-point. Then, we'll do the same for one in two-point. We'll talk about the differences between the two as we go. What follows is, with few exceptions, how you'll be setting up most of your work, so we'll go slowly and discuss things in detail. For the remaining chapters, I'll assume you've developed a comfortable understanding of the material. This way, we can get straight to the point with each of the different topics that follow.

Before You Begin

Before you start drawing, you should have a clear idea what you want your picture to look like. Even though we're only going to draw a simple cube, it makes sense to think about how far away and how tall our viewer is as he or she looks at it. Then there's the cube itself – is it completely facing the viewer? That makes it a one-point cube. Is it turned at an angle? That makes it either a two- or three-point cube. How is it turned away from the viewer? A lot? A little? There are a lot questions that need answering before you begin working, especially in perspective. If you don't think things through, you'll likely be led by your perspective and end up with a drawing that's different from what you intended. How you structure the setup dictates what your picture will look like, so think through your work beforehand by doing some initial sketches. This way, you can use your sketch as the foundation for your setup and start out heading in the right direction.

Why a Cube and not a Box?

The cube is perspective's building block. The rest of the basic forms are all based on a cube, so to be able to draw a cube accurately means you'll have the foundation necessary to set up everything else. In the following chapter, we'll go over the rest of the major forms in detail. Boxes differ from cubes in one important way: a cube's planes are always identical in size, while a box's are not. We'll discuss why that's important in a later chapter. In the meantime, know the process for drawing both is essentially the same.

About the Diagrams

One of the perks of learning perspective from a book is seeing the process unfold step by step. In a classroom setting, even though the information is delivered that way, unless you draw out each step separately, you'll finish with the desired result but no way to remember how you got there. At first, these diagrams may seem technical and intimidating. Once you get the hang of it, you'll know that getting things laid out is actually a quick and painless way to set up believable and accurate space – all without needing to slavishly copy reference.

I've tried to make the diagrams that follow clear and user friendly. There are some conventions that should help you as you navigate through the information. They are as follows:

1. The very first box will show the result we're after. To keep the drawings from getting cluttered, important items have been abbreviated. Here's a list of the more common terms and their abbreviations as used throughout the remainder of this book:

 ● *Horizon Line* – HL

 ● *Vanishing Point* – VP

 ● *Left Vanishing Point* – LVP

 ● *Right Vanishing Point* – RVP

 ● *Station Point* – SP

 ● *Line of Sight* – LS

 ● *Ground Line* – GL

 ● *Reference Point* – RP

 ● *Measuring Point* – MP

 ● *Left Measuring Point* – LMP

 ● *Right Measuring Point* – RMP

 ● *Center of Vision* – CV

2. Embedded in every step is either commentary or directions to help you understand each part of the process.

3. Whether it's a line, shape, or point, when it's the focus of a particular step it's presented in stronger, brighter color. This extends to the corresponding abbreviations as well.

Drawing a Cube in One-Point Perspective

Start by drawing the horizon line and vanishing point. Next, place the station point. Think ahead – the closer the station point is to the horizon line, the smaller the cone of vision will be. Remember, the distance the viewer is from the picture plane (and the subject matter) strongly affects what your drawing will look like. As the viewer gets closer, things get bigger and the angles of your boxes will close up accordingly. If the viewer is too close to your subject matter it will be out of the cone of vision and appear distorted. As the viewer moves away from an object, angles open up, things become smaller on the page, and they move closer to the horizon line. Keep this in mind as you decide where to put the station point.

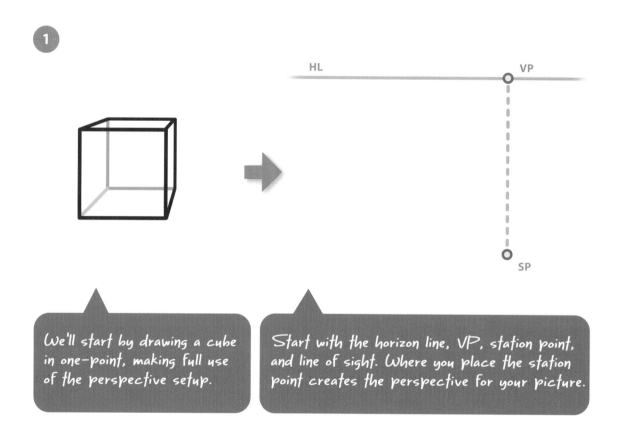

1

HL VP
 SP

We'll start by drawing a cube in one-point, making full use of the perspective setup.

Start with the horizon line, VP, station point, and line of sight. Where you place the station point creates the perspective for your picture.

Once the station point is established, use it to find the cone of vision. In one-point perspective, the vanishing point does double duty as the center of vision. Draw a 30° angle on each side of the line of sight – that adds up to the 60° needed to establish the cone of vision.

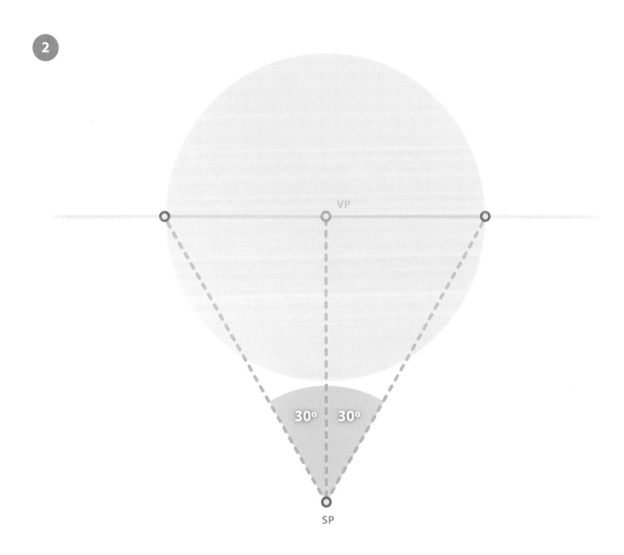

Next we'll find the cone of vision. From the station point, draw a 30° angle on each side of the line of sight, as shown above. Draw a circle to define the cone.

Next, we need to place the measuring point. The rule for placing measuring points is as follows: the distance from the vanishing point to the station point is the same as the distance from the vanishing point to the measuring point. In one-point perspective, we don't have to measure; it's always a 45° angle from the station point.

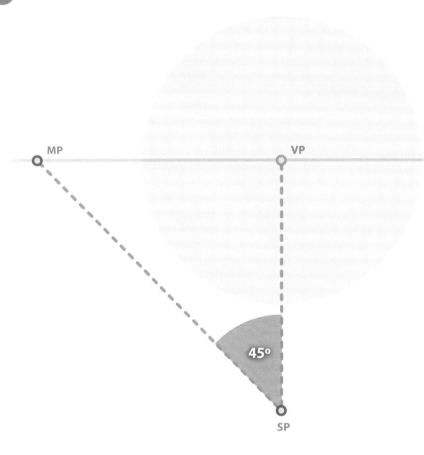

Find the measuring point by running a 45° angle from the station point to the horizon line. This automatically recreates the distance from the vanishing point to the station point on the horizon line.

Now we're ready to start drawing the cube. We'll start by drawing the 'footprint' (the base of a form as it rests on the ground) first. Draw the front bottom edge of the cube (the heavy dark horizontal line), making sure it's in the cone of vision. In one-point perspective, it's always a horizontal line. Draw reference lines to the vanishing point.

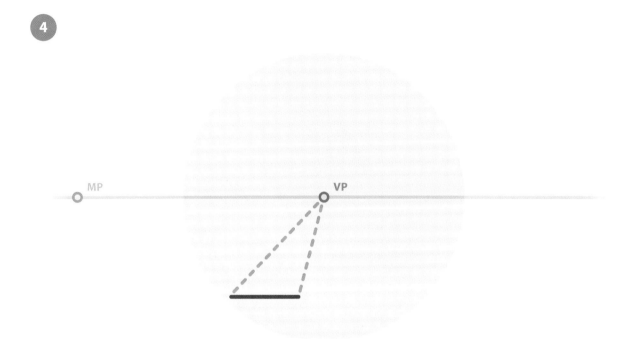

Now we can start drawing. Begin with the front edge of the box, drawn parallel to the horizon line. From each end, draw reference lines to the vanishing point.

Now we'll use the measuring point to locate the depth of the cube. Simply connect the measuring point to the farthest end of the line representing the front of the box. In this example, I'm using the right end; if my measuring point was to the right of my vanishing point, then I would be using the opposite side. The back of the cube is located at the intersection between the measuring line and reference line. From that intersection, draw a horizontal line out to the other reference line, as shown. This is the cube's footprint, a perfect square in perspective.

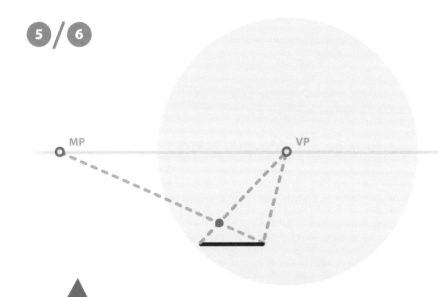

To find the depth of the cube, draw a line from the measuring point to the far end of the horizontal line, as shown. Note where it intersects the blue reference line.

From this intersection, draw a horizontal line until it crosses the other reference line. This creates the cube's footprint.

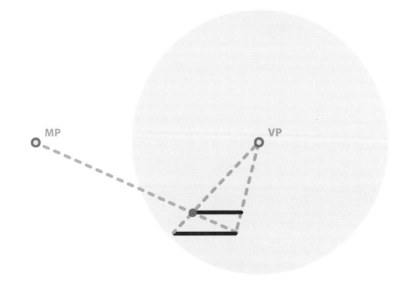

We now have everything we need to build a one-point cube. Each side of a cube is a perfect square, so we can measure the front horizontal edge of the footprint to draw the square representing the front plane. Next, run reference lines from the top corners of the square to the vanishing point.

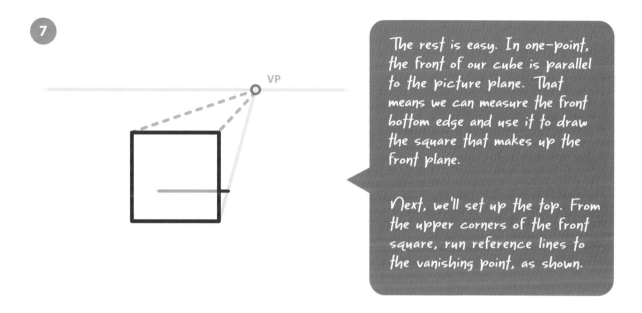

The rest is easy. In one-point, the front of our cube is parallel to the picture plane. That means we can measure the front bottom edge and use it to draw the square that makes up the front plane.

Next, we'll set up the top. From the upper corners of the front square, run reference lines to the vanishing point, as shown.

Connect the necessary vertical lines, horizontal lines, and reference lines to finish the cube.

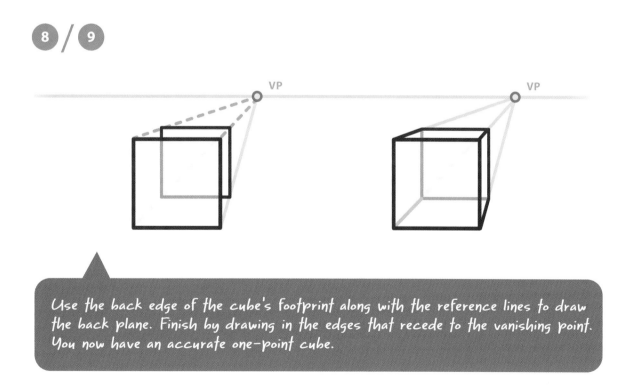

Use the back edge of the cube's footprint along with the reference lines to draw the back plane. Finish by drawing in the edges that recede to the vanishing point. You now have an accurate one-point cube.

Drawing a Cube in Two-Point Perspective

Now that we're drawing a two-point cube, we'll have to readdress how we create the setup. Since the cube is turned away from us, there are two sets of parallel lines that need vanishing points. We also have two measuring points to contend with – one for each vanishing point.

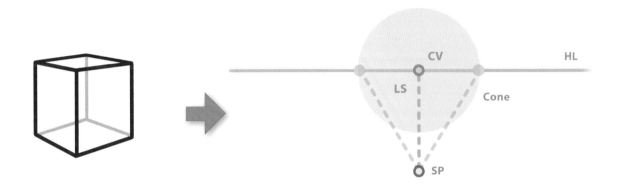

Next up is a two-point cube. We'll use a simple measuring system to help accurately represent the cube in perspective.

Start out with the horizon line, station point, line of sight, center of vision and cone of vision. Before you start, think about the cube in relation to the viewer. How is it turned? How far away is it? Is it above or below eye level? A quick sketch helps!

Next, set up the vanishing points. Again, they're found by drawing lines out from the station point at a 90° angle.

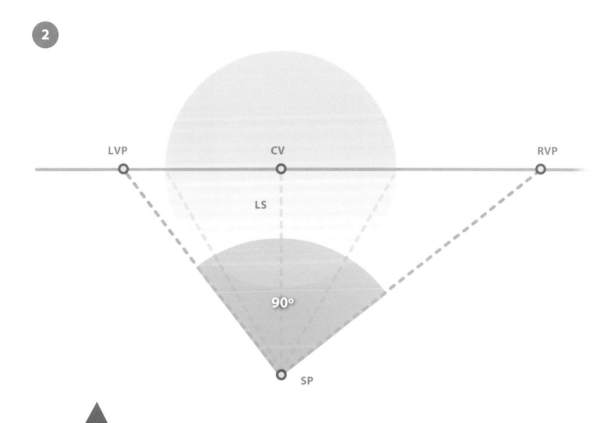

Remember, your vanishing points radiate out from the station point at a 90° angle. How you place that angle defines the specific way the object is turned for the viewer.

Now for the measuring points. Remember, the distance from the vanishing point to the station point is the same as the vanishing point to the measuring point. It's smart to label things as you go; by the time we're done we'll have five distinct points on the horizon line, not including the two that establish the cone of vision.

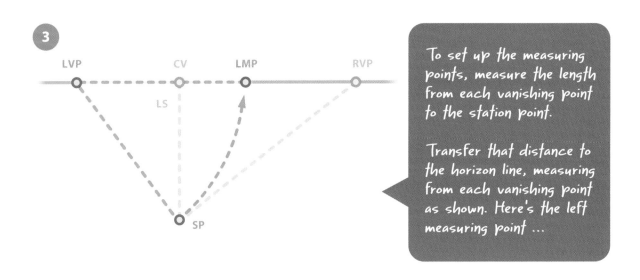

To set up the measuring points, measure the length from each vanishing point to the station point.

Transfer that distance to the horizon line, measuring from each vanishing point as shown. Here's the left measuring point ...

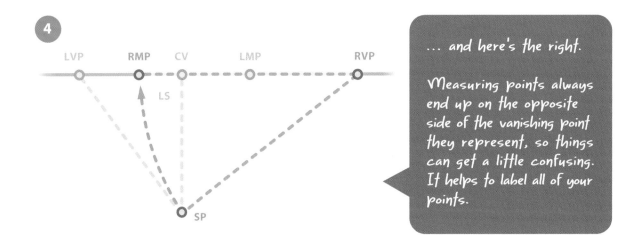

... and here's the right.

Measuring points always end up on the opposite side of the vanishing point they represent, so things can get a little confusing. It helps to label all of your points.

It's easiest to place the ground line where you want the front of your object to be. When you draw the ground line in, you're also defining where the picture plane is, at least when you visualize the scene from above. Looking at it this way, you can see how far the viewer is from your subject matter.

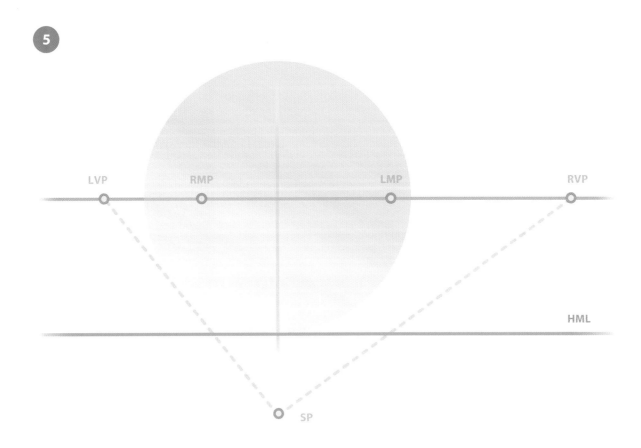

Next, we'll set up the horizontal measuring line. While it can go anywhere on the ground plane, measuring becomes easier if you place it where you want the front of your form to be. Remember to take into account the cone of vision.

The ground line does double duty as the horizontal measuring line. Because we're putting the leading edge of our cube on the line of sight, we need to place the number zero at the intersection between it and the ground line. Measuring begins where the object is, so if our cube were to the left or right of the line of sight, the number zero would go where the bottom corner of the box touches the ground line. Repeat the initial dimension on each side of zero so we can measure each side of the cube.

6 Close-Up

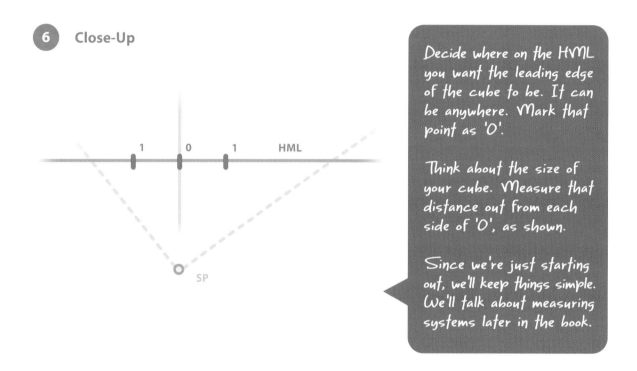

Decide where on the HML you want the leading edge of the cube to be. It can be anywhere. Mark that point as 'O'.

Think about the size of your cube. Measure that distance out from each side of 'O', as shown.

Since we're just starting out, we'll keep things simple. We'll talk about measuring systems later in the book.

On the next page we'll start to set up the vertical measurements. Just as the ground line also serves as a horizontal measuring line, the line of sight also works as a vertical measuring line. Take the same dimension used on the ground line and measure up from zero on the vertical measuring line.

7 **Close-Up**

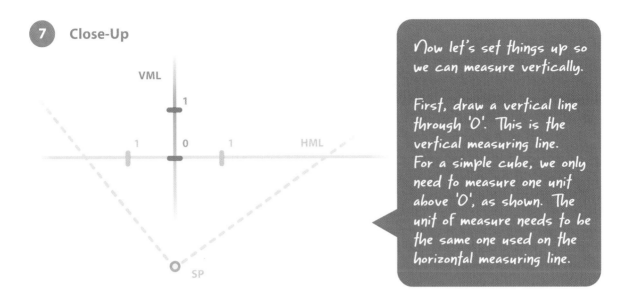

Now let's set things up so we can measure vertically.

First, draw a vertical line through '0'. This is the vertical measuring line. For a simple cube, we only need to measure one unit above '0', as shown. The unit of measure needs to be the same one used on the horizontal measuring line.

Now that everything's set up, it's time to draw the cube. We'll start with the height. Establish the sides by taking the top and bottom to each vanishing point, as shown.

8

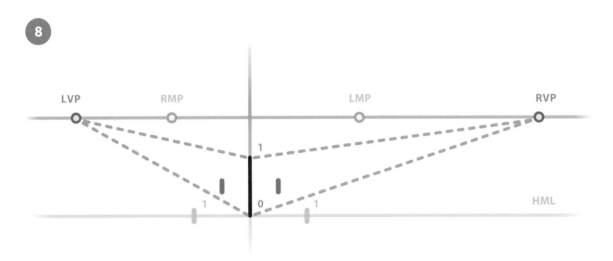

Start with the front vertical edge of the cube. Use the vertical measuring line to measure one unit up.

From the top and bottom, draw reference lines to each vanishing point as shown. These are the two vertical planes that make up the front facing sides of the cube.

Next we'll use the measuring points. If you're drawing the right side of the cube, use your right measuring point. It's on the left – this is why it's a good idea to label everything. Draw from the one-foot measurement on the ground line (HML) to the right measuring point. Draw a vertical line where it first intersects the reference line.

9

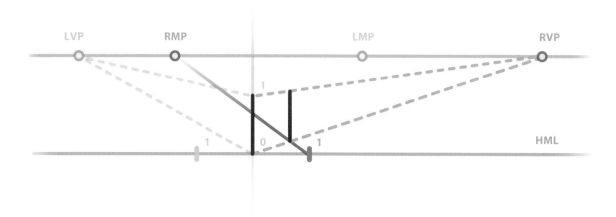

Now we'll find the depth of the cube. This is where we use our measuring points.

From the first division on the right side of the horizontal measuring line, draw a line to the right measuring point, as shown. Next draw a vertical line up its intersection with the reference line. This is the front right side of the cube.

10

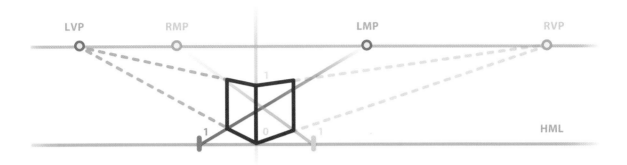

Next, we'll repeat the process for the other side. The cube is beginning to take shape. Add weight to your reference lines to define the form.

To establish the top plane, take the top edges of the box to their respective vanishing points, as shown.

11

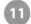
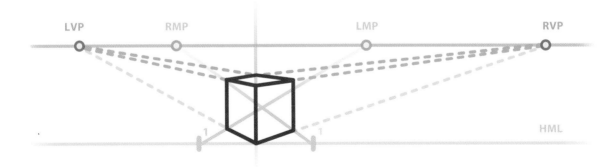

Now for the top of the box – draw reference lines from the outside vertical edges to the appropriate vanishing points, as shown above. Add weight to the reference lines to finish off the top plane.

Finish by drawing though the cube. A common mistake is to confuse the lines used to measure as ones that define the base of the form. Create the bottom plane by drawing lines to the appropriate vanishing points. Do this correctly and you're done.

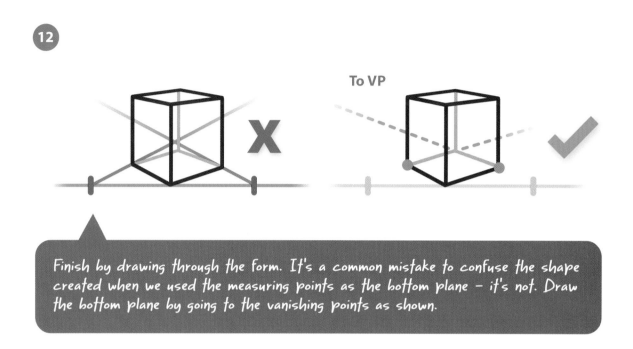

12

To VP

Finish by drawing through the form. It's a common mistake to confuse the shape created when we used the measuring points as the bottom plane – it's not. Draw the bottom plane by going to the vanishing points as shown.

Because we went through this construction in great detail, it can seem like a lot of work. Once you learn the steps, however, it's truly a leisurely three- to five-minute endeavor. Considering that this is typically the way we start a perspective drawing, it makes sense to concentrate on learning these steps until the process becomes routine. Once it's in you, you'll be better able to take advantage of all that perspective has to offer.

Chapter 6
Constructing the Basic Forms

So far, we've explored what perspective is and how it works. Now we're set to discover what it does. We'll use the basic geometric forms as a starting point. These forms – boxes, pyramids, cones, cylinders, and spheres – are the structural bones of almost everything there is to draw. When you master these simple forms, you'll be ready for anything.

Drawing in Three Dimensions

Let's take a break from the formalities of perspective and talk a bit about drawing. While there are many ways to draw, if your goal is to visually express the world around you in an accurate way, then you'll have to learn to describe form. Every physical object exists in three different dimensions – height, width, and depth. Together, they create form. As we translate the three-dimensional world into two dimensions, we have to make sure each component is shown clearly.

Before the Basic Forms – the Anatomy of a Square

A square, turned into a cube, is the foundation for every dimensional object drawn in perspective.

Squares have a couple of distinguishing traits that we rely on – they have two sets of parallel sides that meet at 90°, and each side of a square is always the same length as any other. This makes the square a handy measuring device. With a grid of squares drawn in perspective, we can take any singular part of the grid and know that any other part, anywhere on the page – going in any direction – will represent the same exact length. Using a grid is an easy way to manage scale while drawing.

Both a square and a rectangle have these things in common:

- All corners meet at 90°
- Vertical sides are parallel to each other
- Horizontal sides are parallel to each other

A square is more useful than a rectangle for measuring because all of its sides are equal.

Dividing a Square or Rectangle

When working with squares or rectangles, you'll soon find that you need to divide them in place.

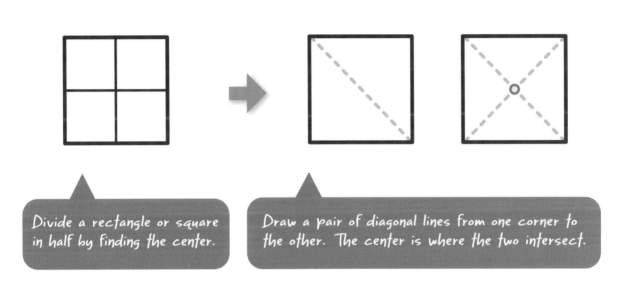

Divide a rectangle or square in half by finding the center.

Draw a pair of diagonal lines from one corner to the other. The center is where the two intersect.

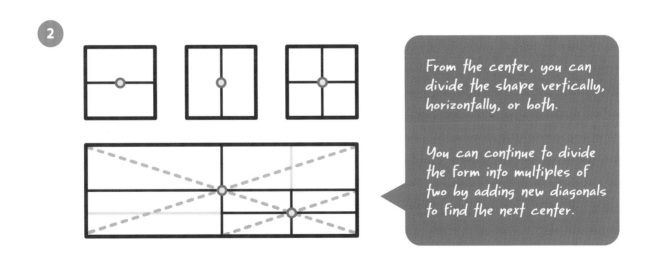

From the center, you can divide the shape vertically, horizontally, or both.

You can continue to divide the form into multiples of two by adding new diagonals to find the next center.

With one exception, the process is the same when drawing in perspective. Since the shape is in perspective, to divide it accurately we need to take the horizontal division to the vanishing point.

1

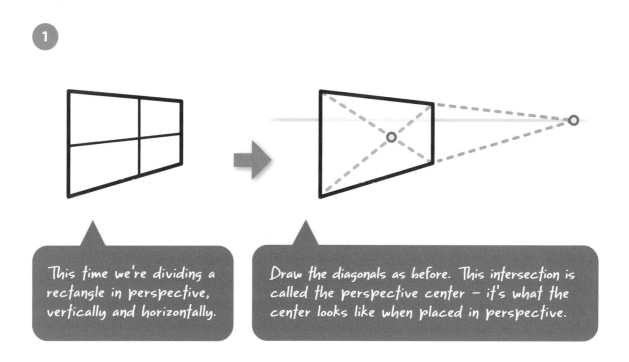

This time we're dividing a rectangle in perspective, vertically and horizontally.

Draw the diagonals as before. This intersection is called the perspective center — it's what the center looks like when placed in perspective.

2

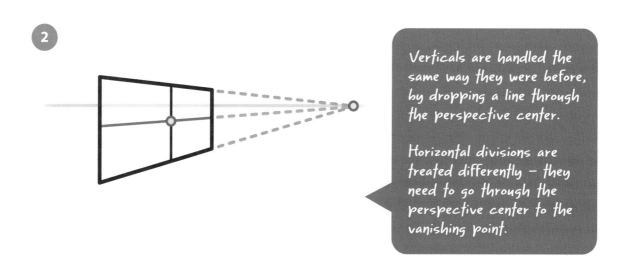

Verticals are handled the same way they were before, by dropping a line through the perspective center.

Horizontal divisions are treated differently — they need to go through the perspective center to the vanishing point.

The Basic Forms

When you can, from imagination, convincingly sketch the basic forms that follow, you'll have the fundamentals necessary to draw just about anything. These forms, sometimes called the primitives or geoforms, are the foundation of everything that surrounds us. Think of the primitives as the all-important 'bones' of your subject matter.

While many consider the basic forms to be a cube, cone, cylinder, and sphere, I like to add a pyramid to the mix. For the beginner, it acts as a useful transition between learning how to draw a box and understanding how to draw a cone.

Our Approach

If you want to learn how to draw well, spend some time sketching these forms. Get used to training your eyes how to visualize where the horizon line is and where the parallel lines of your forms converge. You don't want to have to work in the perspective setup every time you draw. The more you practice sketching these forms accurately, the less you'll need to involve the more technical aspects of perspective. Save that for busier, more complicated work. Still, if you're just starting out and having trouble sketching and drawing these forms convincingly, then plotting them out will help to familiarize you with what they're supposed to look like from any given point of view.

Draw through the Form

Whether sketching or plotting things out in perspective, it's important to clearly define each of your planes. Doing so will help you as you refine your work and add detail, making it easier to follow what an object is doing as you add the information necessary to complete the picture. Drawing through the form gives you a better understanding of dimension, making it easier to work out the problems associated with intricate and complicated forms.

If you have a lot going on in your work, drawing through the form can seem to make things even busier. This is where varying your line weights and using different colors can come in handy. Again, use heavier lines to describe both the outside form and visible planes of your objects. Use lighter lines to show the hidden ones. It may be helpful to use different colors to separate overlapping forms. As you tackle more complicated subjects, managing line weight and color will make it easier to keep track of your work.

The Cube or Box

In the last chapter, we used the cube to go through the basic moves of drawing in perspective. It's important to remember that the remaining basic shapes all start out with the cube as their foundation. Since we've already discussed how to construct a cube in detail, we're almost ready to move on to the rest of the primitives. To do what follows, it's assumed that you're comfortable with setting up the base of a cube. That's the starting point for the remaining basic forms.

Again, it's a good idea to practice sketching the primitives. Once you're comfortable with drawing accurate boxes and ellipses, you'll be able to work out almost anything.

The Pyramid

The base of a typical pyramid and the base of a cube are both squares. The walls of a pyramid meet at a point directly above the center of the base. To start, draw the base and find the center by crossing diagonals from each corner. Bring a vertical line up from the center, stopping where you want the top of the pyramid to be. Connect each of the base's four corners to the top point and you're done. The process is the same whether working in one- or two-point perspective.

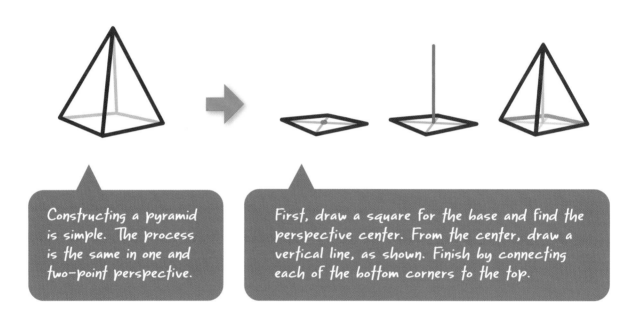

Constructing a pyramid is simple. The process is the same in one and two-point perspective.

First, draw a square for the base and find the perspective center. From the center, draw a vertical line, as shown. Finish by connecting each of the bottom corners to the top.

When sketching pyramids, make sure the center and the vertical that's rising off of it are accurate. Play with differently shaped bases – they don't all have to be squares.

The Cone

Our next shape is the cone. A cone is a lot like a pyramid but has a circle for a base instead of a square. We'll discuss circles and ellipses in more detail in Chapter 9, but to get started, we have to first talk about how a circle relates to a square.

When you place a circle inside a similarly sized square, two things happen. Both shapes share the same center, and a circle touches each side of the four walls of a square in the middle of each side. This happens both in and out of perspective.

A square and circle have a special relationship, in or out of perspective:

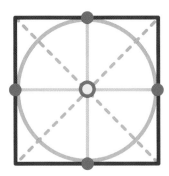

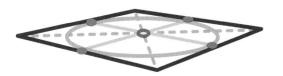

- A circle touches a square in the middle of each side
- They both share the same center

The accuracy of a cone is dependent on the accuracy of the square used as its base. The good news is that whenever you draw an ellipse that's on or parallel to the ground plane, you can always set it up in a one-point square. When sketching, make sure the base looks like an accurate perspective view of a square. Use the square to draw a horizontal ellipse. Like the pyramid, draw a vertical line up from the center. From the top, draw lines that are tangent to the outermost part of the ellipse and you're done.

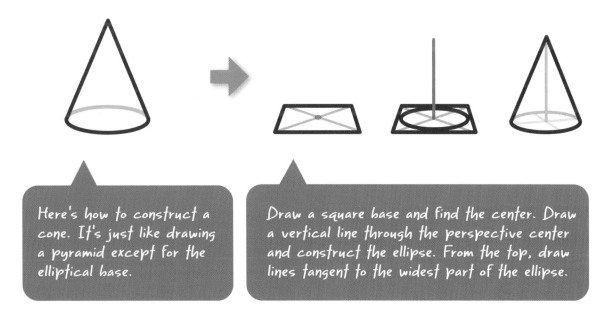

Here's how to construct a cone. It's just like drawing a pyramid except for the elliptical base.

Draw a square base and find the center. Draw a vertical line through the perspective center and construct the ellipse. From the top, draw lines tangent to the widest part of the ellipse.

Drawing ellipses well takes dedicated practice. It's not very exciting, but with a little discipline, being able to confidently handle circles and ellipses will allow you to tackle a wider range of subjects. Many people rely on ellipse guides, and though they do have their place, they can sometimes be so precise that they make your work look mechanical. Ellipse guides are best suited for working in a more diagrammatic way. It's a worthy tool for architects, engineers, and product designers. While they can be useful for artists, they don't really help you learn how to draw.

The Cylinder

There are two ellipses to manage when drawing a cylinder. Since a cylinder is round, it's even more important to keep the top and bottom plane away from eye level. Start a cylinder by drawing a one-point box. Remember, the base and top need to be squares in perspective. From there, it's just a matter of drawing horizontal ellipses inside the top and bottom planes and connecting them with vertical lines.

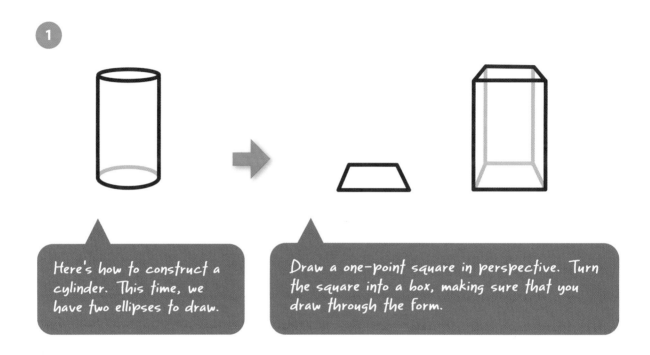

1

Here's how to construct a cylinder. This time, we have two ellipses to draw.

Draw a one-point square in perspective. Turn the square into a box, making sure that you draw through the form.

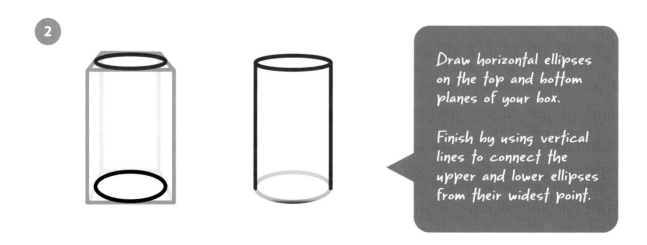

2

Draw horizontal ellipses on the top and bottom planes of your box.

Finish by using vertical lines to connect the upper and lower ellipses from their widest point.

Don't be confused by ellipses as they move from below eye level to above it. When drawing through the form, your ellipses will look the same, whether above or below the horizon line. Make sure that you vary the line weight to emphasize which part of the ellipse represents the front and which part describes the back.

When working with ellipses, pay attention to how you draw through the form. If an ellipse is drawn below eye level, the bottom half represents the front of the cylinder. If it's above eye level, the top half becomes the front. Get this wrong and you could be doing the impossible — looking up at something below eye level.

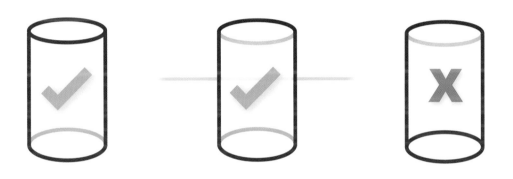

The Sphere

A sphere is the only primitive whose shape doesn't change depending on eye level. Whether looking from above or below, the silhouette of a sphere always looks like a perfect circle. Outside of the silhouette, a sphere has no linear edges. While it's rare to need to plot a sphere in perspective, we're left with a form that doesn't express dimension clearly. There are two ways to fix this.

Whether above or below the horizon line, the sphere is the only geometric form that doesn't change shape in perspective.

Getting Form out of a Sphere

The first approach is to handle the matter later in the drawing process with shading. Outside of using line to show dimension, the only other way to show form is to use value properly. When you shade, you're using light and shadow effects to describe each plane.

The second way to give dimension to a sphere is to draw an ellipse through it. Pretend you're drawing rubber bands wrapped around a ball – when drawn well, it will look like a piece of the ball has been sectioned off, showing how a plane cuts through a sphere. That plane helps to describe both eye level and form.

Another way to give form to a sphere is to draw an ellipse through it. The ellipse should touch the edge of each side. It helps to pretend that you're wrapping a rubber band around a ball. When you draw through the form, you end up defining a plane that in turn clarifies the space for your viewer.

When you draw a plane cutting through a sphere, you're practicing your ellipses and circles at the same time. Try cutting a sphere in multiple places or varying your point of view.

The primitives are the foundation of every physical object on the planet. This is more apparent when drawing man-made items. Houses and cars are clearly boxes, airplanes and coffee mugs are cylinders, etc. You'll find the same to be true when you more closely examine objects in nature. If you can learn to recognize the basic forms in everything you see then you'll be better able to translate the solidity and mass of any object to your work.

Chapter 7
Using Grids

If you're the kind of person that likes to get things in order first so you can more easily concentrate on drawing, then you'll want to give grids a second look. Once set up, a grid helps you stay in perspective as you draw. You can use them informally (think sketching) or set up a detailed, mathematically accurate grid that can help you measure anywhere on the page.

Three Ways to Use a Grid

Sketching Grids

Depending on your needs, you can approach grids in three different ways. The first is to use them while sketching. These grids tend to be informal. They're not mechanically precise, so they won't be able to help you measure, but what they offer is a way to jumpstart the accuracy of your picture in the beginning stages of work. Once you have a rough composition in place, analyze the sketch and see if you can identify the underlying perspective. You're looking for anything that can help you locate the horizon line and principal vanishing points. This information becomes the foundation for the sketching grid. A sketching grid guides you as you draw, the way lines on the road keep you from drifting out of lane. Once you take your rough sketch and revisit it using a preliminary grid, you'll be able to see if your composition can still work once believable form and space have been imposed on it. If it can't, you're better off knowing now rather than finding out later.

Some people prefer to make an all-encompassing grid that's used for everything. These grids work best when working digitally, since you can zoom in and out to find the part of the grid that best serves your picture. They come in three flavors – one-point, two-point, and three-point.

One-Point Grids

In a one-point grid, the vertical and horizontal lines act as guides for elements parallel to the picture plane. Lines from the vanishing point help to accurately portray depth.

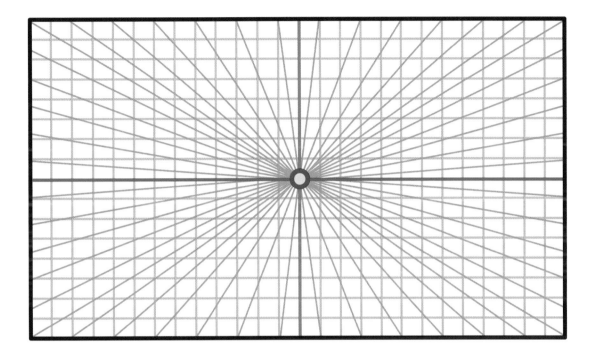

Typically, a grid like the one above is meant to work as an underlay for sketching. We don't normally use the entire grid, just a small piece of it based on the placement of the viewer.

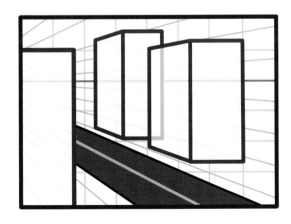

Using a grid is a great way to transition the content of a rough sketch into basic believable forms. Doing so will help you identify spatial problems before you encounter them in perspective.

Two-Point Grids

With a two-point grid, we gain a vanishing point and lose our horizontal guides. It's best to place the vanishing points as far away as possible — this gives you more room to draw as you try to sketch within the cone of vision.

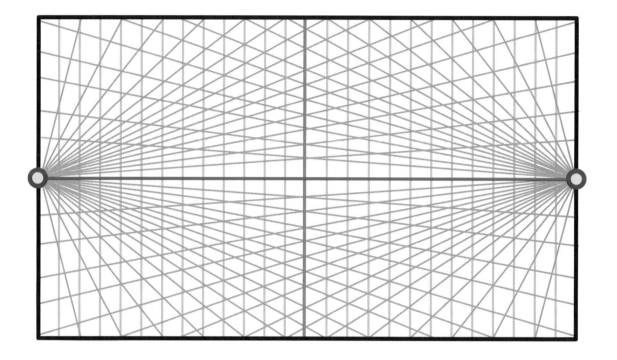

Three-Point Grids

This is a three-point grid. While the third vanishing point is off the frame, the vertical lines still converge at the bottom. With this example, the horizon line is high on the page – meaning our viewer is high up as well.

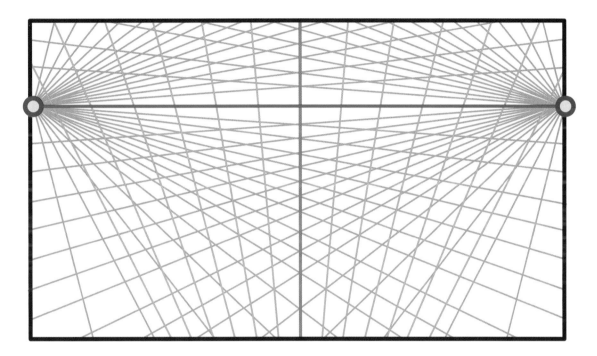

A three-point grid is based on a triangle. Make sure your vertical vanishing point isn't too close (there's too much distortion) or too far away (it looks like two-point). We'll discuss three-point perspective in more detail in the final chapter.

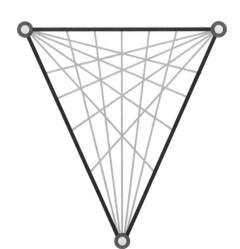

To change from a worm's eye to a bird's eye view, simply turn the grid over.

Transfer Grids

Grids can also be used to transfer an image. This is typically used for graphics or logos that need to be drawn at an angle. A grid helps you plot an image out by transferring relevant points into perspective.

1

Let's take a simple graphic element and transfer it into perspective using a grid.

Start by placing your graphic in a grid. If your image is simple, the grid can be as well. Use squares as the grid's foundation.

2 / 3 / 4

Add points to your image. Place as many as you need, concentrating on corners and wherever curves peak. Next, draw the grid in perspective. It's important that you accurately represent the shape; use a measuring system if necessary. Use the grid to transfer the points, paying careful attention to the ones that don't line up with the grid's intersections. Once everything's transferred, simply connect the dots to reveal your image in perspective.

Measuring Grids

When drawn with precision, a grid can be used to measure in any direction. While the work isn't hard, it's a bit time consuming. Once everything is set up, it's easy to keep track of scale anywhere on the page. We'll end the chapter by going over how to draw a two-point grid.

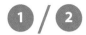

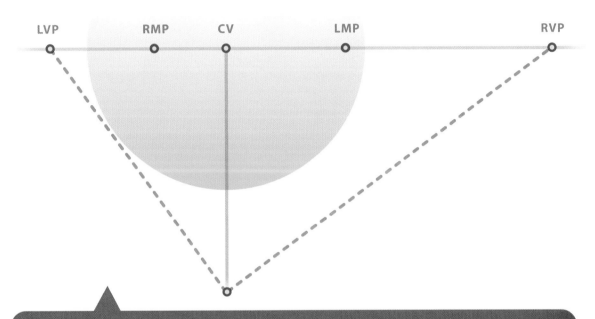

Start with the basic setup, include each measuring point and the cone of vision. Add a horizontal measuring line (ground line) and one unit of measurement on each side of the line of sight as shown below.

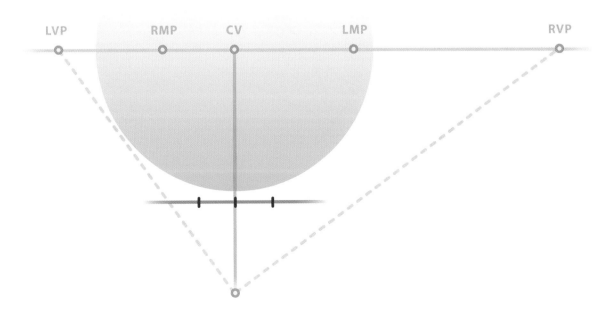

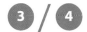

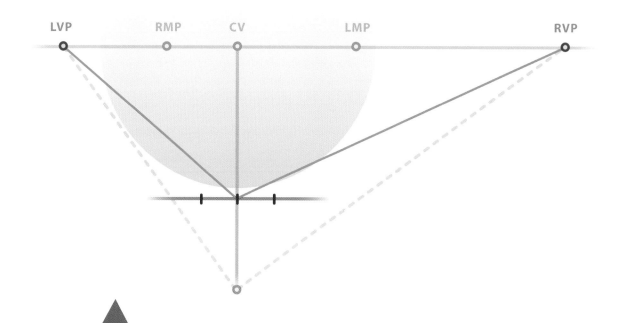

Start with the basic setup, include each measuring point and the cone of vision. Add a horizontal measuring line (ground line) and one unit of measurement on each side of the line of sight as shown below.

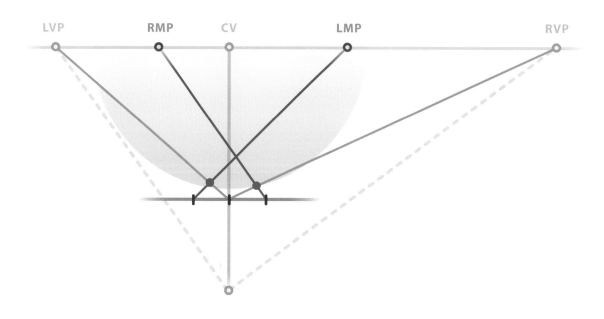

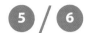

Use the measuring points to finish drawing the square. Instead of setting up an extended horizontal measuring line, we'll use this square to create the grid.

Remembering that all parallel lines converge to the same vanishing point, we can use the square's diagonal as an extra vanishing point. This will help us quickly draw the grid.

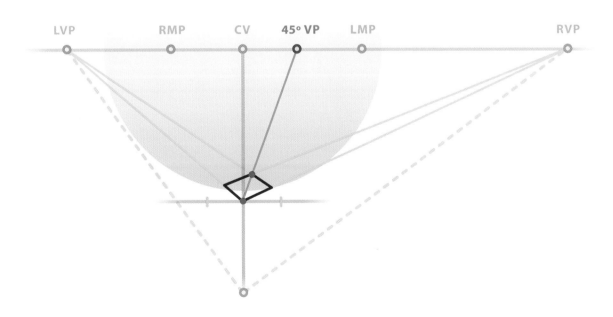

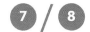

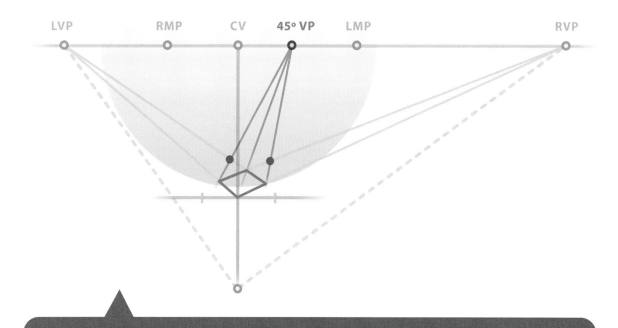

From the 45° vanishing point, draw lines to each of the square's outside corners. Note where they intersect the square's construction lines. These are the diagonals of the adjacent squares. From the left and right vanishing points, draw through each intersection. We now have new corners for (purple dots) for the 45° vanishing point.

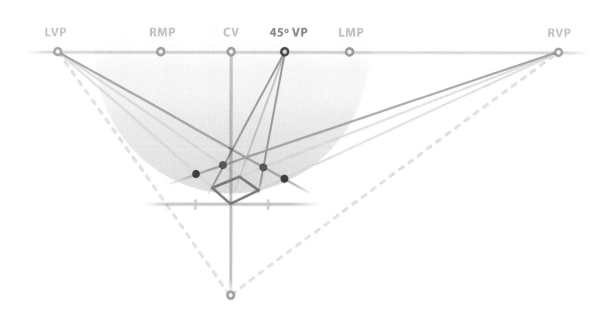

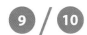

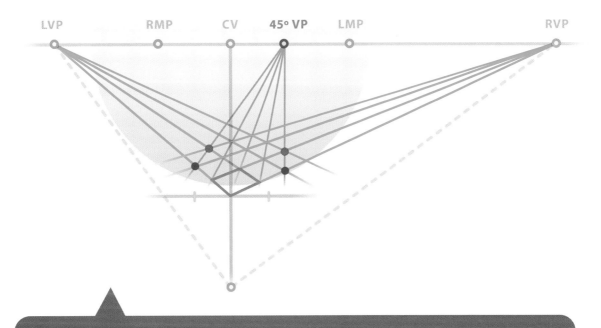

> Continue going back and forth, adding lines from the 45° vanishing point to finish the grid as needed. As you start to approach the horizon line, the grid becomes very small and you'll inevitably lose the ability to be accurate. Below is the finished horizontal plane grid.

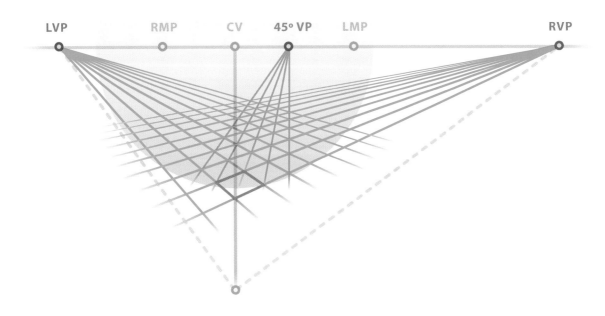

11 / **12**

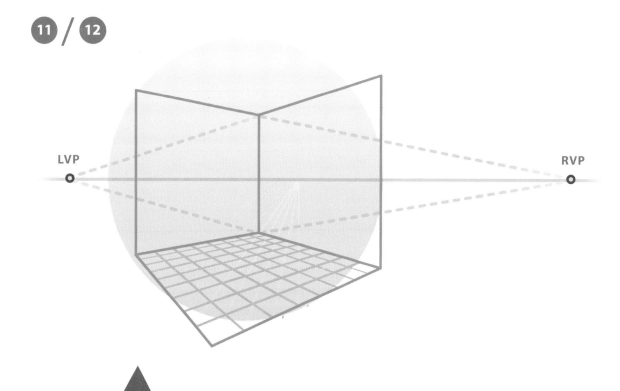

Next, we'll transfer the grid to a vertical plane. Start by setting up two walls. Using the original unit of measure, transfer one unit back until it's even with the bottom front of one of the walls. This is what one unit looks like set back in space.

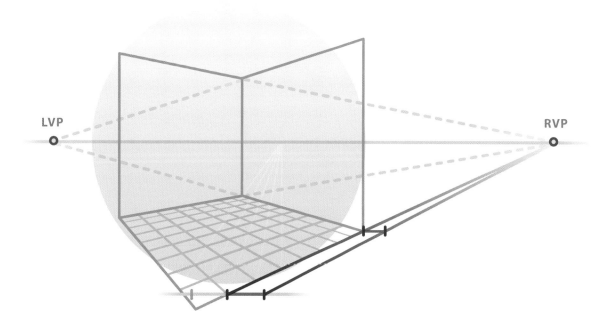

13 / **14**

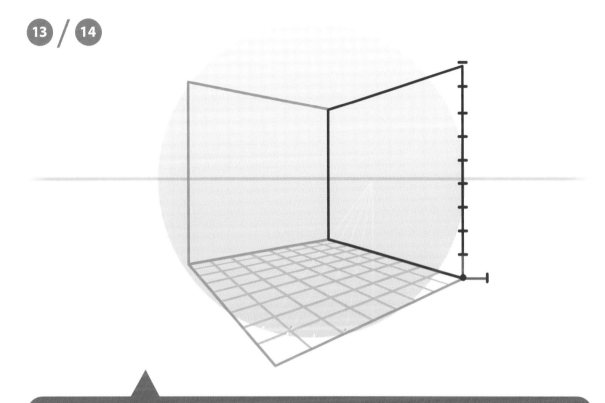

Because our unit of measure is parallel to the picture plane, we can also use it to measure height. Use the transferred measurement vertically to measure the wall, as shown above. Take the divisions to the opposite vanishing point, marking where they intersect the opposite end of the wall, as shown below.

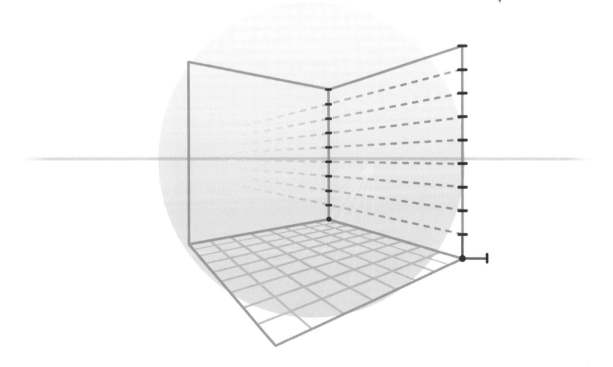

15 / **16**

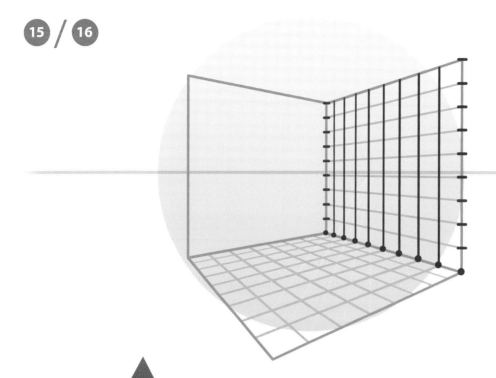

> To transfer the grid to a vertical surface, draw lines from each division on the horizontal plane up the wall, as shown above. Finish by repeating the entire procedure for the remaining vertical plane.

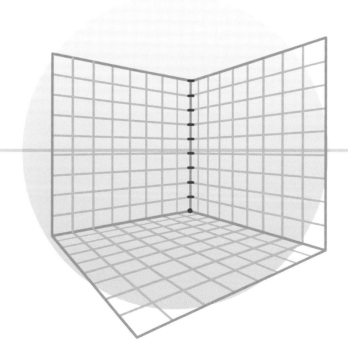

17

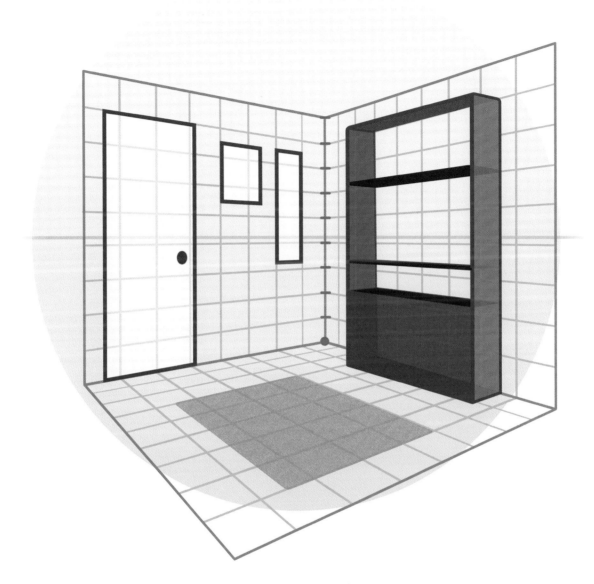

Whether you use a grid to measure scale or as a guide to help you as you draw, you'll find them a great help once they're set up. They're reusable if drawn on a separate piece of paper, or, if working digitally, kept on a different layer.

Chapter 8
Measuring in Perspective

This is where perspective gets to show off. In this chapter, we'll talk about how to use perspective to measure just about anything. You'll find tools to help you divide, multiply, or transfer scale anywhere on the page. We'll start by measuring with nothing but the horizon line and end with a fully developed measuring system that we'll use to transfer an entire house.

Perspective Is Made for Measuring

It takes a lot of experience to develop an eye for scale, especially when trying to manage dimension over great distances. While using a grid can be helpful, it's not the only way to control size when you're drawing. Built into perspective are formal (mechanical) and informal (estimative) ways of measuring. This is where perspective really shines; many of the ideas are decidedly simple yet incredibly powerful. So much so, that they can even be used while sketching – no rulers, vanishing points, or cones of vision. The precise mechanical nature of most of perspective can wait.

All We Need Is a Horizon Line

Remembering that the horizon line represents the viewer's eye level, once we decide what height it represents, we can start to informally measure anything on the page.

Once you've decided what the horizon line represents, you can start measuring. In the image below, I've decided that eye level is four feet off the ground. That means that anything that ends at the horizon line is four feet tall.

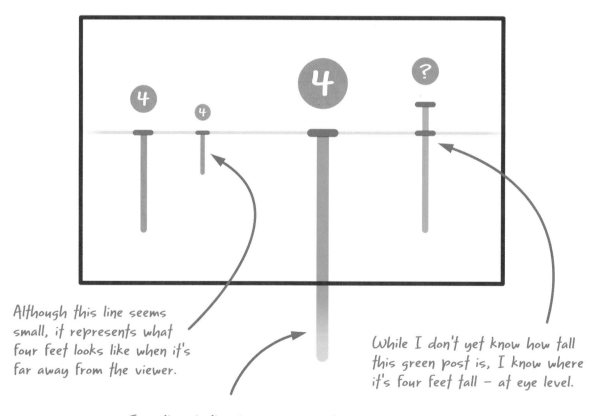

Although this line seems small, it represents what four feet looks like when it's far away from the viewer.

Even though this line is cropped off the page, we know it's four feet tall because it ends at eye level.

While I don't yet know how tall this green post is, I know where it's four feet tall – at eye level.

In our example, anything that starts on the ground plane and ends at eye level represents a height of four feet. It doesn't matter where an object is on the page. It doesn't even matter if something is cropped off of the bottom of the page. Even if an object rises above eye level, we still know where four foot is on that object.

Assigning a value to eye level does more than identify a specific height. With very little effort we can use that information to set up an informal measuring system. The goal is to get to a measuring unit of one.

If I cut a four-foot post in half, I'll end up with a pair of two-foot segments. If I cut it in half again, I'll know exactly what one foot looks like. That's incredibly useful.

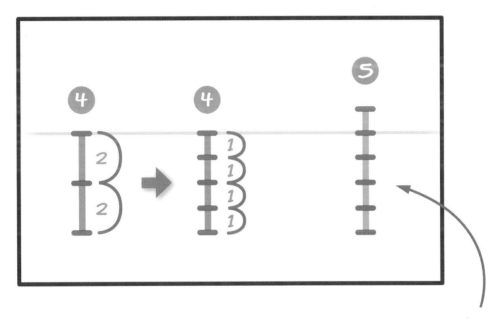

It's harder to divide numbers like five or seven by eye. We'll talk about how to do that later in the chapter.

Because we now know what one foot represents, we can accurately measure anything on the page.

While this is a quick and useful way to informally measure things in your picture, it should be noted that once you move back or forward in space, the scale of your measuring system will change accordingly. Specific dimensions only remain accurate when measuring parallel to the picture plane.

Everything gets smaller as it moves back in space, even our units of measure. Once you've found what one unit looks like, you can use that measurement anywhere on the page as long as you remain parallel to the picture plane. When you have to measure things that are a different distance from the viewer, you'll need to reestablish your measuring system for that location in space.

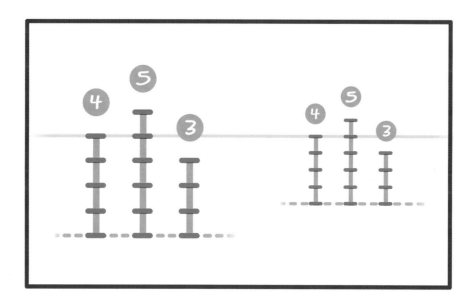

We're not limited to measuring vertically. As long as we're measuring parallel to the picture plane, we can measure anything.

As long as you remain parallel to the picture plane, you can measure in any direction. Below, the four- and five-foot posts are two feet apart from each other. There's three feet between the five- and three-foot posts.

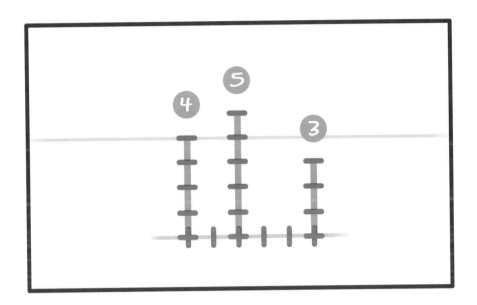

While you can set all of this up mechanically by creating a grid, being able to use these ideas while sketching gives your work a head start in the right direction.

It's easier to estimate how to divide something in halves or quarters than it is to equally divide something into thirds, fifths, or sevenths. To remain accurate, we'll have to rely on a different method. The following technique has more uses than is readily apparent; following this demonstration, I'll show you how it's used to help deal with vanishing points that extend off of the page.

Remember, this only works on lines that are parallel to the picture plane. For it to work in perspective, we'll need to transfer these measurements into space.

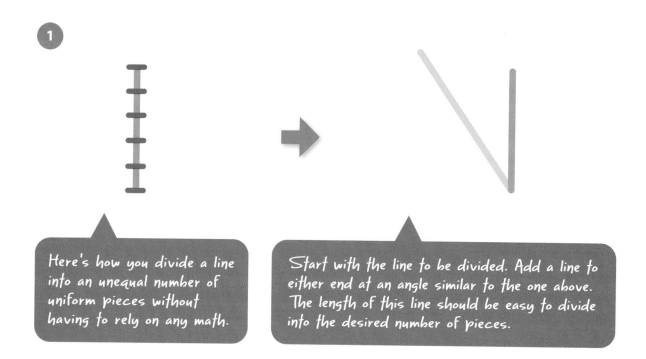

Here's how you divide a line into an unequal number of uniform pieces without having to rely on any math.

Start with the line to be divided. Add a line to either end at an angle similar to the one above. The length of this line should be easy to divide into the desired number of pieces.

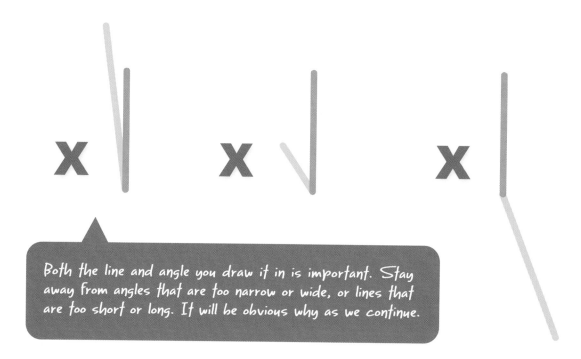

Both the line and angle you draw it in is important. Stay away from angles that are too narrow or wide, or lines that are too short or long. It will be obvious why as we continue.

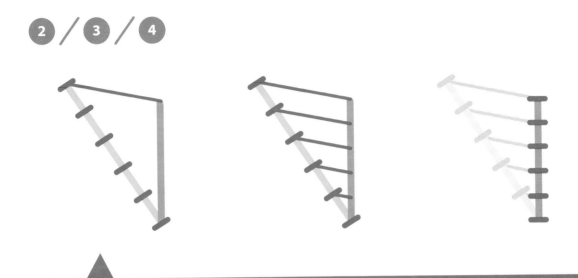

Set the scale up on the angled line. As an example, let's say I want to divide the vertical line into 5 equal pieces. If it's 9.36 inches long, then I'll make sure my angled line is 10 inches long — that's something that can easily be divided by 5. Once it's set up, connect the top of the angled line to the top of the vertical line.

From the remaining measurements on the angled line, draw lines parallel to the line connecting the angled and vertical line. This effectively transfers the scale of one line to the other, all without having to do any math.

Using Scale for Faraway Vanishing Points

When we make the most out of our image area, our vanishing points usually end up being off of the page. Sometimes a vanishing point can be so far away that working in perspective is seemingly undoable. Instead of using a yardstick to reach to a faraway vanishing point, we can use the previous technique to help us accurately aim in the right direction.

Below you'll find a common problem; many times our vanishing points are off the page. We can use what we just learned to address this. You'll always need to know where your station point is to find the vanishing points, so if that's an issue, attach a separate piece of paper to your picture to get that set up.

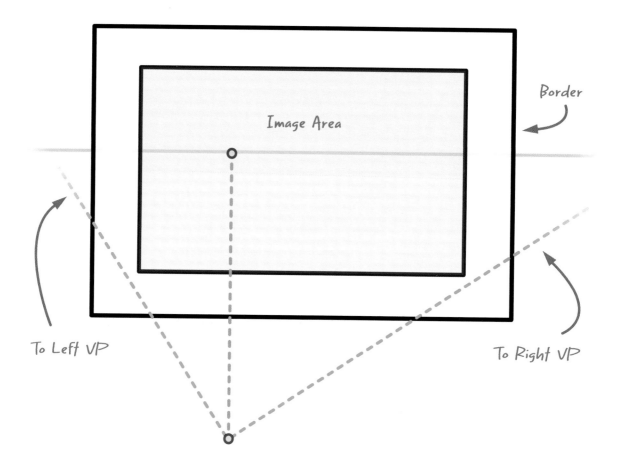

We'll use the horizon line and the lines from the station point to get started:

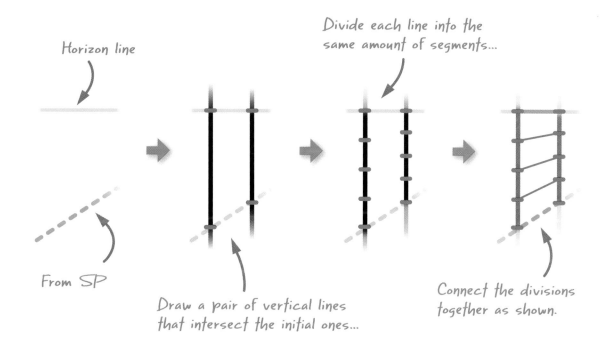

Horizon line

Divide each line into the same amount of segments...

From SP

Draw a pair of vertical lines that intersect the initial ones...

Connect the divisions together as shown.

This is what it looks like once you're done. Now you're ready to draw.

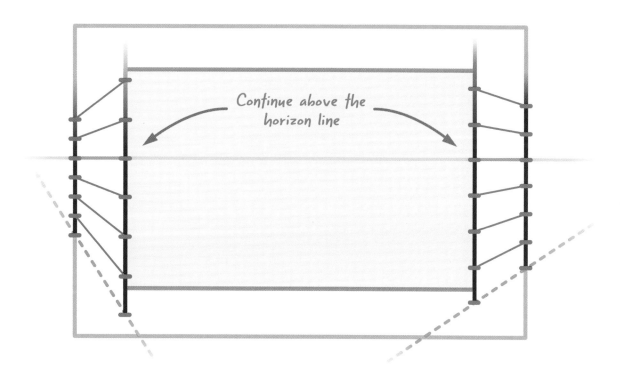

Continue above the horizon line

Instead of reaching for the vanishing point each time, use the guides on the outside of the drawing to aim your ruler in the right direction. When your vanishing points are far away, this extra bit of effort will save you time and spare you from the headache of having to wield a very long ruler.

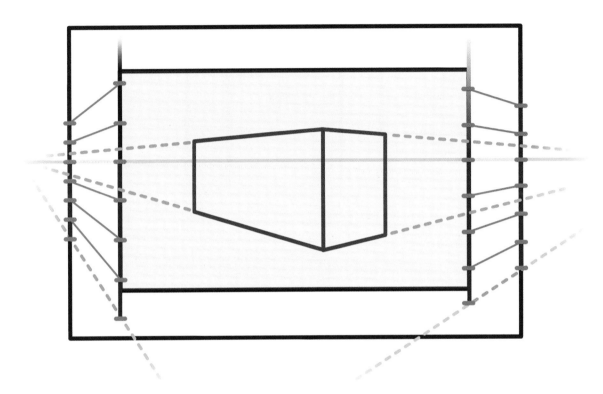

Transferring Scale in Space

So far, all the measuring we've done has been parallel to the picture plane. Now it's time to talk about how to manage scale in perspective. The following methods will help you control dimension as you move forward or back in space. While many of these techniques are different ways of achieving the same goal, they each have unique strengths that you should take into account. We can categorize them in three main ways – we can either multiply a measurement back in space, divide something up into equal pieces while moving forward or backward, or simply transfer a non-repetitive measurement anywhere on the page.

Multiplying in Perspective

Use this method for the times when you don't have a form established but need to repeat a specific distance back in space. This is a great technique for things such as fences, light posts, marching soldiers, or trees in an orchard, for example. Here's how it's done.

This is a very versatile technique; while it's not obvious, we can use it to measure vertically as well.

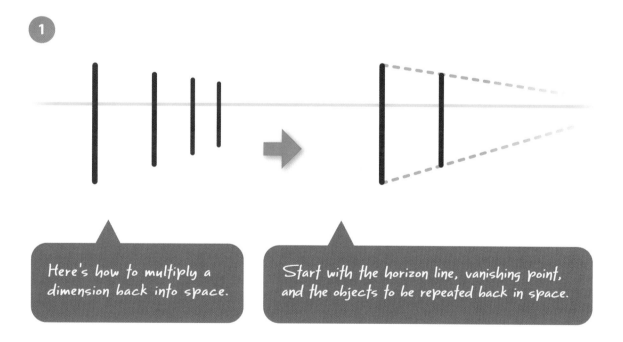

Here's how to multiply a dimension back into space.

Start with the horizon line, vanishing point, and the objects to be repeated back in space.

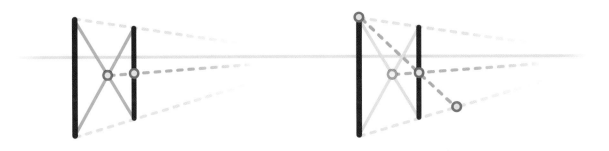

Draw an X to find the middle between the two posts. Draw a line from the middle to the vanishing point, noting where it crosses the second post.

From the top of the first post, draw a line through the middle of the second, as shown. This transfers the distance between the first two posts back in space, telling you where to place the third. To place more posts, simply continue by drawing from the top of one post through the middle of the next.

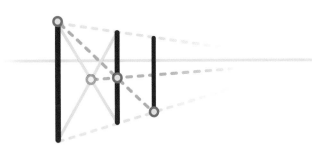

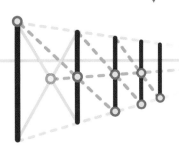

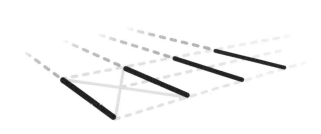

This works on the ground plane as well. There's one difference, though. You'll need to use a second vanishing point to keep each post parallel to the next.

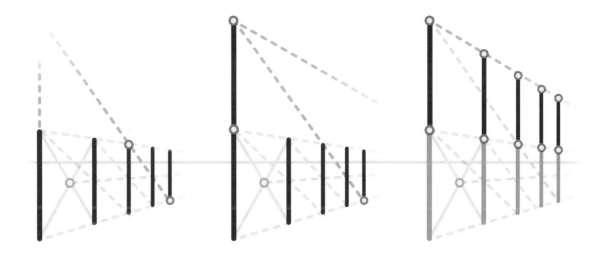

It's easy to use this method to 'stack' equal dimensions on top of each other. The process is the same, you're just moving in a different direction. To build up, start at the bottom, go through the middle of the next post, and stop when you intersect the path of the intended post. Once you've defined the intersection, take it to the vanishing point to quickly get the height of the remaining posts.

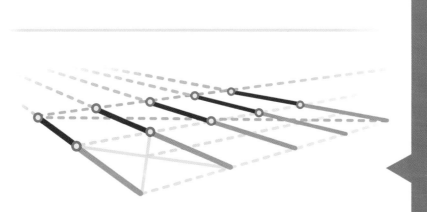

Again, this works on the ground plane as well. Depending on the perspective, you may find that when you use this method to move forward in space, you can very quickly move out of the cone of vision. Use this technique to move back instead.

Dividing in Perspective

We're already familiar with this idea. When we use an X to divide a square or rectangle in half, we're dividing it into equal pieces. We could then take one of the pieces and cut it up again. That leaves us with the ability to cut things into multiples of two. If we need to divide something into three, the following technique is your simplest option.

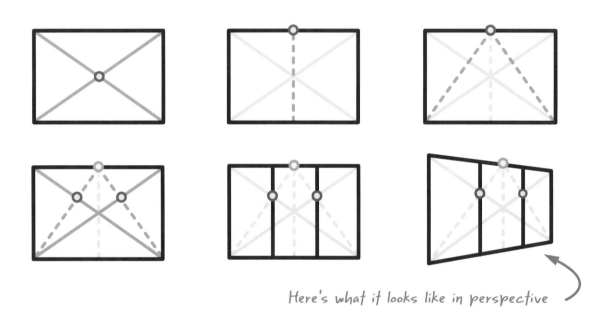

Here's what it looks like in perspective

If you want to divide something into anything beyond halves, thirds, or quarters, it's easiest to use a completely different technique. We'll start by dividing a line into equal pieces and transfer the results into equal divisions in perspective. After we go through the process, we'll make practical use of the process and draw stairs.

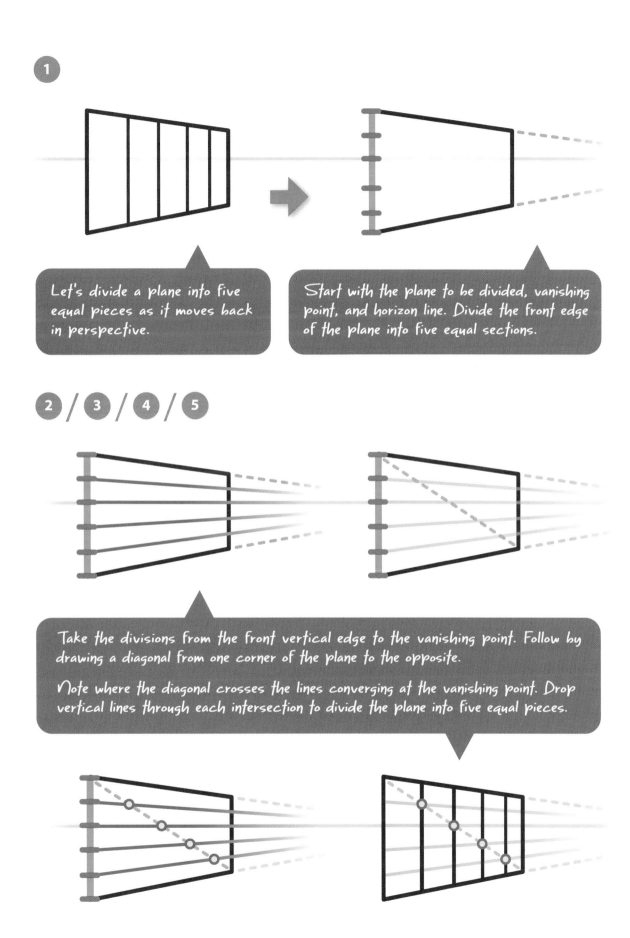

1

Let's divide a plane into five equal pieces as it moves back in perspective.

Start with the plane to be divided, vanishing point, and horizon line. Divide the front edge of the plane into five equal sections.

2 / 3 / 4 / 5

Take the divisions from the front vertical edge to the vanishing point. Follow by drawing a diagonal from one corner of the plane to the opposite.

Note where the diagonal crosses the lines converging at the vanishing point. Drop vertical lines through each intersection to divide the plane into five equal pieces.

1

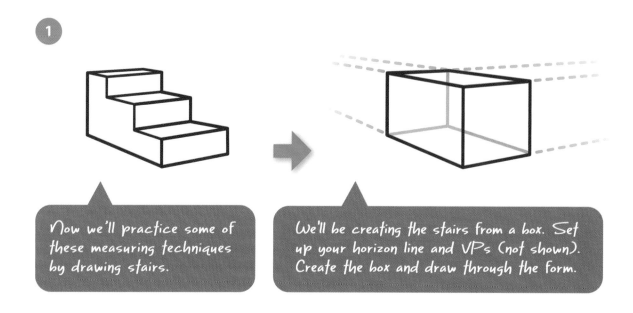

Now we'll practice some of these measuring techniques by drawing stairs.

We'll be creating the stairs from a box. Set up your horizon line and VPs (not shown). Create the box and draw through the form.

2 / 3 / 4 / 5

Start by dividing the leading vertical edge into the number of steps you wish to have. I'm keeping things simple and will be drawing three steps. Draw a diagonal on the appropriate vertical plane as shown. Take the divisions on the leading vertical edge to the vanishing point, noting where they intersect the diagonal. Drop verticals through the intersections. You can already see the stairs begin to take shape.

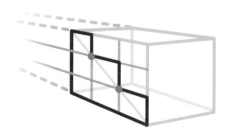

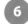

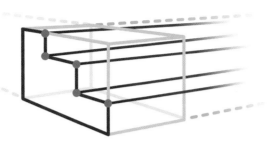

Draw lines from each intersection to the vanishing point. These lines show all of the plane changes we need to finish constructing the stairs.

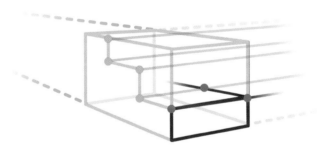

Take a line from the previous step and follow it until it intersects the edge of the box. From that point, take a line back to the left vanishing point as shown. This transfers the information from the near vertical plane to the far one, helping us to carve the stairs out of the initial box. Follow each plane change, back and up, over and over until the stairs are complete.

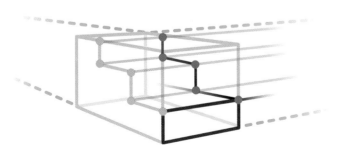

Transferring Height Anywhere

When you only need to transfer height in perspective, you can rely on either of the following two methods.

1

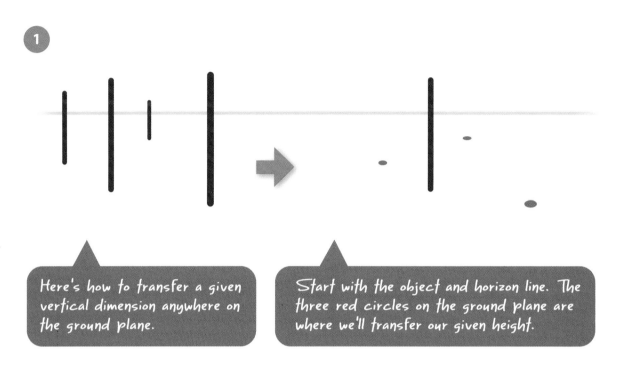

Here's how to transfer a given vertical dimension anywhere on the ground plane.

Start with the object and horizon line. The three red circles on the ground plane are where we'll transfer our given height.

2 / **3**

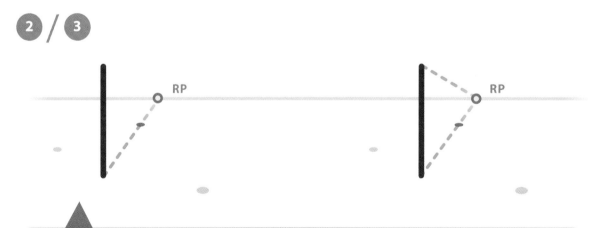

Start by drawing a line from the base of the object through one of the points on the ground, continuing until the horizon line. Label this as a reference point. While it's not a vanishing point, it acts like one when we transfer dimension back and forth in perspective.

From the reference point, come back towards the top of the initial line, as shown.

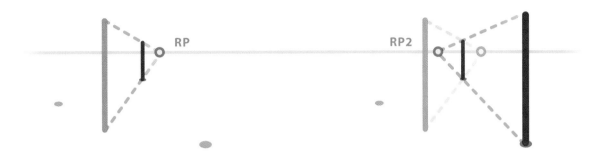

Draw a line from the ground plane until it intersects the upper reference line, as shown. Two more lines to go. Repeat the process – continue by lining up the bottoms of your vertical lines to find a new reference point. Come back with a reference line to define the specific height of the transferred measurement.

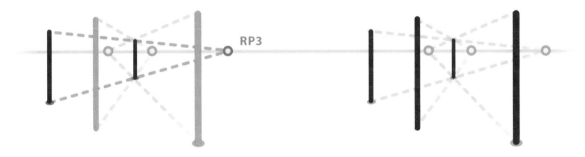

1

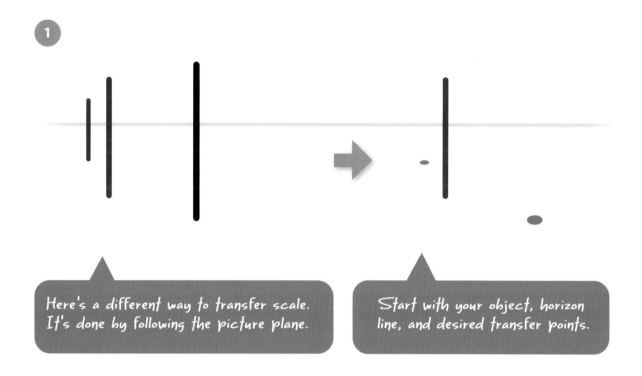

Here's a different way to transfer scale. It's done by following the picture plane.

Start with your object, horizon line, and desired transfer points.

2 / **3**

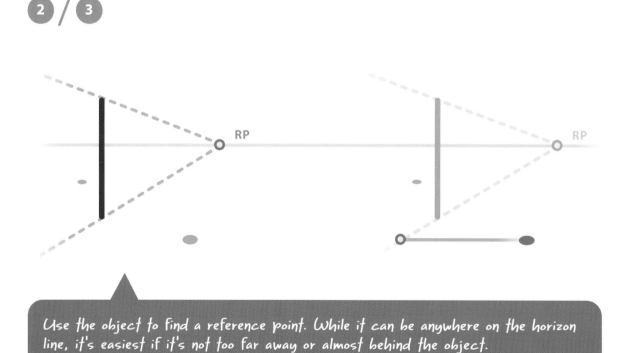

Use the object to find a reference point. While it can be anywhere on the horizon line, it's easiest if it's not too far away or almost behind the object.

Draw a horizontal line from one of the transfer points until it intersects the bottom reference line, as shown above right. We'll continue from this point.

4 / **5**

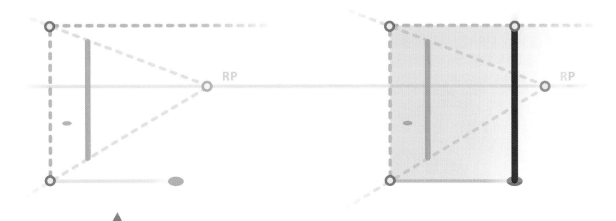

Continue by drawing a vertical line until it intersects the upper reference line. From there, travel horizontally back towards the transfer point.

To transfer scale, draw a vertical line up from the transfer point until it intersects the line above it, as shown above, right.

6 / **7**

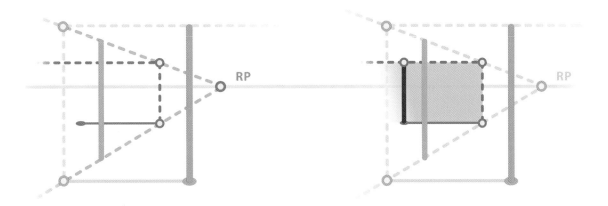

To transfer the remaining line, repeat the process. To recap, use a reference point to create a path, horizontally slide the transfer point over until it intersects the path, then move up to find the height. Bring that dimension back to the transfer point and from there draw the object at its new height and you're done.

Transferring Horizontal Scale

So far, we've only talked about how to transfer vertical scale. The process changes somewhat when working with horizontal elements. Let's have a look.

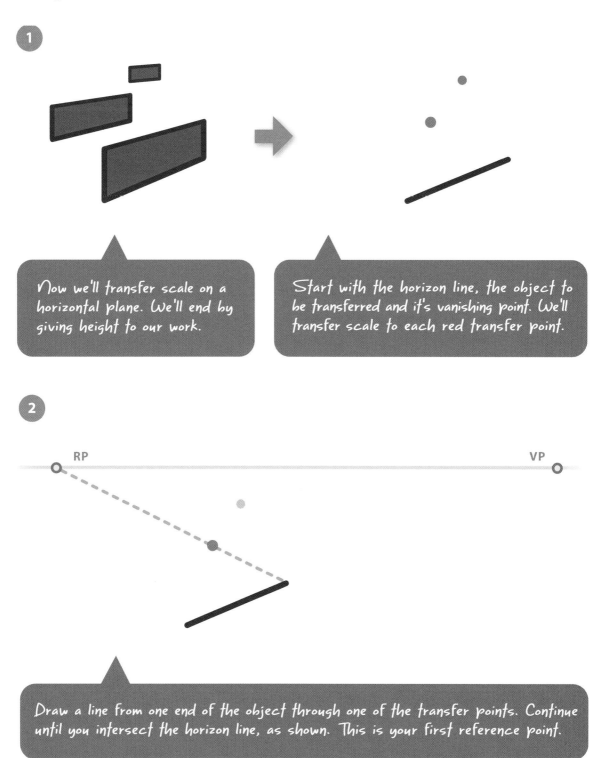

1

> Now we'll transfer scale on a horizontal plane. We'll end by giving height to our work.

> Start with the horizon line, the object to be transferred and it's vanishing point. We'll transfer scale to each red transfer point.

2

RP VP

> Draw a line from one end of the object through one of the transfer points. Continue until you intersect the horizon line, as shown. This is your first reference point.

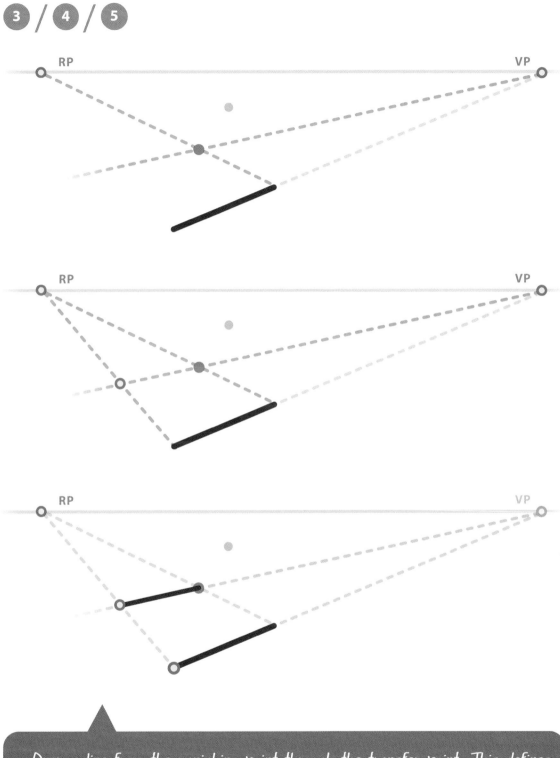

Draw a line from the vanishing point through the transfer point. This defines the direction of our transferred line. To determine its length, draw a line from the object to the reference point, as shown.

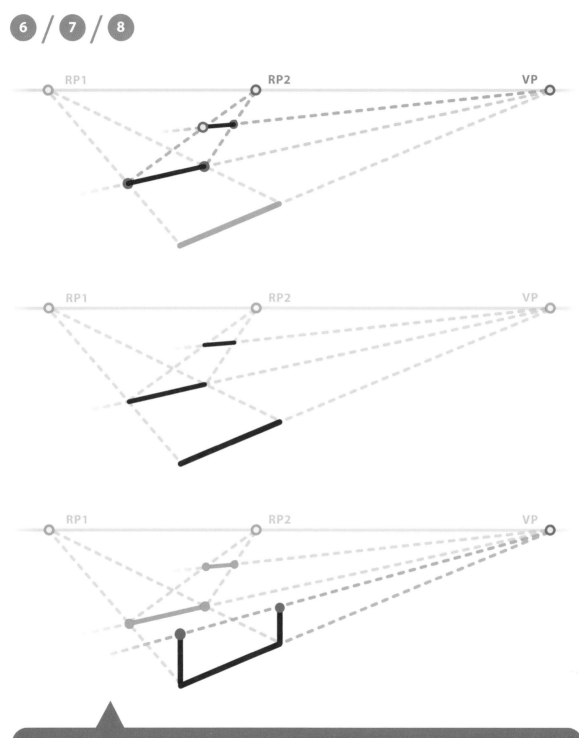

Continue by repeating the process – find a new reference point, use the vanishing point to determine direction and revisit the reference point to determine length. Next, we'll give each line a consistent height. Decide how tall you want your shape to be. Add the height and draw a line from the vanishing point through the top, as shown. Use this line to determine the height on the opposite end of the form.

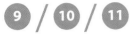

By now, this should all be second nature. While the process for transferring vertical and horizontal scale is similar, there's one important difference. When transferring verticals, the reference points and vanishing points work the same way. When transferring horizontal dimensions, your vanishing points are used to determine direction and the reference points are used to find length.

Using the Measuring System to Transfer Scale

When you have many different measurements that need to be placed in perspective, it makes sense to set up a measuring system. Since we're using it to transfer specific but unequal scale, we don't have to divide and number the measuring line. To close the chapter, we'll take information from the front view of a house and use the measuring system to transfer it into perspective.

Now we'll take a series of unequal measurements and transfer them into perspective. For this example, we'll use the elevation of a simple house and accurately transfer the door, both windows, and the house itself. We'll finish by adding a roof.

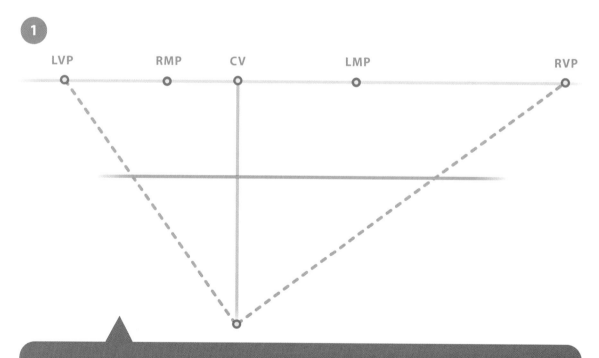

Begin with the perspective setup – start with the horizon line, decide where to put the station point, and set up the VPs. Find the measuring points and, if necessary, define the cone of vision (not shown). Add the ground line, placing it where you want the bottom front corner of the house to be.

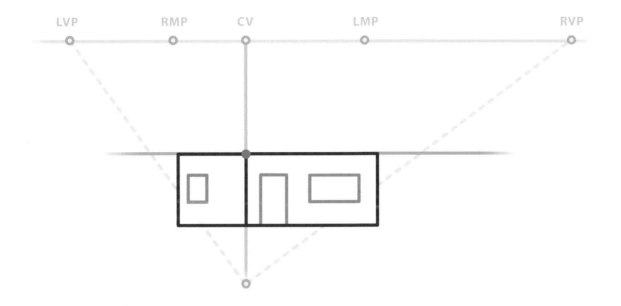

Next we'll add the elevation (the front view of the visible sides of your form) to the picture. The ground line always runs through the top of the elevation and will separate the elevation view of the house from the dimensional one. Transfer the height of the leading edge of the house directly on top of itself, as shown below.

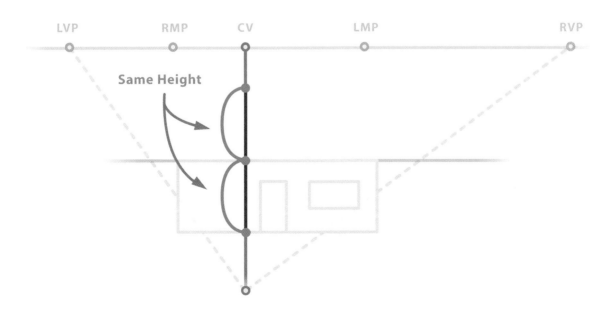

4 / 5

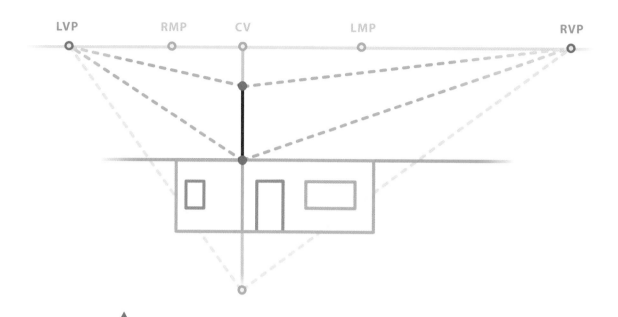

Now we'll find the exterior walls of the house. Draw lines from the edge of the house to each vanishing point, shown above.

Use the measuring points to transfer the depth of the house, as shown below.

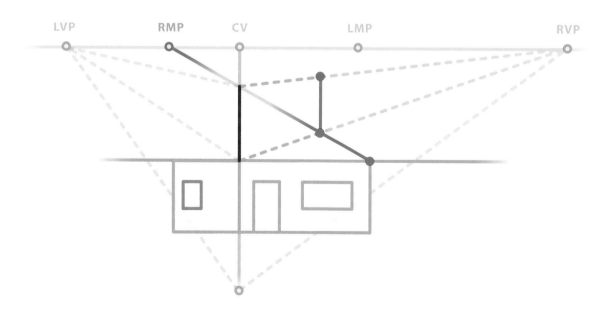

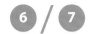

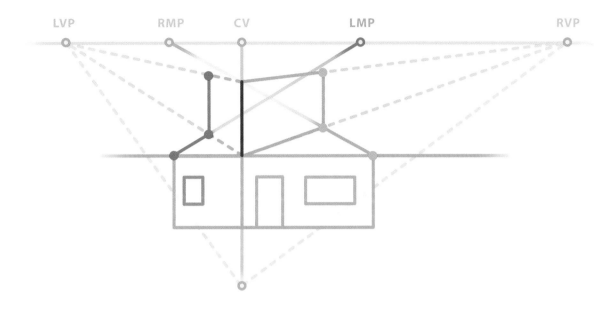

> Repeat the process for the left wall. Draw lines from the top outside corners to the appropriate vanishing points to finish the basic shape of the house.

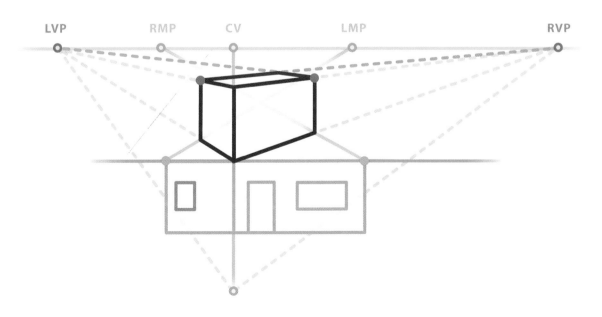

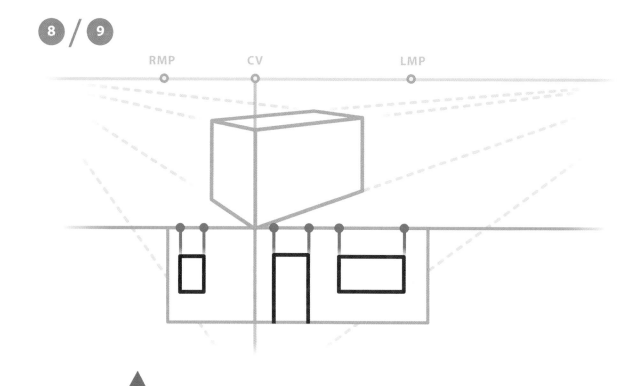

To transfer the door and windows, we'll first need to collect their measurements at the ground line. Extend the vertical lines from each object until they cross the ground line, as shown above. Working with the right side of the house, use the right measuring point to define the vertical paths of the windows and doors.

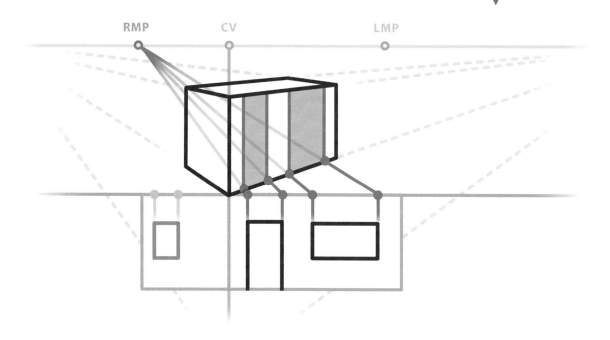

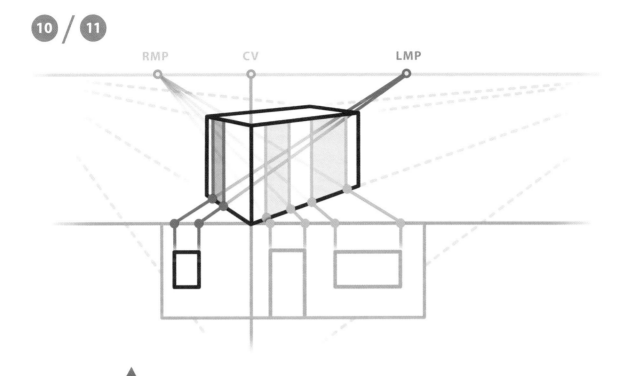

Repeat the process for the left side. While using the ground line and measuring points will help you determine the depth of an object when placed in perspective, it doesn't help with transferring height. That's done in the elevation view. Take each horizontal measurement to the house's leading edge, as shown below.

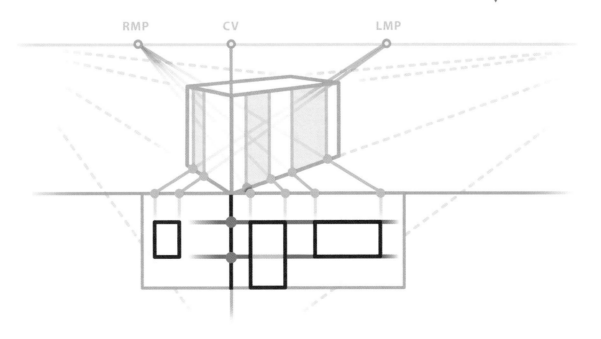

12 / **13**

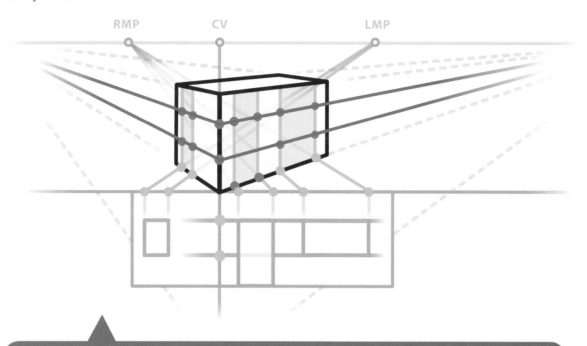

Remember, the height of the front edge of the house is the same above and below the ground line (see Step 3). That means we can transfer the measurements taken in the previous step to its counterpart directly above it. Once that's done, take each point to the appropriate vanishing point. As these lines intersect the vertical paths drawn earlier, the exact placement of the windows and door are revealed.

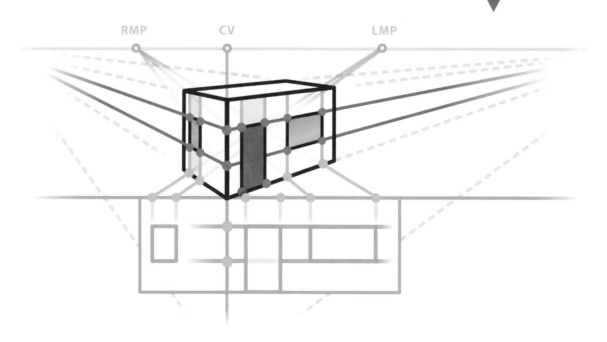

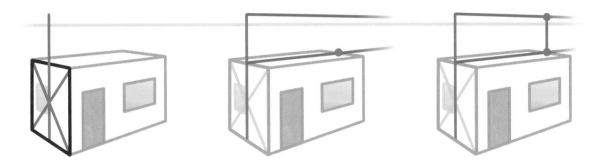

Adding the roof is simple. First, find the middle of the left side of the house. Draw a line through the middle, ending where you want the peak of the roof to be.

Next, draw a line from the height of the centerline to the right vanishing point. This determines the peak of the roof. To find the height of the roof on the right side of the house, transfer the center from the top of the left side to the right, as shown in the middle diagram.

Draw a vertical line connecting the height of the roof on the right side through the center of the right side of the house as shown in the last diagram above.

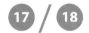

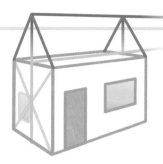 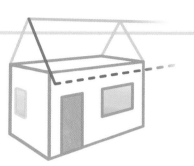

Connect the peak of the roof to the top of the house, as shown above left.

Next we'll create the overhang. Extend the roof downward, past the top plane of the house. Take the extension to the right vanishing point, as shown.

 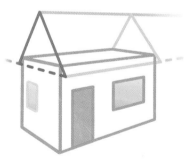 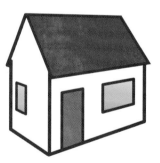

To find the roof's overhang on the back of the house, take the roof extension back to the left vanishing point.

To finish, extend the roof down until it intersects the line from the previous step.

Chapter 9
Circles and Ellipses

If drawing circles and ellipses makes you feel a little crazy, you're not alone. If they're horizontal, they act one way; when vertical, they act another. They're hard to draw well, especially if you're just starting out. In this chapter, we'll go over some tools that will help you get better at drawing and plotting out ellipses, and discuss how they reveal the limitations of perspective.

The Hardest Line Is a Well-Drawn Curve

Circles and ellipses represent a particular challenge for beginners. It's hard to draw them with any kind of precision, and unfortunately even the tiniest of mistakes shout from the page. While it may be tempting to rely on ellipse guides, they can be expensive and are sometimes limiting since they don't come in very large sizes. They also don't come in every size. As mentioned earlier, they can also make your work look a little mechanical. It's one thing if that's the approach for your entire picture, but if your image is drawn in an expressive and informal way while your ellipses remain mechanical and precise, your picture will be inconsistent. It ultimately makes sense to buckle down and learn how to draw them.

You'll find ellipses in more places than you think. Wheels, cups, plates, and lamps are common everyday examples. Ellipses also live in less obvious places. Whenever you swing open a door, move your arm, or open a book, you've defined the path of that movement with a circle or ellipse. To draw these things accurately means you need to understand how ellipses work.

So what's an ellipse? In perspective, an ellipse is the shape that represents what a circle looks like when it's foreshortened. To get a handle on ellipses, we first need to remember how circles interact with squares.

We've seen this before – a square and a circle have a special relationship, in and out of perspective:

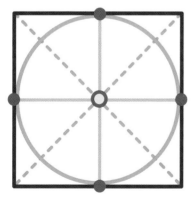

- A circle touches a square in the middle of each side

- They both share the same center

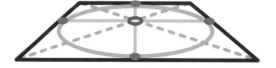

A circle only looks like a circle when it's parallel to the picture plane. When it's at an angle, that circle needs to be represented by an ellipse.

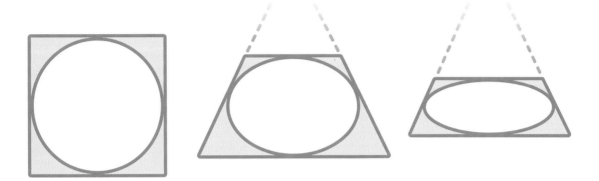

As a circle leans back in space, it becomes foreshortened and turns into an ellipse.

While you'll probably be drawing more ellipses than circles, it's important to be able to draw circles as well. All it takes is practice. For the times when you do need mechanical precision, circle and ellipse guides can help.

Understanding Ellipses

While some use the words oval and ellipse interchangeably, that's not really accurate. An ellipse is a very particular type of oval, and it has these key characteristics:

- All ellipses are symmetrical, both horizontally and vertically.
- All ellipses have two unequal axes.

These axes are incredibly important. They are:

- The minor axis, which cuts through the middle of the small side of the ellipse.
- The major axis, which cuts through the middle of the widest part of the ellipse.

These axes always act a specific way:

- The major and minor axes always intersect each other at a 90° angle.
- This intersection occurs directly in the center of the ellipse.

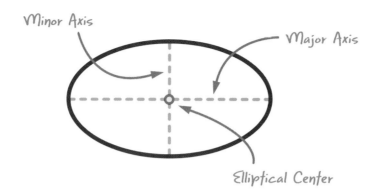

- The minor axis goes through the widest part of the short side – it's not always the vertical axis, but it's always the short one.

- The major axis goes through the widest part of the long side.

- The elliptical center is where the major and minor axis meet. It's the exact center of an ellipse – it does not describe perspective.

These characteristics, along with the ideas about how a circle relates to a square, are almost all we need to get started.

Defining a Circle in Perspective

When we draw an ellipse using the major and minor axis, we end up with the elliptical center – the intersection between the two axes that occurs in the exact center of the ellipse. When that ellipse is meant to represent a circle in perspective, we have to find the perspective center. The elliptical center and the center of an ellipse representing a circle in perspective are never in the same place. While both shapes can be identical, how we interpret the form in space is decided by where we establish the center. For your work to be accurate, you have to get this right.

The major axis will never run through the perspective center of a circle in space. Think of the major and minor axes as a set of tools that we use to construct an ellipse. To then make the viewer understand it as a circle in perspective, the perspective center needs to be made clear.

In the example below, it's important to know that the ellipses are exactly the same size and shape.

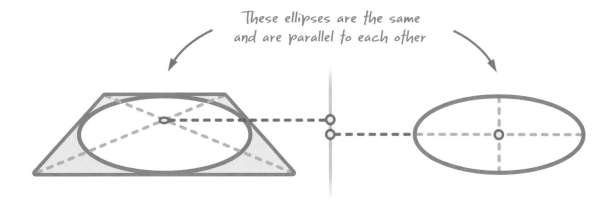

These ellipses are the same and are parallel to each other

The ellipse on the left reads as a circle, while the one on the right seems parallel to the picture plane. Even though the ellipses are identical, the given or implied center leads the viewer to interpret each one in a different way.

How to Draw an Ellipse

It's important to learn how to sketch and draw ellipses and circles. Once you've mastered drawing boxes and ellipses, you'll be ready to tackle almost any typical, man-made object.

Following are some ideas that, with a bit of practice, will have you free-handing successful ellipses in no time.

Start by drawing the major and minor axes. Make sure they meet at a 90° angle.

Start your drawing on one of the axes. I usually like to start with the top of the minor axis.

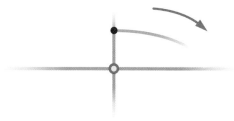

When you hit the major axis, you'll have some tools that will guide you as you finish.

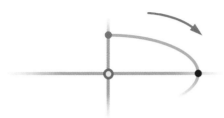

Remember, ellipses are symmetrical; repeat the horizontal and vertical measurements on the axes as shown.

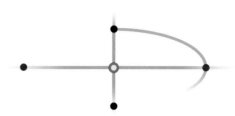

As you draw each quadrant, compare them. They should look like mirror images of each other.

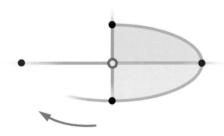

Continue making your way around the ellipse. With practice, hand-drawing ellipses will become second nature.

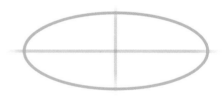

Watch for these common mistakes:

No corners, ever. Even with extremely narrow ellipses, make sure each transition is a smooth curve

The peak of the curve should be on an axis

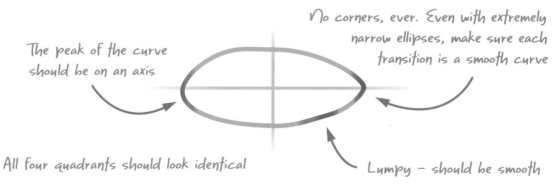

All four quadrants should look identical

Lumpy – should be smooth

Most ellipses represent circles in perspective, so again, you'll probably need to establish the perspective center. Most of the time, the context of your imagery will do that for you. No one, for instance, really misinterprets the elliptical top of a can sitting on a table. However, if you feel your ellipse is confusing or spatially ambiguous, then find and show its perspective center. This is done by placing it in a box and drawing an X. If it's a horizontal plane ellipse (one that's parallel to the ground plane), a one-point box will always do.

Horizontal Plane Ellipses

The easiest ellipses are ones that are on or parallel to the ground plane. Horizontal plane ellipses have two characteristics:

- The minor axis is always vertical/perpendicular to the horizon line.
- The major axis is always parallel to the horizon line.

Like any other form, the closer the ellipse gets to eye level, the narrower it becomes.

Horizontal plane ellipses are either on or parallel to the ground plane.

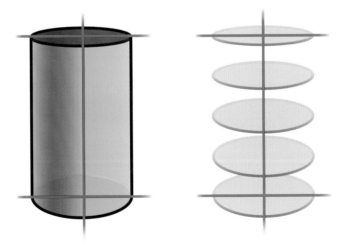

In a horizontal plane ellipse, the minor axis is always vertical and the major axis is always parallel to the horizon line.

All horizontal plane ellipses get thinner as they approach eye level.

Vertical Plane Ellipses

Here's where things get more challenging. When drawing a vertical ellipse, the minor axis does double duty – it now leads us to one of the vanishing points. It helps to think of the minor axis as some kind of axle between a pair of wheels. Since the major axis is always perpendicular to the minor axis, this will change the angle that our ellipse gets drawn in. To believably present a vertical plane circle in perspective, we must get both the foreshortening and angle right.

Vertical plane ellipses change angle based on their relationship to the horizon line.

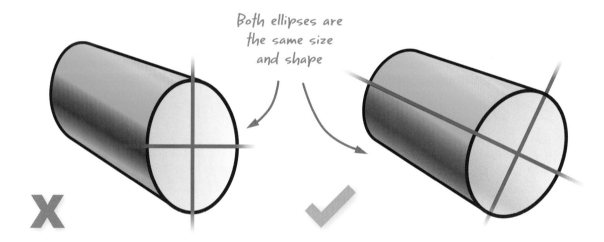

Both ellipses are the same size and shape

Wrong! With vertical plane ellipses, the minor axis always goes to a vanishing point. The only time this kind of ellipse can be perfectly upright is when the minor axis overlaps the horizon line.

Correct! This ellipse is drawn properly. The major and minor axes are perpendicular to each other and the minor axis is going to the vanishing point. This causes the ellipse to change angle. The further away an ellipse is from the horizon line, the greater the angle.

Remember, with vertical plane ellipses, just because an ellipse is the right shape doesn't mean it's the right ellipse – it needs to be drawn at the correct angle. This isn't an issue when drawing a horizontal plane ellipse, because the minor axis is vertical and doesn't recede. While horizontal plane ellipses get skinnier as they approach the horizon line, vertical plane ellipses become more vertical. Keep that difference in mind, even when you sketch.

Vertical Ellipses Can't Keep a Secret

In an earlier chapter, we discussed how most of what we do in perspective isn't quite correct, but is ultimately believable (as long as our work remains in the cone of vision, that is). Again, the only place where our drawings are true to life is at the center of vision. This is perspective's little secret, but it usually isn't much of a concern. Even when drawing realistically, our goals are more about looking right rather than being right, especially when doing so interferes with the success of the former. Vertical plane ellipses don't really cooperate as we try to conceal the limitations of perspective. This becomes obvious as we try to draw a vertical ellipse away from the horizon line. There's really no way to keep the major and minor axes at 90° while being true to the symmetrical characteristics of the shape and its relationship to the vanishing point. It's a distortion inherent in the imperfect (but again, believable) process of perspective; one that's not noticeable when drawing boxes but is clear as day when trying to draw a vertical ellipse away from eye level.

The best way to reconcile this problem is to defer to what looks right. It's more important to maintain the integrity of how the minor axes and major axes work together than to have the minor axis faithfully make its way to the vanishing point. A distorted asymmetrical ellipse, even aimed perfectly in the right direction, will always look wrong. Your first priority is to draw the shape correctly. Then, do what you can to aim it in the right direction. So, while we have many useful tools to help plot out ellipses, if they're being drawn away from the horizon line, your best judgment will need to override the results of your process.

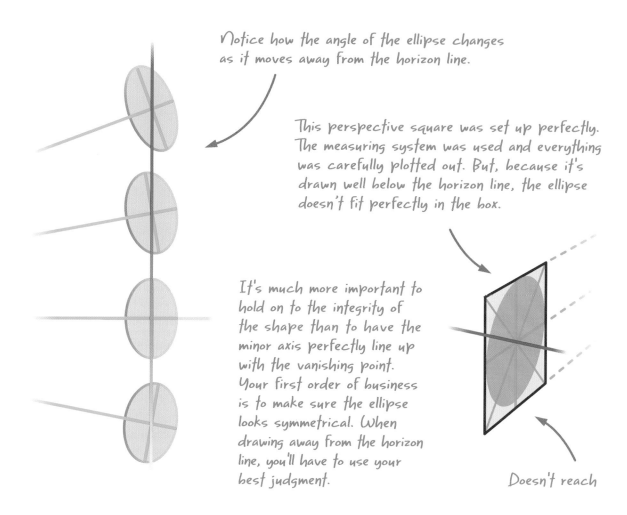

Notice how the angle of the ellipse changes as it moves away from the horizon line.

This perspective square was set up perfectly. The measuring system was used and everything was carefully plotted out. But, because it's drawn well below the horizon line, the ellipse doesn't fit perfectly in the box.

It's much more important to hold on to the integrity of the shape than to have the minor axis perfectly line up with the vanishing point. Your first order of business is to make sure the ellipse looks symmetrical. When drawing away from the horizon line, you'll have to use your best judgment.

Doesn't reach

Plotting Ellipses – Give Me Points!

Even with a thorough understanding of how ellipses work, they can still be a struggle to draw accurately. The more guidance you have, the more precise your ellipse will be. Luckily, we can use perspective to create a trail of points to follow as a guide. Here are three ways to do just that.

This first method was popularized by Andrew Loomis, an American illustrator and educator. While this method doesn't quite place the guide points exactly where they need to be, they end up being close enough to help you get the job done. What little we lose in accuracy we gain in simplicity and speed; this is by far the easiest and least intrusive method of the three we'll be going over. It adds four points to the four we already have.

1

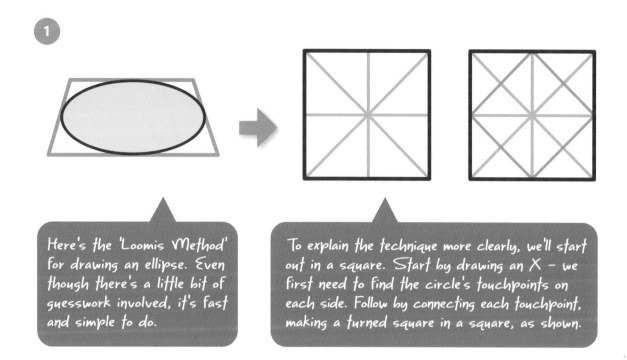

Here's the 'Loomis Method' for drawing an ellipse. Even though there's a little bit of guesswork involved, it's fast and simple to do.

To explain the technique more clearly, we'll start out in a square. Start by drawing an X – we first need to find the circle's touchpoints on each side. Follow by connecting each touchpoint, making a turned square in a square, as shown.

2

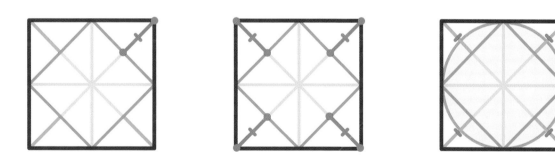

Here's what we're after – the halfway point on the diagonal between the turned square and each corner. Find each division as shown in the middle diagram.

In the last diagram, you can see that these halfway points almost intersect with a circle. The same will hold true in perspective. If you accurately find the four halfway points and come in a bit behind them as you draw, you'll end up with a convincing ellipse after just a little work.

Let's use this to create an ellipse. Start off with a square in perspective. Draw the X, find the center of each side, and draw the turned square within a square.

Next, divide each diagonal in half. Even though the square is in perspective, you don't really have to compensate for that as you find each middle. Having an accurate silhouette is much more important than having an ellipse that's a touch too wide or narrow; the latter isn't really noticeable.

Don't forget the initial points that we get from the square. Those, along with these four new ones, will have you drawing great ellipses in no time.

 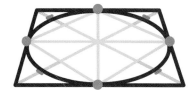 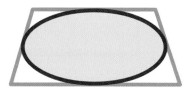

This next method takes information from one plane and transfers it into perspective. It's very accurate, but more involved. So you don't clutter up your drawing, set it up on tracing paper (or if you're working digitally, on a separate layer). It too adds four more points to help you accurately draw your shape.

1

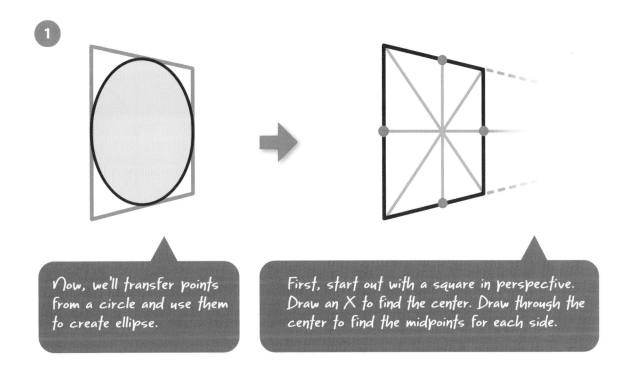

Now, we'll transfer points from a circle and use them to create ellipse.

First, start out with a square in perspective. Draw an X to find the center. Draw through the center to find the midpoints for each side.

2

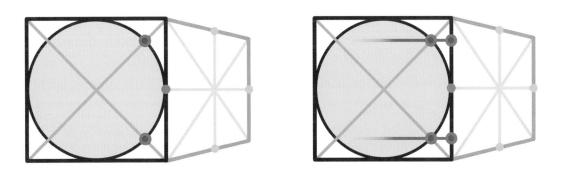

Attach a square to the foreshortened square as shown above. Draw a circle in the square, making sure it's large enough to touch each side. Draw an X in the square and identify where the X intersects the circle.

Horizontally transfer the intersection to the shared edge as shown above, right.

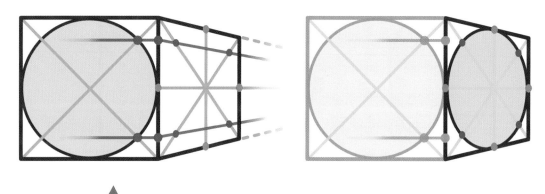

From the shared edge, draw lines towards the vanishing point, noting where they intersect the X in the receding square. There are now eight accurately placed points to use as you construct your ellipse.

This last method is a lot more work. It will, however, give you a total of 12 points to guide you; it practically draws itself. Reserve this technique for large ellipses – this process doesn't work well if it's drawn too small; at that size it's hard to be accurate. For large ellipses, these extra points will come in handy. While not difficult, this method is fairly labor intensive. We'll start out by constructing a circle and follow with instructions for a 12-point ellipse.

Here's a useful but laborious 12-point method for plotting accurate circles and ellipses.

We'll first use this method to construct a circle. Start with a square, an X to find the center, and the turned square within a square.

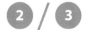

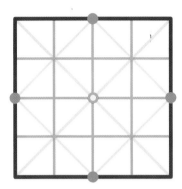 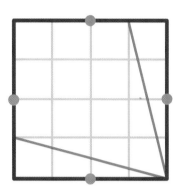

Use the previous step to subdivide the square into sixteen smaller squares, as shown. We'll call these grid lines. We need them to plot out eight of our points.

This is where it gets tricky – from each corner, draw lines that radiate out towards each opposite edge the distance of one square, as shown in red above.

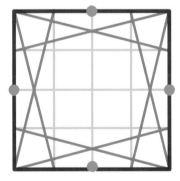 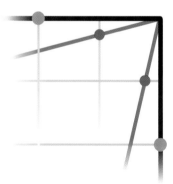

After doing this for each corner, your work should look like the diagram above, left.

Now it's time to plot the points. Using the lines from the previous step, follow one from the corner, moving out until it crosses its first grid line, as shown in the close-up above, right. Mark the intersection. Do this for the remaining seven lines.

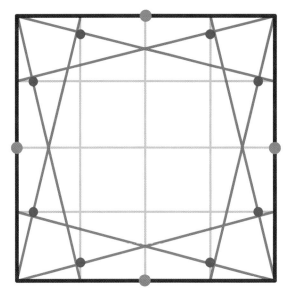

Here's what things should look like once all the points are plotted. Don't forget to include the four points we get from the square. Finish by drawing the circle.

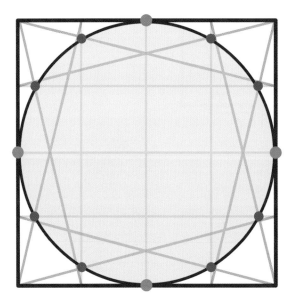

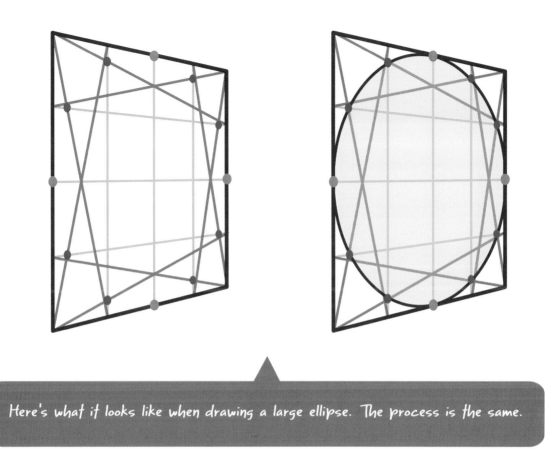

Here's what it looks like when drawing a large ellipse. The process is the same.

Dividing a Circle in Perspective

There are times when you'll need to divide an ellipse into equal pieces. Clocks, combination locks, and umbrellas are each examples of ellipses that are subdivided equally. We'll start things off by dividing a horizontal plane ellipse into six identical pieces.

1

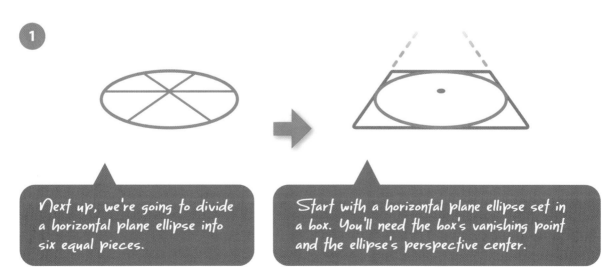

Next up, we're going to divide a horizontal plane ellipse into six equal pieces.

Start with a horizontal plane ellipse set in a box. You'll need the box's vanishing point and the ellipse's perspective center.

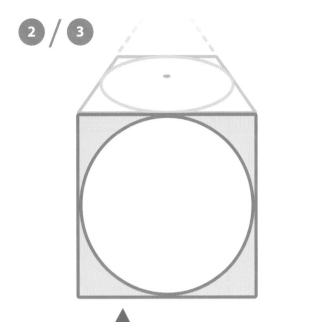
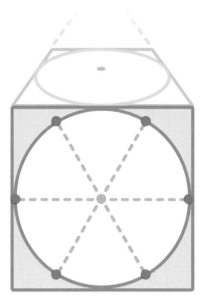

Next, attach a square and circle to the box that contains the horizontal plane ellipse, making sure the edges are the same length.

Using a protractor, divide the circle into any number of pieces. To keep things simple, I've subdivided the circle above into six equal pieces of 60°.

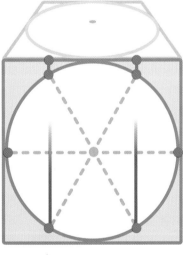
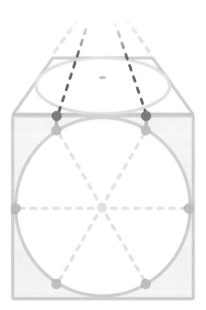

Follow by vertically taking the divisions from the circle to the shared edge. It's important to note that in the example above, the top and bottom parts of the circle are the same, so there's no need to transfer the points from the lower half.

From the shared edge, take the transferred measurements to the vanishing point.

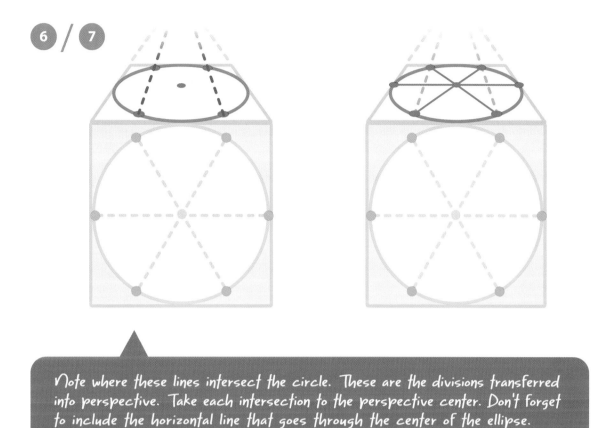

Note where these lines intersect the circle. These are the divisions transferred into perspective. Take each intersection to the perspective center. Don't forget to include the horizontal line that goes through the center of the ellipse.

Vertical plane ellipses are handled the same way. In the example that follows, I've instead divided the circle into five equal pieces. We lose the symmetry of the previous example, so we have to pay closer attention to the differences between front and back. Let's have a look.

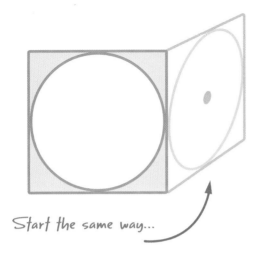

Start the same way...

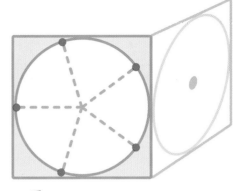

I've divided this circle into five equal pieces

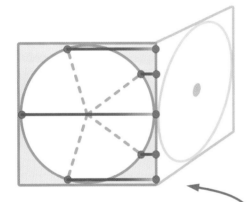

Unlike the previous example these divisions aren't symmetrical, so each point needs to be taken to the shared edge

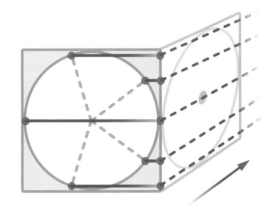

Take these divisions to the vanishing point ...

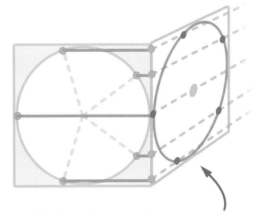

Pay attention to where the divisions are on the initial circle — make sure you transfer the points to the correct location.

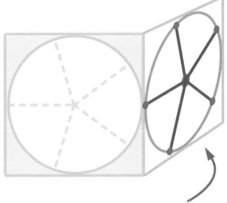

Done! This example can now be turned into a wheel on a sports car. Or large servings of cake.

Chapter 10
Mastering Slopes

Understanding how slopes are drawn will help you illustrate everything from the flaps of an open box to complicated architectural details. We'll start by going over the two different ways to draw a slope, continue with inclined roads drawn in both one- and two-point perspective, and end by going over how to make slopes intersect other forms.

Slopes are planes that are at an angle to the ground plane. Sometimes called inclined planes, they can be found everywhere. Examples include rooftops, stairs, roads, ramps, and playground slides. Even the flaps of an open box are slopes. There are two approaches to drawing them – the first is form based while the other relies on the introduction of two new elements into the setup. While the methods are interchangeable, they each have their strengths. Let's take a look.

Creating Inclined Planes Using the Basic Forms

Once you've drawn through a form, you'll have everything you need to add or subtract a simple slope. The process is an extension of the information covered in Chapter 6.

Adding to a Form

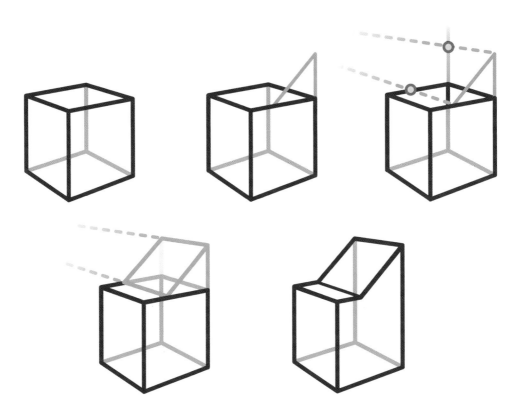

Removing from a Form

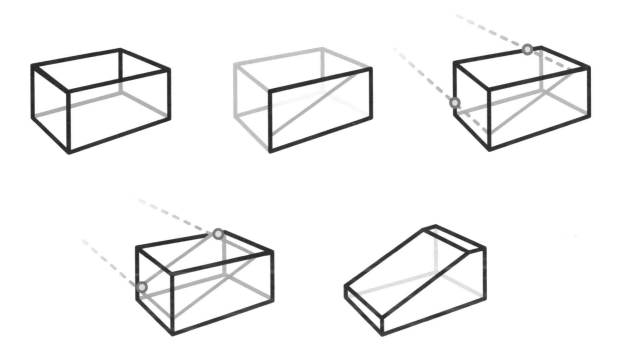

Inclined Planes from a Vertical Vanishing Line

Because slopes move away from the ground plane at an angle, they need their own vanishing point. These VPs are either directly above or below the existing vanishing point. Here's what we need to integrate into the setup:

> **Vertical Vanishing Line** – The vertical vanishing line (VVL) is a line that intersects the horizon line at 90° through a vanishing point. It's sometimes referred to as the vanishing trace.

> **Vertical Vanishing Point** – Vertical vanishing points (VVP) serve as the vanishing points for our slopes. They are always placed on the vertical vanishing line.

Both tools work the same way that the horizon line and regular vanishing points do; they just do so vertically. Here's what it looks like in the setup:

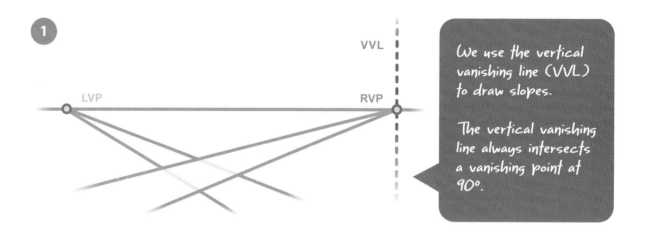

We use the vertical vanishing line (VVL) to draw slopes.

The vertical vanishing line always intersects a vanishing point at 90°.

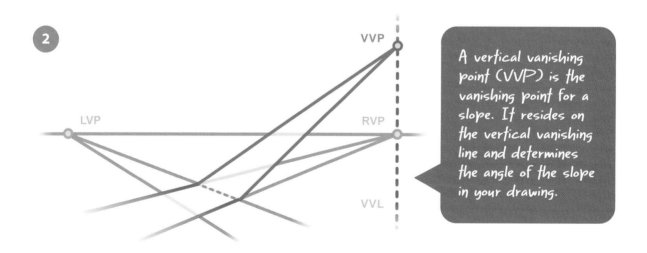

A vertical vanishing point (VVP) is the vanishing point for a slope. It resides on the vertical vanishing line and determines the angle of the slope in your drawing.

Once this is established, it can be used repeatedly to indicate any change in vertical direction.

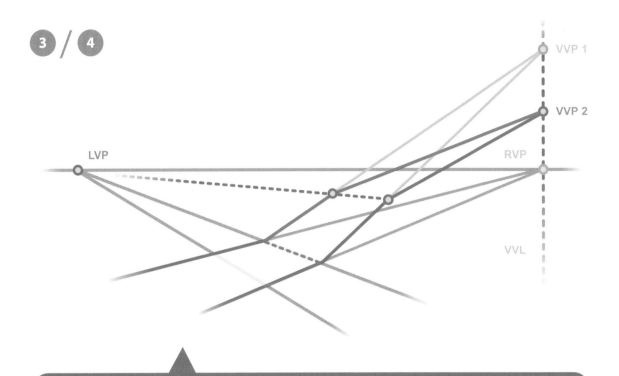

You'll need a new vertical vanishing point every time your plane changes direction.

When a plane slopes downward, the VVP will be below the horizon line. Notice where the downward slope intersects the ground plane.

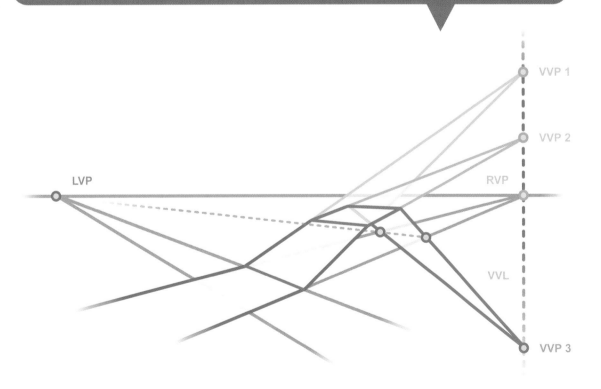

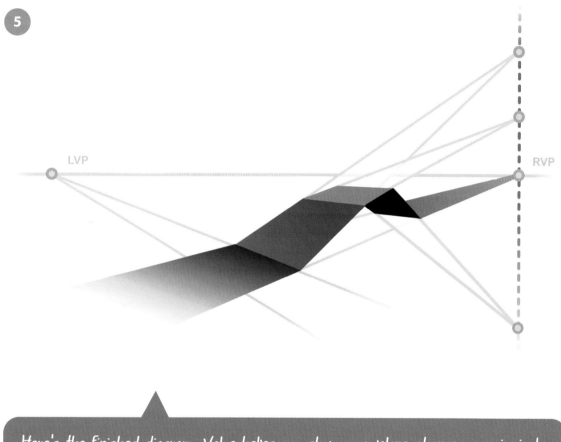

5

LVP

RVP

Here's the finished diagram. Value helps you show your plane changes convincingly.

While using a vertical vanishing line is a great method for quickly establishing accurate slopes, sometimes the vertical vanishing points are so far away that this technique is impractical. Following is a useful trick that keeps everything closer to home.

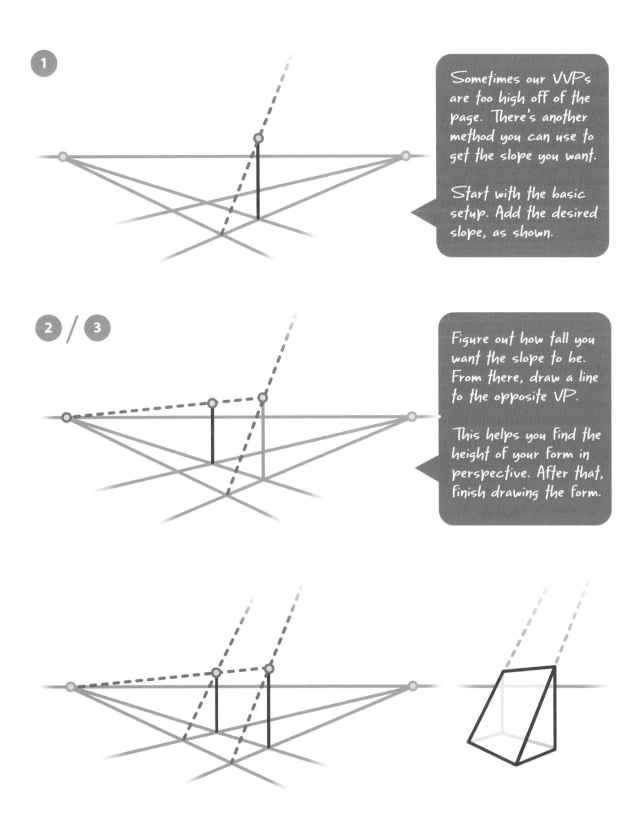

Sometimes our VVPs are too high off of the page. There's another method you can use to get the slope you want.

Start with the basic setup. Add the desired slope, as shown.

Figure out how tall you want the slope to be. From there, draw a line to the opposite VP.

This helps you find the height of your form in perspective. After that, finish drawing the form.

Buildings on a Hill

Now we'll go through how to place buildings on an inclined plane. At the same time, we'll go over what slopes look like in one-point perspective. Remember to make these buildings habitable! Even though a hill is an inclined plane, don't make the mistake of drawing the roof, windows, and doors at the same angle – they need to recede to the vanishing point on the horizon line.

1

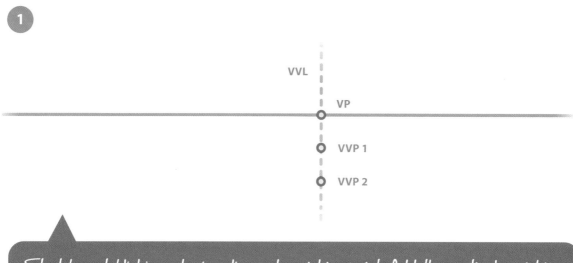

Start by establishing a horizon line and vanishing point. Add the vertical vanishing line and the vertical VPs necessary to draw your one-point inclined plane.

2

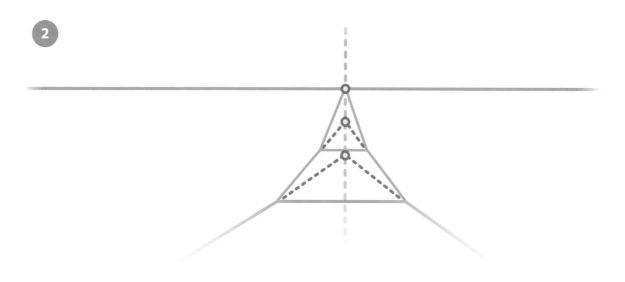

Here's the road drawn in one-point perspective. Each plane leads to its own vertical vanishing point. Because it's in one-point, each plane change is divided by a horizontal line. While drawn simply, it's already easy to see the road dip down and come back up.

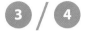

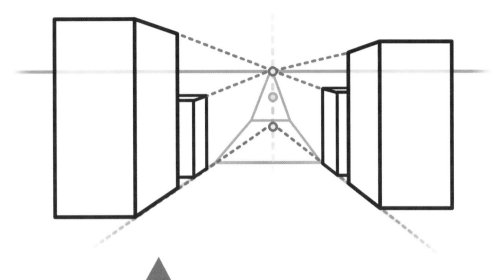

Pay attention to where each plane is going — the footprint of each building will follow the plane that they're on, but the rest of the building will recede towards the horizon line. That means windows and doors need to recede to eye level.

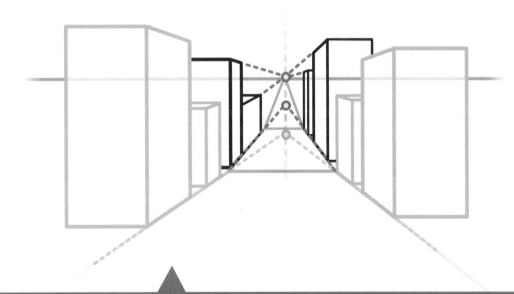

Remember to go to the correct vertical vanishing point whenever a slope changes direction. The middle buildings are on a different plane than those in the foreground. They use a different vertical vanishing point.

Intersecting Slopes

You'll find many instances where slopes intersect other planes, especially when drawing architecture. First, we'll go over the basics so you can understand how to handle intersecting planes. We'll follow with an example of how an inclined plane cuts through a vertical surface and exits a horizontal one.

When cutting through a vertical slope, take the point of intersection to the vertical vanishing point.

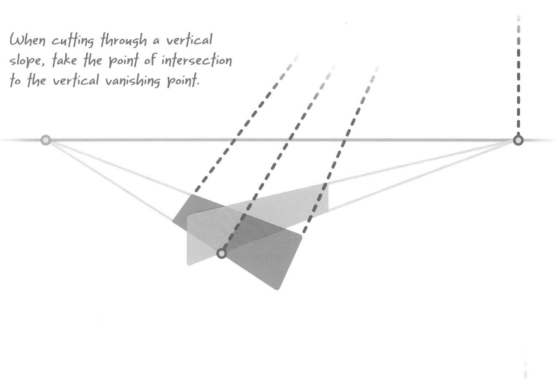

When cutting through a horizontal slope, follow the plane back to its vanishing point.

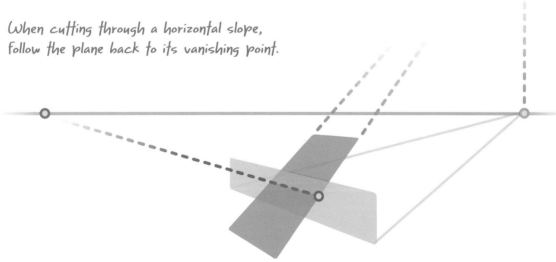

Entering and Exiting a Form

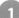

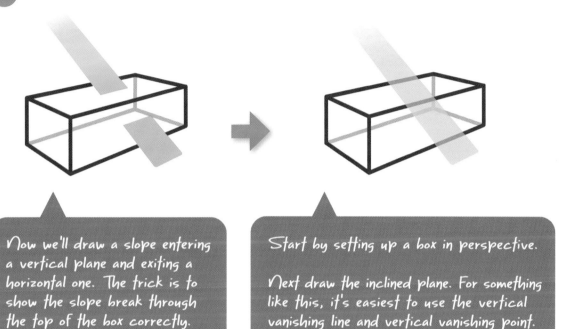

Now we'll draw a slope entering a vertical plane and exiting a horizontal one. The trick is to show the slope break through the top of the box correctly.

Start by setting up a box in perspective.

Next draw the inclined plane. For something like this, it's easiest to use the vertical vanishing line and vertical vanishing point.

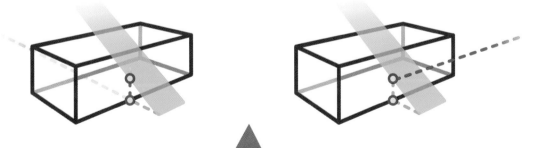

From the base of the slope, draw a line to the left vanishing point. When the line intersects the base of the form, draw a vertical line until you cross the slope.

Next, draw a line from the intersection between the slope and vertical plane to the right vanishing point, as shown.

3

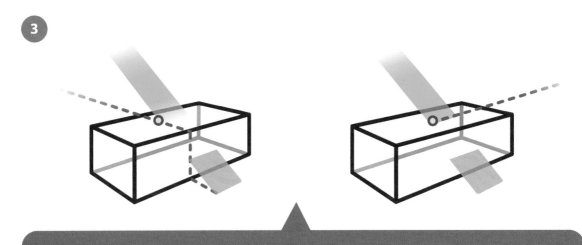

The process is the same when finding the exit point. Continue following the form. Move up the front, then back towards the left vanishing point once on the top plane.

The path on the top of the box will eventually intersect the inclined plane. From that intersection, draw a line to the right vanishing point – that's where the slope exits the top of the box.

Intersecting Equally Inclined Planes

Sometimes you'll have a pair of inclined planes that intersect each other. If they're at the same angle, the intersection is shown as an angle that's halfway between each inclined plane. When each slope rises at a different angle, you have to take a slightly different approach.

1

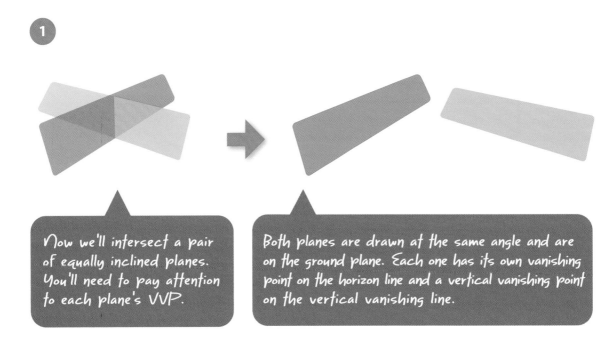

Now we'll intersect a pair of equally inclined planes. You'll need to pay attention to each plane's VVP.

Both planes are drawn at the same angle and are on the ground plane. Each one has its own vanishing point on the horizon line and a vertical vanishing point on the vertical vanishing line.

2

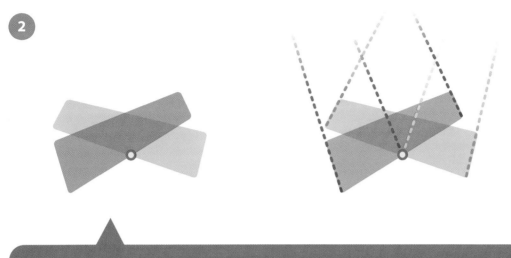

Overlap the planes and take note where they intersect the bottom. Both planes share this point. Draw lines from the intersection to each plane's vertical vanishing point. You don't have to get too technical — you can use the sides as a guide.

3

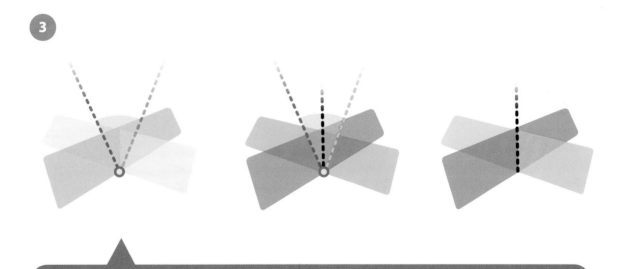

Notice the angle made when the two planes intersect. All we have to do is cut the angle in half to show where they intersect each other. Clarify the overlapping forms either with line weight or value contrast and you're done.

Intersecting Unequally Inclined Planes

1

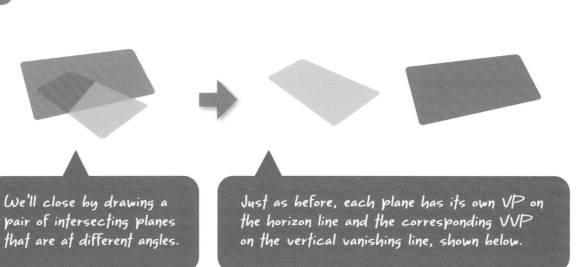

We'll close by drawing a pair of intersecting planes that are at different angles.

Just as before, each plane has its own VP on the horizon line and the corresponding VVP on the vertical vanishing line, shown below.

2

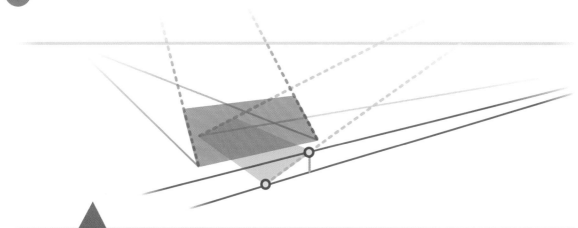

The goal is to identify where the height of one intersecting plane touches the other. Once that's established, determining the intersection is easy. Start by setting up each plane and overlapping them. Determine which plane has the lowest slope, then draw lines from its vanishing point through the top and bottom of the plane as shown.

3

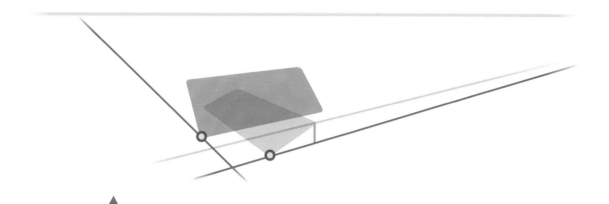

Next, from the other plane's vanishing point, draw a line through the bottom outside corner of the slope as shown. Be sure to intersect the bottom line from the previous step.

4

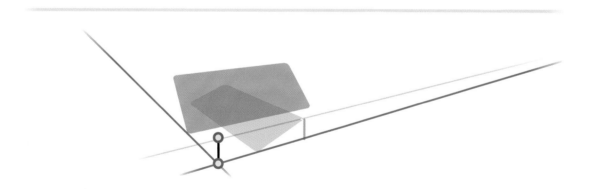

We can now transfer the height of one plane to the other. Determine the height by drawing a vertical line from the intersection on the ground to the reference line above it, as shown.

5

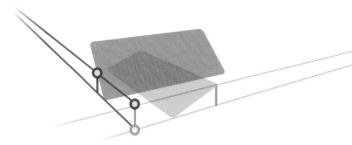

To transfer the height back to the other slope, draw a line from the top of the vertical line from the previous step to the vanishing point as shown. Note where it intesects the slope. This is the height of the first slope transferred back in space.

6

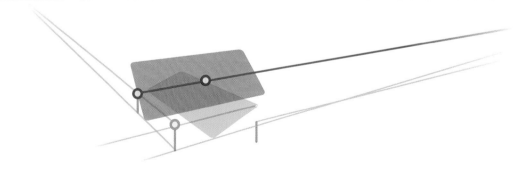

Next, take the point to the opposite vanishing point as shown. Note where it intersects the initial slope – this is where both slopes meet.

7

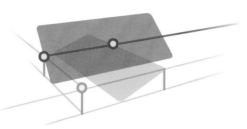

Next, take the point to the opposite vanishing point as shown. Note where it intersects the initial slope — this is where both slopes meet. To finish, simply connect the point to where the two planes intersect on the ground plane.

Chapter 11
Indicating Reflections

Trying to draw an accurate reflection out of your head is a lot like playing the lottery – you'll probably lose. You can improve your odds by learning the information in this chapter. We'll go over important new vocabulary, discuss the differences between parallel and angular reflections, and go through examples of how to draw reflections on vertical and horizontal surfaces.

Seeing What the Mirror Sees

Reflections occur when a particular material is able to visually reproduce the surrounding objects on its surface. They can be tricky, especially when drawing from imagination. Luckily, we can use perspective to figure out what our reflections should look like. Before we start, we need to address a few new vocabulary terms.

Reflective Surface – An object capable of reflecting its surroundings.

Mirrors, bodies of water (especially when still) and many polished, glossy objects are all reflective surfaces.

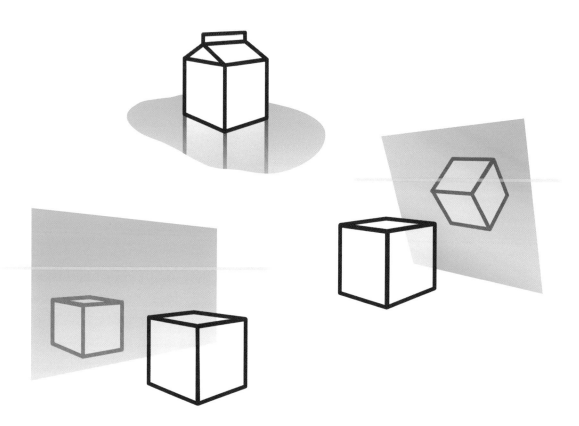

Reflective surfaces can be vertical, horizontal, or anything in between.

Reflective Plane – An imaginary continuation of the reflective surface in perspective.

Sometimes we need to temporarily extend the reflective surface so we can accurately plot a reflection. The reflective plane infinitely extends the reflective surface.

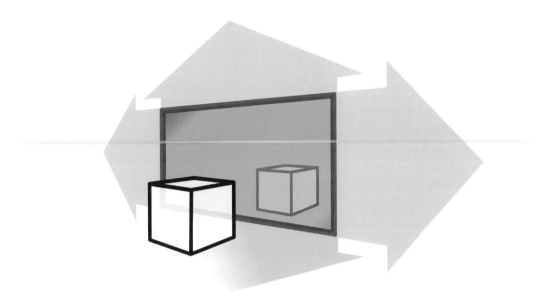

The reflecting plane is an infinite continuation of the reflective surface.

Reflective Edge – The dividing line that creates the symmetry between the reflective plane and what's being reflected.

We use this line to transfer a reflection into perspective. When reflecting something onto a vertical surface, the line is represented by the intersection between the ground plane and the reflective plane. On a horizontal surface, these lines are described by the footprint of the object being reflected.

The reflective edge separates the object being reflected from the reflection. It helps us transfer reflections in perspective.

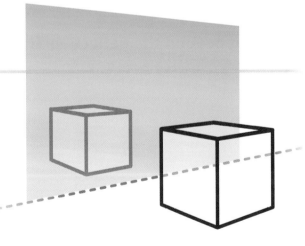

With horizontal reflections, the reflective edge is the footprint of the object on the reflecting surface.

Reflective Path – Lines whose lengths are symmetrically repeated, in perspective, into the reflective surface.

These lines represent the space between the object being reflected and its reflection. The intersections between a reflective path and the reflective edge are used to recreate the object as a reflection in perspective. In a horizontal reflection, the vertical lines of our object together with their reflection describe the reflective path. Think of the reflective path as a group of lines that extend into the reflective surface.

The intersections between the reflective paths and the reflective edge gives us the points we need to transfer our reflection in perspective.

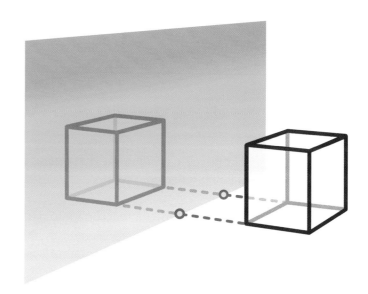

Seeing beyond the Reflective Surface

Let's examine these ideas a bit more closely. It's important to note that the reflective edge won't necessarily be on the reflective surface. Looking at the image below, we see the mirror above the reflective edge, representing only a small part of the reflective plane.

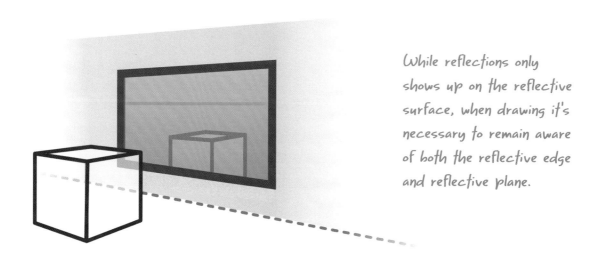

While reflections only shows up on the reflective surface, when drawing it's necessary to remain aware of both the reflective edge and reflective plane.

Occasionally an object will be located in a position where it seemingly can't be reflected. Make sure that's really the case. In the following example, the red ball looks to be out of the mirror's range while the green one seems like it should be reflected. Neither happens to be true. Sometimes it's hard to know if and how a reflection will appear, especially when a reflective surface is strongly foreshortened.

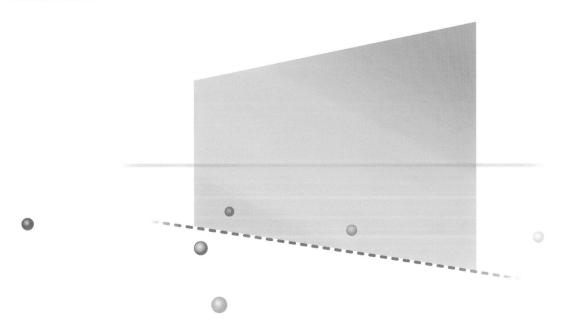

Sometimes objects can be misleading. Some will look like they'll be reflected but aren't, while others look like they wouldn't have a reflection, yet do. Here, the red ball shows up as a reflection while the green ball's position keeps it from being reflected.

Two Kinds of Reflections

A reflection is an equal and opposite representation of an object on a reflective surface. Objects can be reflected in any direction and the viewer can see these reflections from either a one-, two-, or three-point setting. How you go about creating a reflection is determined by the relationship between the object and the reflecting surface – they'll either be parallel to each other or set at an angle.

Parallel Reflections

When the object and the reflective surface are parallel to each other, you have a parallel reflection. This occurs in any kind of perspective, and the reflections can be either horizontal or vertical. These are the easiest kinds of reflection to draw.

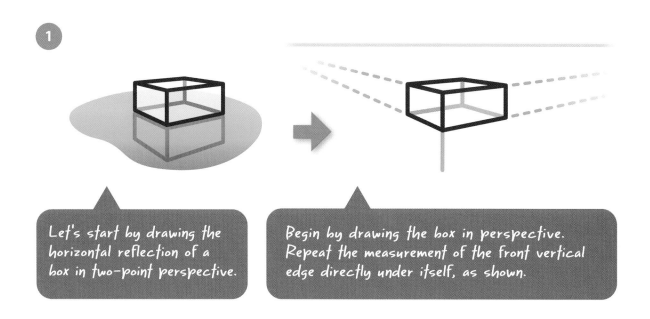

Let's start by drawing the horizontal reflection of a box in two-point perspective.

Begin by drawing the box in perspective. Repeat the measurement of the front vertical edge directly under itself, as shown.

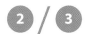

Take the bottom of the line from the previous step to each vanishing point.

To finish, draw the remaining vertical lines, as shown. Since vertical lines are always parallel to the picture plane, when they're reflected they will always be the same length as their corresponding object lines.

The table below is based on the previous diagram. Note how we're looking down at the table while looking up at its reflection. Remember, a reflection is an equal and opposite representation of an object on a reflective surface. When transferring vertical dimension in a horizontal reflection, make sure you place your information on opposite sides of your form.

Remember, reflections are equal and opposite representations of objects on the reflective surface.

Make sure you draw the reflection as an opposite view what's down is up, and vice versa.

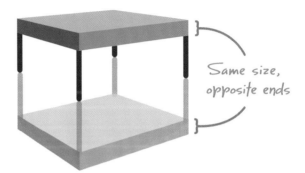

Same size, opposite ends

Parallel Reflections on a Vertical Surface

Things change when creating vertical plane reflections. When a form is up against a reflective surface, it's just a matter of using an X to transfer scale into the reflective plane. When your object is away from the reflective surface, we instead place the X on the ground plane. Let's have a look at both conditions.

1

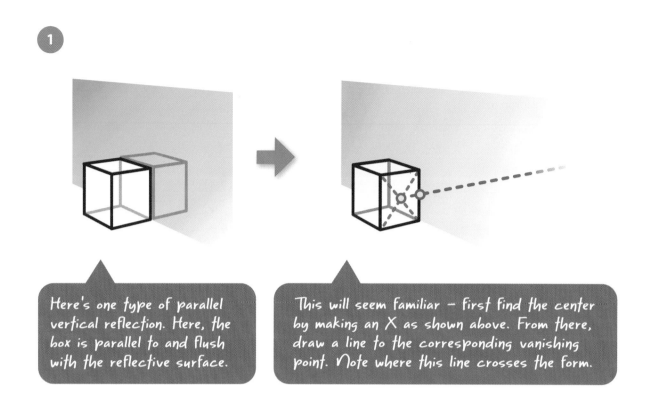

Here's one type of parallel vertical reflection. Here, the box is parallel to and flush with the reflective surface.

This will seem familiar – first find the center by making an X as shown above. From there, draw a line to the corresponding vanishing point. Note where this line crosses the form.

2 / 3

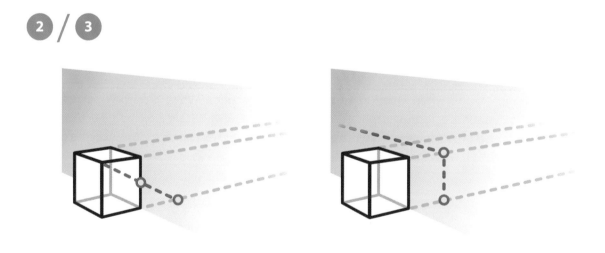

Set up the reflection by drawing lines from the box through the reflective surface to the vanishing point. To find the depth of the box as a reflection, draw a line from the top corner through the midpoint. Note where it intersects the reference line.

Next, draw a vertical line up towards the middle reference line. Define the top plane by turning the corner and going to the opposite vanishing point. You now have enough information to create the reflection.

1

Here's another parallel vertical reflection – this time we have to account for the space between the box and the reflective surface.

To avoid clutter, start with a the base of the box and the reflective surface. Since they're parallel to each other, they'll both be using the same vanishing point.

2

From the box, draw lines through the reflective plane towards the vanishing point. Doing this defines the reflective path.

In the space between the box and the reflective edge, draw an X from corner to corner as shown. We need to find the center before we move on to the next step.

3 / **4**

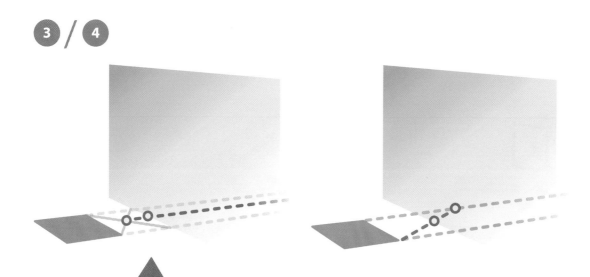

Bring the center back to the vanishing point. Note where the line crosses the reflective edge.

Draw a line from one of the box's corners through the centerpoint on the reflective edge, as shown. Stop when you've intersected the reflective path.

5 / **6**

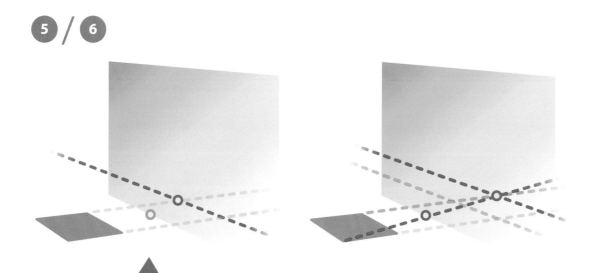

From the new intersection, draw a line to the left vanishing point. This creates a reflection of the space between the front of the square and the reflective surface.

Now we'll find the back of the box. Draw a line from the box's back corner through the center point at the reflective edge, continuing until you hit the reflective path. From there, draw a line to the right vanishing point. This is the square's reflection.

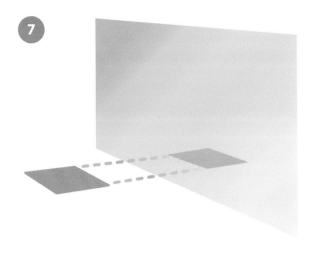

7

Here's a clearer look at the square and it's reflection.

From here, it's easy work to turn the square into a box. Decide how tall you want the box to be and take that measurement to your VPs. By now, the rest should be second nature.

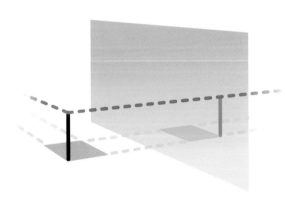

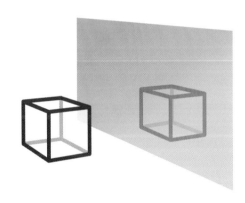

There's another way to transfer a parallel reflection onto a reflective surface. So far, we've created a reflection by transferring a rectangle into the reflective surface. An alternative method uses the vanishing point for a 45° angle. Here's how it's done.

1

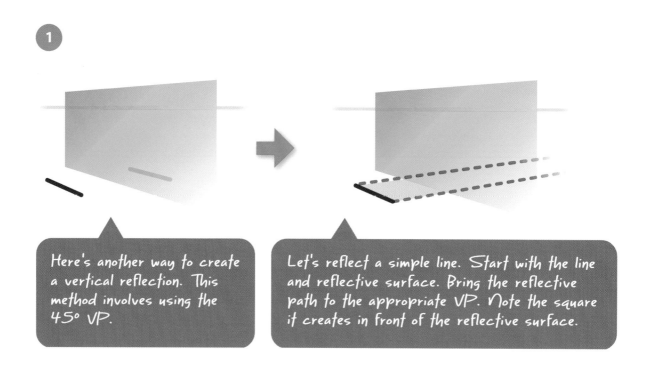

Here's another way to create a vertical reflection. This method involves using the 45° VP.

Let's reflect a simple line. Start with the line and reflective surface. Bring the reflective path to the appropriate VP. Note the square it creates in front of the reflective surface.

2

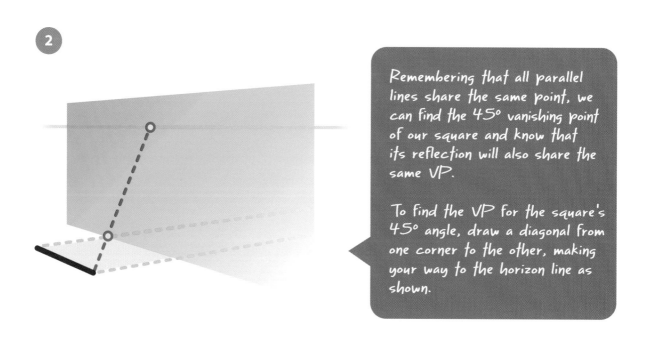

Remembering that all parallel lines share the same point, we can find the 45° vanishing point of our square and know that its reflection will also share the same VP.

To find the VP for the square's 45° angle, draw a diagonal from one corner to the other, making your way to the horizon line as shown.

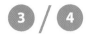

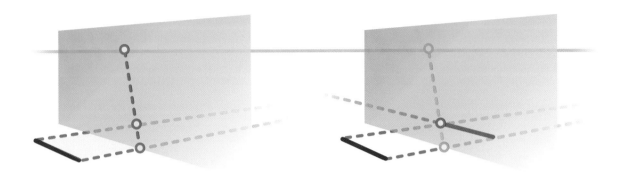

Next, draw a line from the point where the reflective path meets the reflective edge to the 45° VP. Note where the line intersects the other reflective path.

To create the reflection, draw a line from the left VP through the intersection.

Angular Reflections

You'll have an angular reflection if the reflecting surface isn't parallel to your subject matter. With a parallel reflection, we rely on squares and rectangles to create our reflection. When creating an angular reflection, we have to take a different approach.

With an angular reflection, the object and reflecting surface are no longer parallel to each other. That changes how we create reflections.

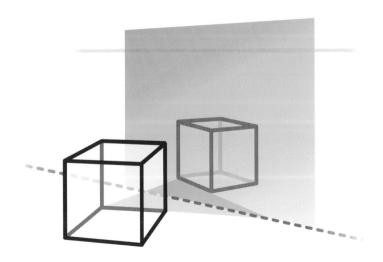

The easiest way to approach an angular reflection is to think of having to mirror a series of points into the reflective surface. Taken one at a time, after a few points you'll have enough information to reconstruct your object as a reflection. As you do this, work from the base of the form (the footprint) and build up. Let's start by reflecting a line that's at an angle to the reflecting surface. We'll end the chapter by transferring vertical height into an angular reflection.

1

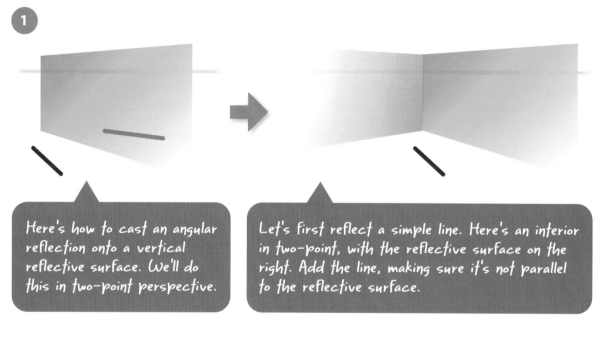

Here's how to cast an angular reflection onto a vertical reflective surface. We'll do this in two-point perspective.

Let's first reflect a simple line. Here's an interior in two-point, with the reflective surface on the right. Add the line, making sure it's not parallel to the reflective surface.

2

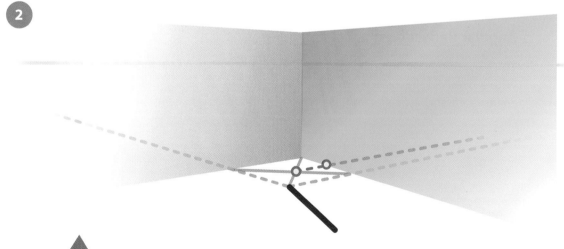

Take one end of the line to both vanishing points. Note the rectangle formed on the ground plane. Find the center of the rectangle by drawing an X from corner to corner. Take that center to one of the vanishing points and mark where the line intersects the reflective edge, as shown.

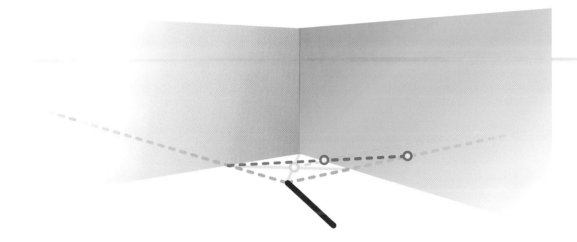

Draw a line from the far end of the rectangle through the point on the reflective edge. Continue until you intersect the reflective path. This is the reflection of the far end of the line.

To find the other end of the line, we'll first need to set up it's reflective path. Draw a line to the right vanishing point as shown below.

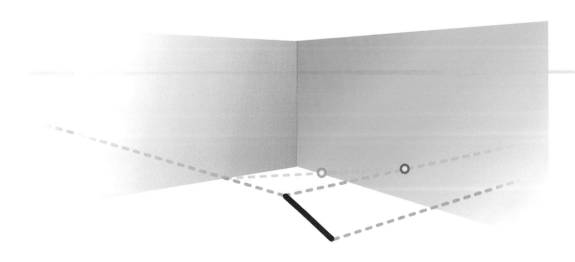

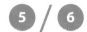

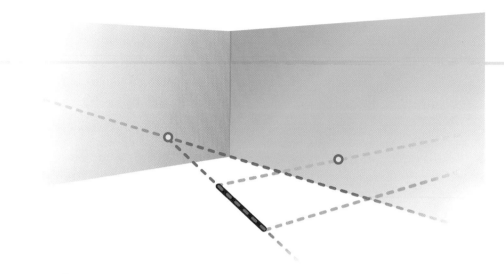

Next, extend the line until it intersects the reflective edge, as shown above. This reference point will help us finish the reflection.

From the reference point, draw a line through the point in the reflective surface, as shown. Stop when you intersect the reflective path.

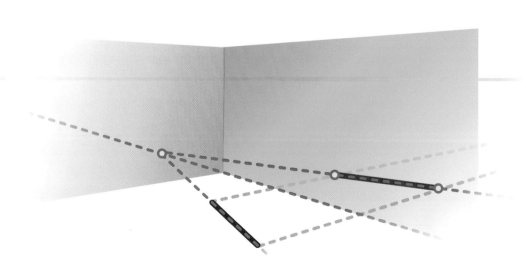

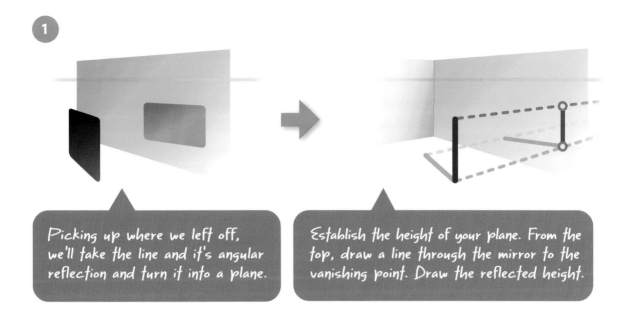

1

Picking up where we left off, we'll take the line and it's angular reflection and turn it into a plane.

Establish the height of your plane. From the top, draw a line through the mirror to the vanishing point. Draw the reflected height.

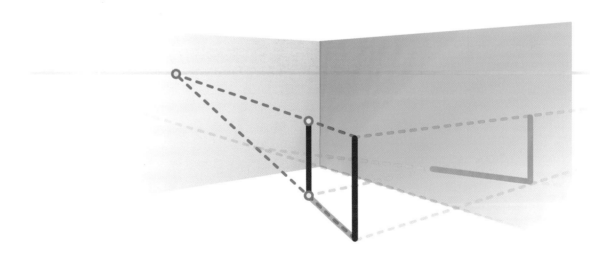

2

Next we'll find a reference point so we can transfer height to the opposite end of the line. Take the line on the ground plane and extend it to the horizon. From that intersection, draw a line back to the top of the given vertical line, as shown.

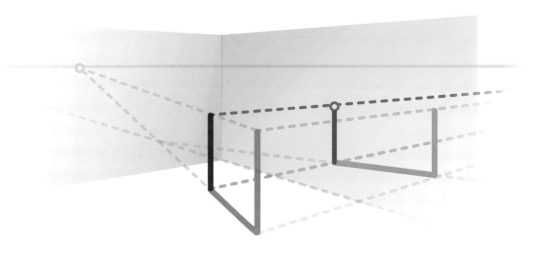

Next we'll find the height of the left edge of our plane when reflected. It's a common mistake to use the reference point; in this case it doesn't work because the lines on the ground plane aren't parallel to each other. Instead, draw from the top of the line to the vanishing point. Follow by drawing in the reflected height.

To finish, simply close off the top of each plane as shown below.

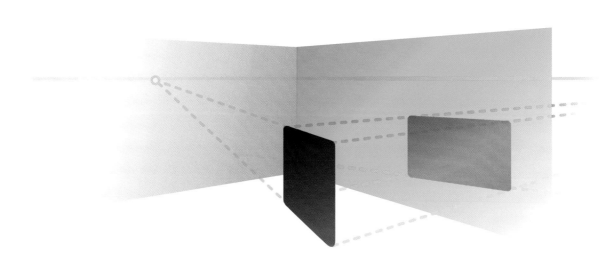

Chapter 12
Casting Shadows

Shadows are easier than they look. Drawing one in perspective can be reduced down to constructing three sides of a triangle. In this chapter, we'll discuss shadows in detail and go over the four different lighting conditions. We'll talk about shadows from floating objects, cutouts, and vertical shadows. We'll end by learning how to cast the shadows of cylinders and spheres.

Shadows add drama and mystery to your work. They help describe form and they imply a specific light source. A well-planned shadow is a useful compositional tool. To understand how shadows work in perspective, we first need to go over how shadows are formed, and define the four different kinds of light.

Shadow Setup Basics

We get a shadow when an object blocks the path of light as it travels away from its source. The shape of a shadow is determined by the angle of light, the shape of the object in its path, and sometimes the surface upon which the shadow is cast. Let's examine these ideas in more detail:

Light Source – The location where light originates. In perspective, there are four ways of describing light: positive sun, negative sun, parallel sun, and radiating (artificial) light. We'll talk about these soon.

Shadow Vanishing Point (SVP) – A specific point directly below or above the light source. It acts as the vanishing point for our shadows. Its location is determined by the type of light source being used.

Light Angle – The angle or direction the light is moving in as it travels away from the source. The light angle determines the length of the shadow.

Cast Shadow – A shadow projected onto an adjacent surface by a form.

To understand how this works in perspective, let's examine a simple pole, its shadow, and a light source, shown below.

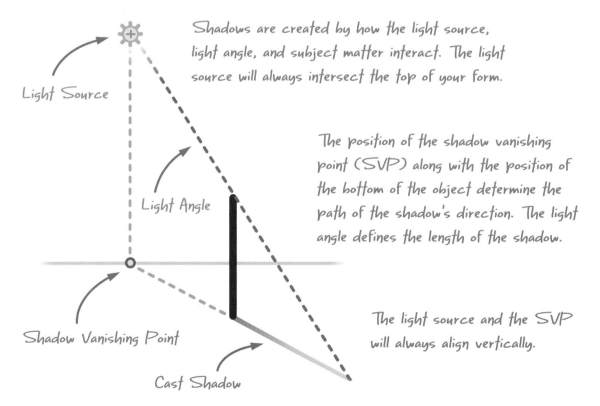

Light Source

Shadows are created by how the light source, light angle, and subject matter interact. The light source will always intersect the top of your form.

Light Angle

The position of the shadow vanishing point (SVP) along with the position of the bottom of the object determine the path of the shadow's direction. The light angle defines the length of the shadow.

Shadow Vanishing Point

The light source and the SVP will always align vertically.

Cast Shadow

The general setup for casting shadows is a simple one. While there are a few variables, you're ultimately managing three different lines that together make up a triangle drawn in perspective. The one constant will be the need to keep your light source and the shadow vanishing point (SVP) aligned vertically. As we move forward, remember that you'll always fundamentally be drawing a version of one of these three triangles:

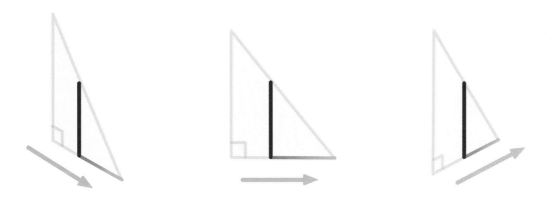

Casting shadows can be reduced down to plotting out triangles in space. You'll either be drawing a triangle coming towards you (left), parallel to you (center) or moving away from you (right). You'll use this method even when casting shadows from elliptical forms.

With the shadow setup, where you place your light source and shadow vanishing point are key. The light source will always intersect the top of your form, creating the light angle. The steepness of that angle will define the length of the shadow. The shadow vanishing point, in tandem with the bottom of your form, dictates the path of your shadow's direction.

Thinking about Light

In perspective, light is divided into two broad categories – natural and artificial light. These categories are a bit misleading. When a light source is anything but the sun, it's considered to be artificial light. This is really all about distance – a candle's light, while natural, is much closer to our subject matter. The sun, on the other hand, is almost 93 million miles away. When the faraway sun isn't our light source, the rules for drawing shadows change.

The height of your light source strongly affects the mood your work will convey. When a light source is high above our subject matter, it creates short, abrupt shadows. As a light source gets closer to eye level, cast shadows become long and gradual. This holds true whether the light source is natural or artificial.

The placement of your light source determines a shadow's orientation. For instance, when the light source is placed behind the viewer, shadows will move back toward the horizon. When the light source is in front of the viewer (and behind the subject matter) shadows will move toward the viewer.

The four lighting conventions used in perspective specify placement more fully. Let's have a look.

The Four Shadow Types in Perspective

Positive Sun – when the sun is in front of the viewer.

This position creates cast shadows that are in front of the object, moving toward the viewer. In a drawing, the light source is placed above the horizon line and the shadow vanishing point is directly below it on the horizon line. Since shadows move toward the viewer, pay careful attention to how high you place the light source. If it's too low, you'll create unnaturally long shadows that could creep out of the cone of vision.

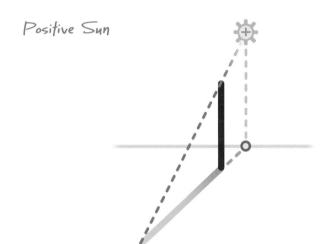

Positive Sun

- The light source is in front of the viewer but behind the object

- The light source is above the horizon

- The SVP is directly below the light source on the horizon line

- All shadows move toward the viewer

More Examples of Positive Sun

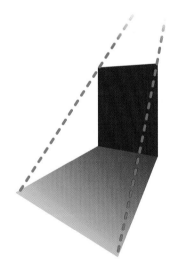

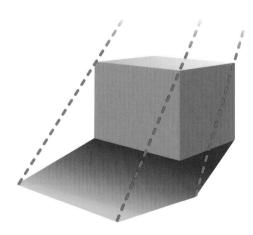

Parallel Sun – when the sun's rays are parallel to the picture plane.

This creates perfectly horizontal shadows. Since light is traveling parallel to the picture plane, there's no shadow vanishing point or light source indicated on the page. Shadows always run parallel to the horizon line. Once the angle of light is defined, it's used consistently throughout the image – all light angles are parallel to each other.

Parallel Sun

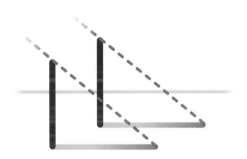

- The light source and SVP are not indicated

- All light angles are parallel to each other and the picture plane

- Shadows move parallel to the horizon line

More Examples of Parallel Sun

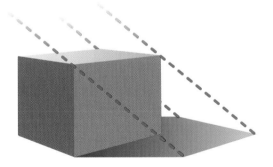

Negative Sun – when the sun is behind the viewer.

Here, cast shadows move away from the viewer toward the horizon. While it's counter-intuitive, when constructing shadows from a negative sun we place the light source below the horizon and the shadow vanishing point directly above it on the horizon line, as shown. After that it's business as usual – the SVP still goes through the base of the form, and the light source still intersects the top.

Negative Sun

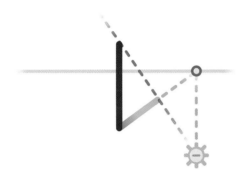

• The light source is behind the viewer

• The light source is placed below the horizon

• The SVP is located on the horizon line, directly above the light source

• Shadows move back, toward the horizon

More Examples of Negative Sun

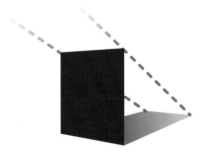
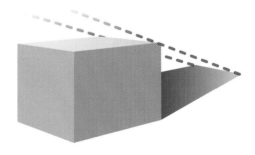

Artificial (Radiating) Light – when the light source is closer than the sun, it's treated as artificial light.

Shadows will radiate around the shadow vanishing point. The difference here is that the SVP is placed on the ground plane directly below the light source, not on the horizon line.

Artificial (Radiating) Light

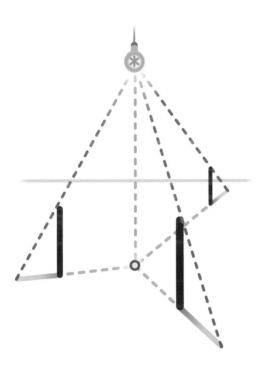

- The light source is physically close to your subject matter

- The SVP is directly below the light source on the ground plane

- All shadows converge towards the SVP

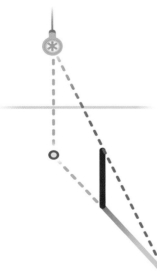

Where you place the SVP dictates the length and direction of each shadow. The closer the SVP is to the horizon line, the further away the light source is. The only difference between these two pictures is the placement of the SVP.

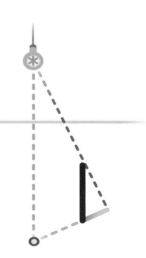

Because our light source is close to us, we can have objects that are behind it. That's not the case with the sun. With artificial light, the shadow vanishing point is our way of establishing how close the light source is to our subject matter. Where you place the SVP affects what your shadows end up looking like.

Drawing the Four Shadow Types

Now that we've discussed the basic shadow setup and explained the four lighting conventions, it's time for action. The trick to drawing an accurate shadow is to treat the process as a collection of vertical poles. If you can accurately cast a pole's shadow in each of the four lighting conditions, you're ready.

Whatever kind of shadow you're drawing, the process will be the same. Lines from the SVP run through the bottom corners of your form. Lines from the light source run through the top corners of your form, continuing until they intersect the lines from the shadow vanishing point. These intersections, taken together, create the shape of the cast shadow. It's that easy.

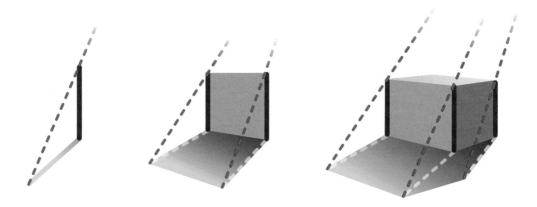

No matter what kind of shadow you're drawing, the method is always the same.

It's important to know that when drawing a box, you don't need to plot out each corner. Remember that parallel lines all converge to the same vanishing point. As you draw your shadows, use the regular vanishing points as the VPs for the horizontal edges of your form. Use the SVP as the vanishing point for your vertical edges. If this is confusing, the following diagrams should clear things up.

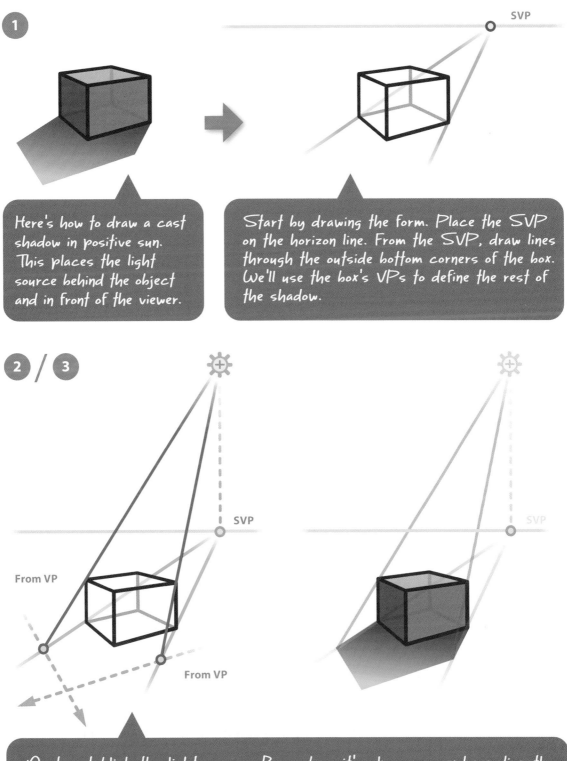

1

SVP

Here's how to draw a cast shadow in positive sun. This places the light source behind the object and in front of the viewer.

Start by drawing the form. Place the SVP on the horizon line. From the SVP, draw lines through the outside bottom corners of the box. We'll use the box's VPs to define the rest of the shadow.

2 / 3

SVP

From VP

From VP

SVP

Next, establish the light source. Remember, it's always somewhere directly above the SVP. From the light source, draw lines through the top outside corners of the box, continuing until they intersect the lines drawn from the SVP. Next, draw lines from the box's VPs through these intersections as shown. To finish, connect the intersections to the outside corners of the box.

1

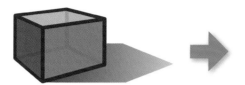

Next, we'll draw a cast shadow from parallel sun. Here, the light source runs parallel to the picture plane.

Because shadows from parallel light don't move back in space, there's no need to indicate the light source or SVP. Start by drawing the form, then draw horizontal lines from the near and far bottom corners as shown.

2 / **3**

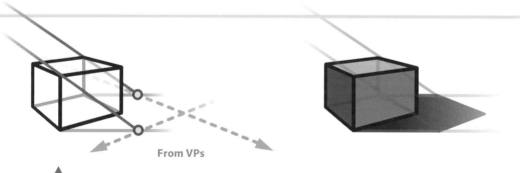

From VPs

With parallel sun, the light angles are drawn parallel to each other. From the light source, go through the top near and far corners of your box, stopping when they intersect the two lines from the SVP. Draw lines from the VPs through the points created by the intersections between the light source and lines from the SVP. Finish the shadow by drawing lines from the intersections to the near and far bottom corners of the box.

1

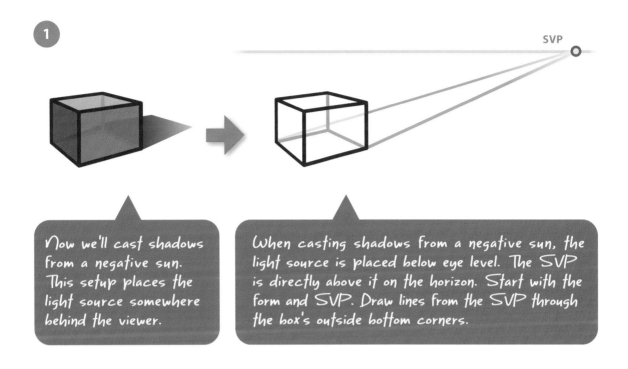

SVP

> Now we'll cast shadows from a negative sun. This setup places the light source somewhere behind the viewer.

> When casting shadows from a negative sun, the light source is placed below eye level. The SVP is directly above it on the horizon. Start with the form and SVP. Draw lines from the SVP through the box's outside bottom corners.

2 / **3**

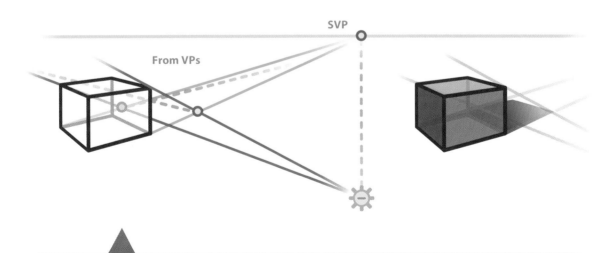

SVP

From VPs

> Place the light source below the horizon line. The closer it is to the horizon the longer your shadows will be. From the light source, go through the top two outside corners of the form. Find the intersections on the ground plane, then draw lines from the VPs through the intersections to define the shadow.

By now it should be pretty clear how shadows are drawn. As we move toward explaining how to cast shadows in artificial light, remember that there's one key difference. Because the light source is close, we need to place the shadow vanishing point somewhere on the ground plane. You'll see that the shadows will radiate around that point. Outside of this one difference, the drawing process is the same.

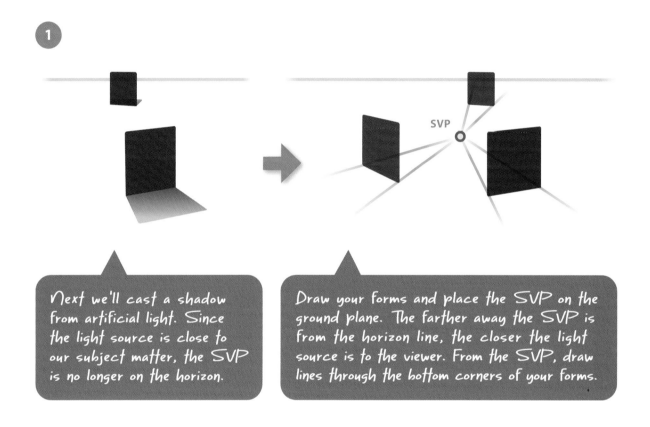

Next we'll cast a shadow from artificial light. Since the light source is close to our subject matter, the SVP is no longer on the horizon.

Draw your forms and place the SVP on the ground plane. The farther away the SVP is from the horizon line, the closer the light source is to the viewer. From the SVP, draw lines through the bottom corners of your forms.

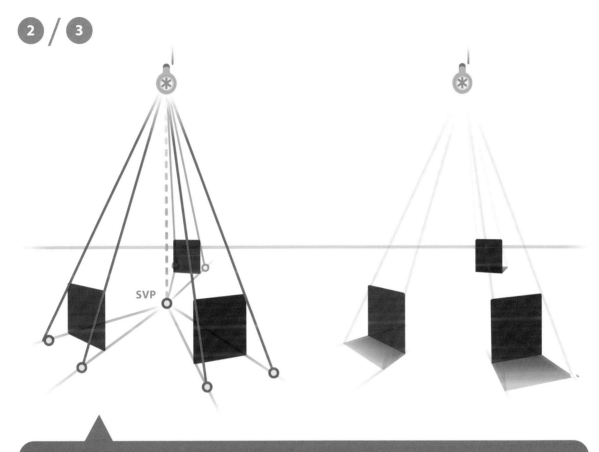

Next, establish the light source directly above the SVP. From the light source, draw lines through the top corners of your forms, ending where they intersect the lines from the SVP. To complete the shadow, connect the dots and bring them to the outside bottom corners of the shape as shown.

Shadow Cutouts and Floating Objects

Now that we've gone over how to cast shadows in the four lighting conditions, we can dive in more deeply. Next, we'll talk about how to handle cutouts and floating objects.

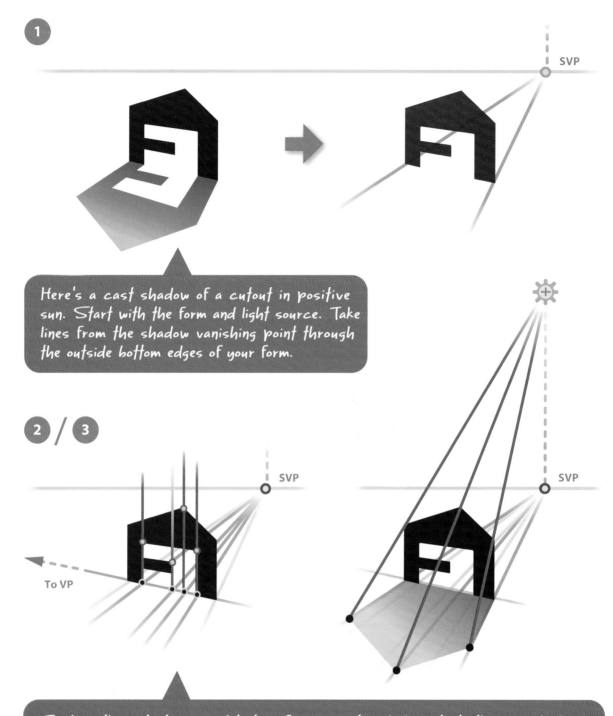

1

SVP

Here's a cast shadow of a cutout in positive sun. Start with the form and light source. Take lines from the shadow vanishing point through the outside bottom edges of your form.

2 / **3**

SVP

To VP

SVP

To draw the cutout, we need to transfer some internal elements to the ground plane. First, define the ground under the cutout by drawing a line from the base of the form to the VP. Next, draw vertical lines through the points that make up the cutout. Define these points on the ground plane. Draw lines from the SVP that intersect these points. Establish the basic shadow shape by drawing lines from the light source through the top parts of your form until they intersect with their corresponding lines from the shadow vanishing point.

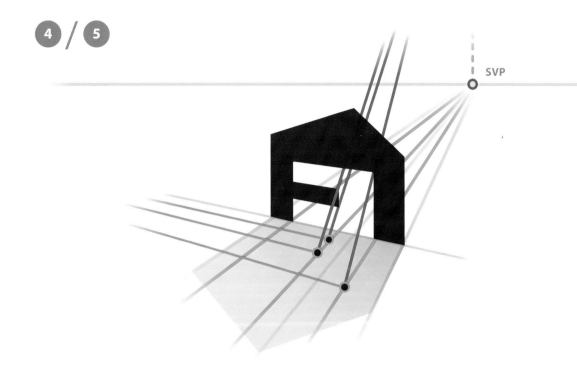

Now we'll define the internal cutout. From the light source, draw lines that intersect the top and bottom of the vertical lines in your cutout. Since we'll finish the interior shape by drawing to the vanishing points, we don't need to go through each point. Decide which corners you need to intersect and draw through them. To complete the cutout, take the intersections on the ground plane to the vanishing point.

1

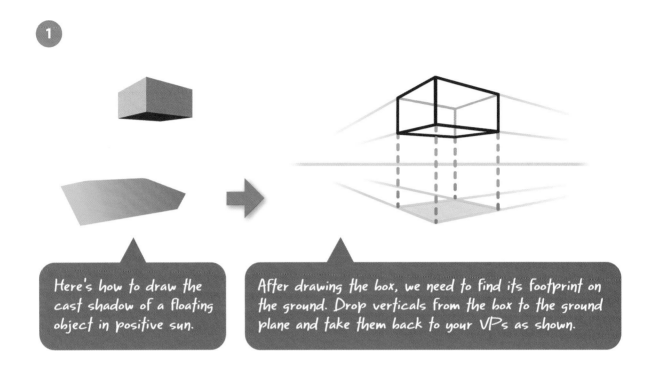

Here's how to draw the cast shadow of a floating object in positive sun.

After drawing the box, we need to find its footprint on the ground. Drop verticals from the box to the ground plane and take them back to your VPs as shown.

2

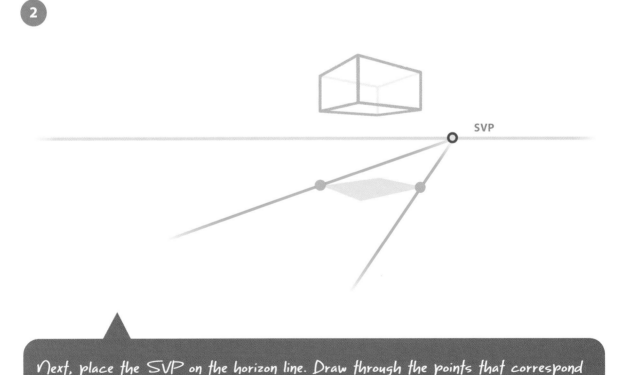

SVP

Next, place the SVP on the horizon line. Draw through the points that correspond to the outside corners of the box. Since we'll use the box's VPs to draw the rest of the shadow, there's no need to transfer the other two points.

3

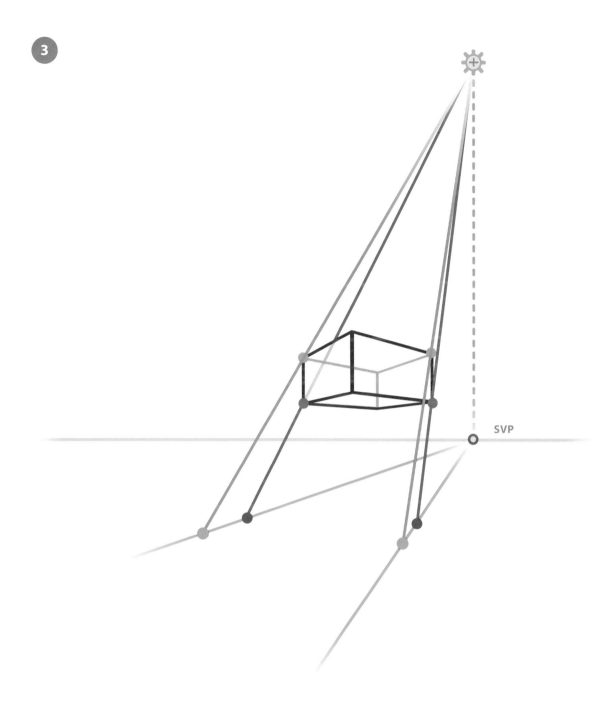

SVP

Next, establish the light source above the SVP. From the light source, draw lines through the bottom corners of the box going until they intersect the lines coming from the SVP. Follow by drawing lines that intersect the outside top corners of the box, again continuing until they intersect lines from the SVP. These are the two outside vertical edges of the box in shadow.

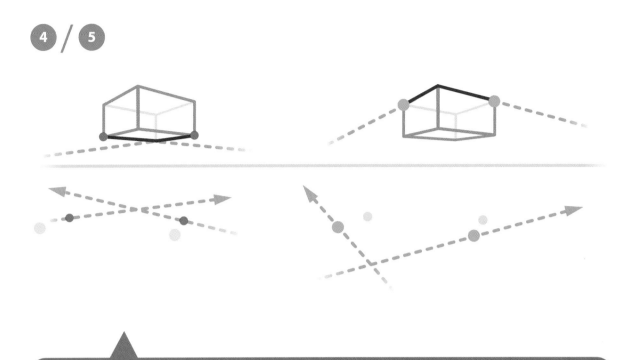

Next we'll take the two sets of points on the ground plane to their respective VPs. So you know where to go, it helps to remember what each point on the ground represents. Bottom points (red go to) the opposite VP, while top points (orange) go to their closest VP, as shown above. Draw through the points to create the intersections that represent the finished shadow, shown below.

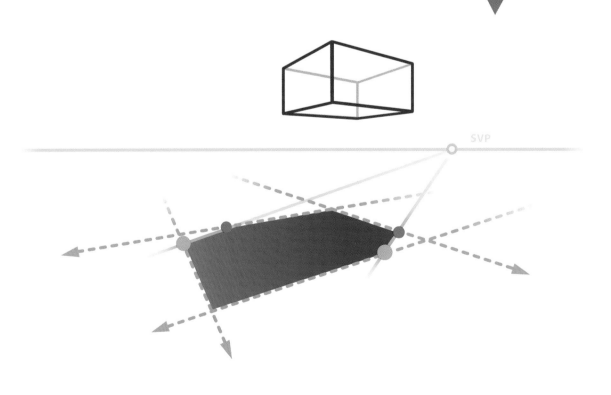

Shadows in Parallel Sun – Floating Objects

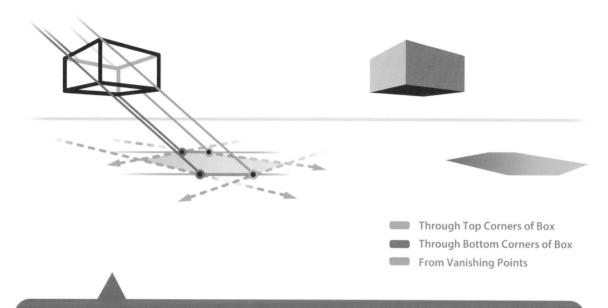

Through Top Corners of Box
Through Bottom Corners of Box
From Vanishing Points

With the other light sources, things work much the same way. Start by finding the footprint of your box on the ground. Bring lines from the SVP to the necessary corners. Continue by going from the light source through the top and bottom corners of the box's relevant vertical edges. To define the shadow's shape, take each intersection to the appropriate VPs.

Shadows in Negative Sun – Floating Objects

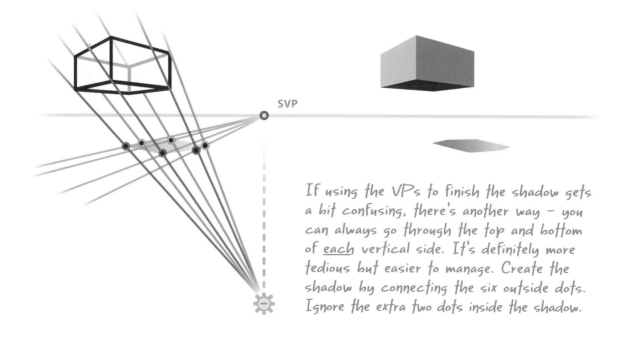

SVP

If using the VPs to finish the shadow gets a bit confusing, there's another way – you can always go through the top and bottom of _each_ vertical side. It's definitely more tedious but easier to manage. Create the shadow by connecting the six outside dots. Ignore the extra two dots inside the shadow.

Shadows on Vertical Planes

Not all shadows are cast on the ground plane. When casting shadows on a vertical plane, it's important to remember that a shadow follows the form it's being cast on. Following are examples of shadows being cast on vertical surfaces shown in the four types light.

Positive Sun

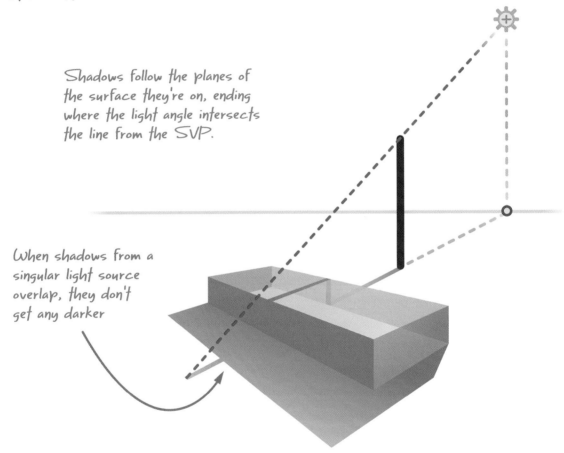

Shadows follow the planes of
the surface they're on, ending
where the light angle intersects
the line from the SVP.

When shadows from a
singular light source
overlap, they don't
get any darker

Negative Sun

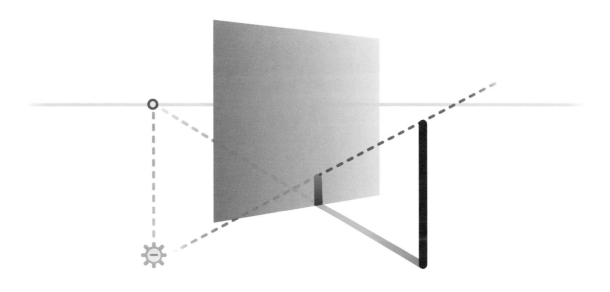

Parallel Sun

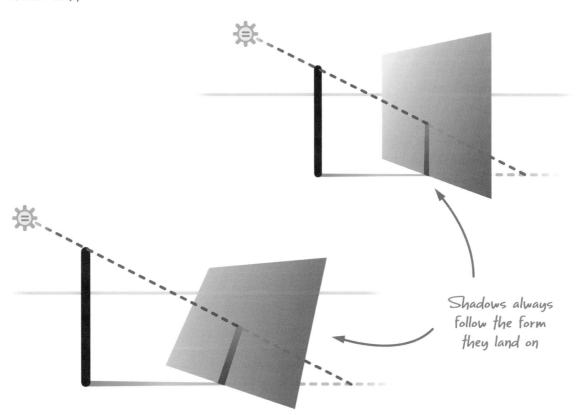

Shadows always
follow the form
they land on

Artificial Light

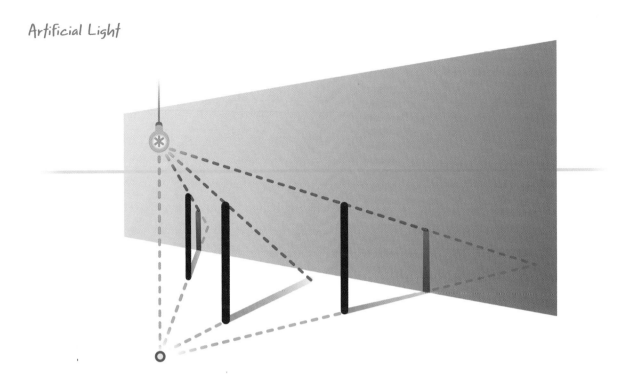

For a more in-depth look, let's go through the process of casting one wall's shadow onto another, step by step.

1

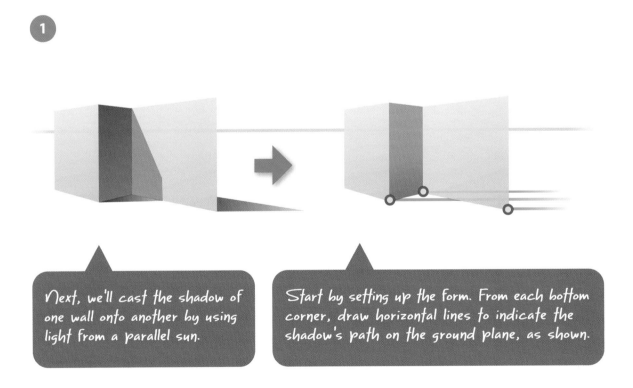

Next, we'll cast the shadow of one wall onto another by using light from a parallel sun.

Start by setting up the form. From each bottom corner, draw horizontal lines to indicate the shadow's path on the ground plane, as shown.

2 / **3**

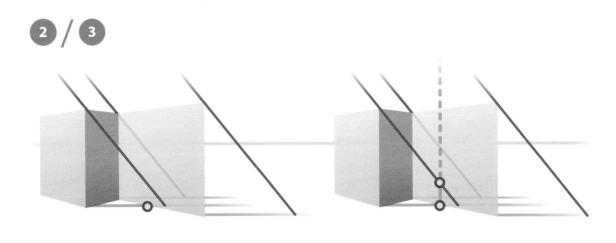

Next, add light angles for each vertical edge. Remember that shadows follow the form they're being cast on. To draw the shadow being cast on the wall, draw a vertical line up from where the shadow path intersects the wall on the ground plane, as shown. Stop once you've intersected the light angle.

4 / **5**

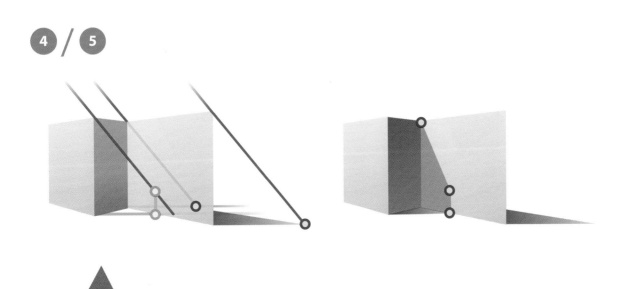

To finish, find the remaining points on the ground plane and create the shadow. Remember to follow the shadow on the wall to its point of origin, as shown.

Shadows of Sloping Objects

While the process essentially remains unchanged, there tends to be one area where mistakes are made. If your object is sloping from the ground plane, you'll need to connect the shadow to the base of your form.

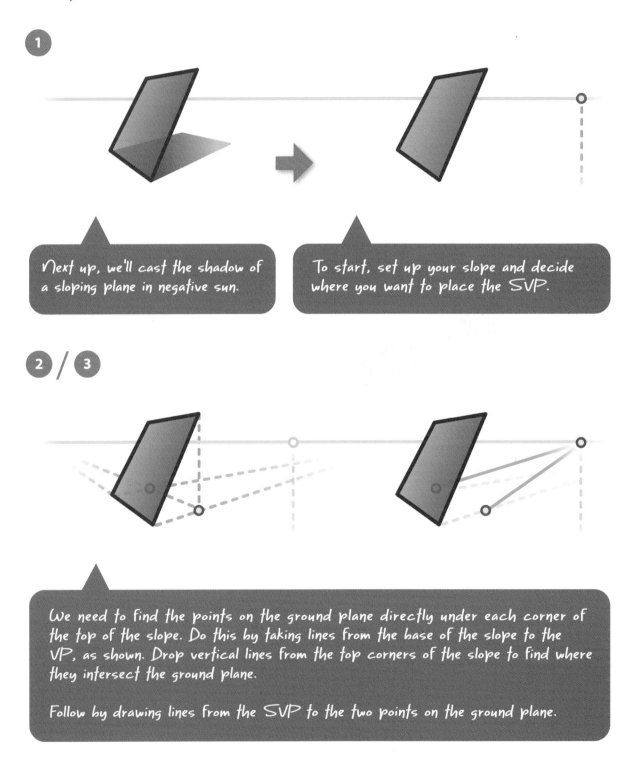

1

> Next up, we'll cast the shadow of a sloping plane in negative sun.

> To start, set up your slope and decide where you want to place the SVP.

2 / 3

> We need to find the points on the ground plane directly under each corner of the top of the slope. Do this by taking lines from the base of the slope to the VP, as shown. Drop vertical lines from the top corners of the slope to find where they intersect the ground plane.
>
> Follow by drawing lines from the SVP to the two points on the ground plane.

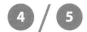

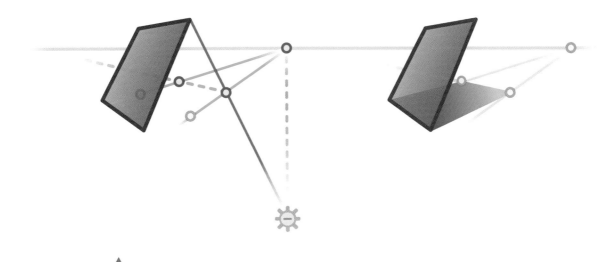

Now we need to find the top edge of the shadow. Draw a line from the light source to the top corner of the slope. Take that intersection to the opposite VP to find the shadow's other corner. To finish, take the points to the base of the shape as shown. Don't follow the lines from the SVP!

Cylinders and Spheres Cast Shadows Too

Once you're able to construct the shadows of spheres and cylinders, you're set to tackle almost anything. While the same rules still apply, the approach is somewhat different. Here's what to keep in mind:

- Since neither ellipses nor spheres have corners, the lines from the SVP are instead tangent to the outer edges of the form.

- A sphere's shadow will be an ellipse; a cylinder's shadow will end in an ellipse.

- While we still reduce the process down to casting the shadow of a pole, we need to do more of them in order to accurately create the ellipse that terminates the shadow – see the following page.

Working with Cylinders

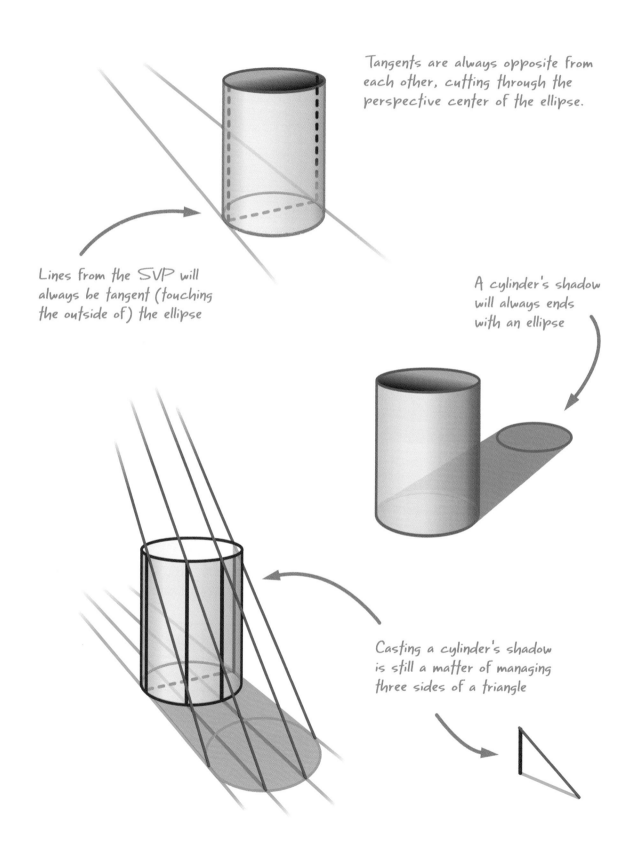

Tangents are always opposite from each other, cutting through the perspective center of the ellipse.

Lines from the SVP will always be tangent (touching the outside of) the ellipse

A cylinder's shadow will always ends with an ellipse

Casting a cylinder's shadow is still a matter of managing three sides of a triangle

1

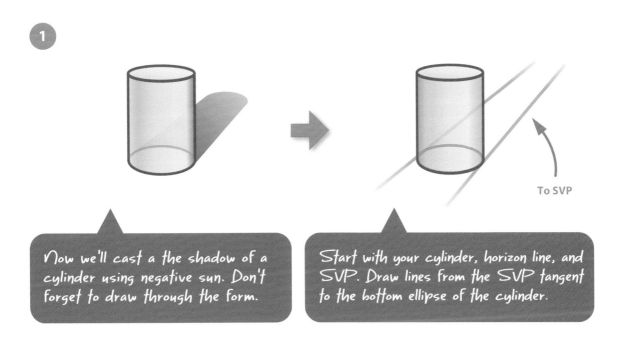

To SVP

Now we'll cast a the shadow of a cylinder using negative sun. Don't forget to draw through the form.

Start with your cylinder, horizon line, and SVP. Draw lines from the SVP tangent to the bottom ellipse of the cylinder.

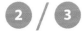

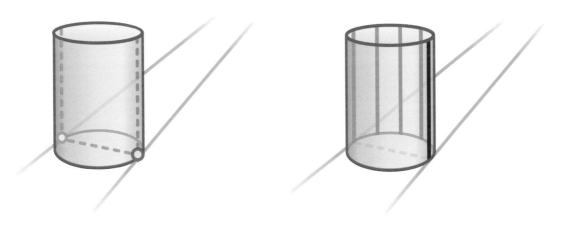

These points represent where the cast shadow starts on the ground, so it's important to be accurate when drawing your tangents. Remember, they should be opposite each other. If you were to draw a line connecting the two points together, that line should run through the perspective center of the ellipse. From the tangents, draw lines up the walls of the form. Draw a few more lines from the base of the cylinder to the top, as shown. These need to be drawn on the side opposite the light source. In this example, they're drawn on the back of the cylinder.

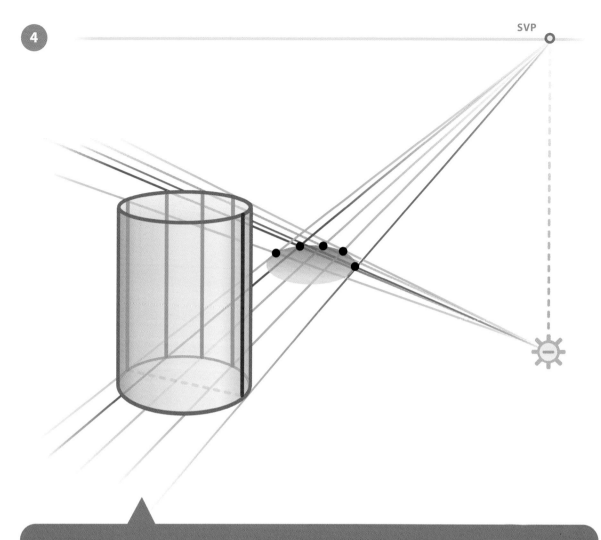

SVP

From here the process is a familiar one. Draw lines from the light source through the tops of each of the vertical lines running up the side of the cylinder. Note where each light angle intersects with it's corresponding line from the SVP. If you've been accurate with your work so far, you should be able to see the top part of an ellipse start to form. Finish the shadow by taking the ellipse back to the tangents at the base of the cylinder.

The Finished Shadow

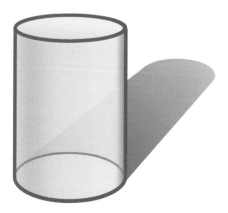

Working with Spheres

When working with spheres, light always cuts the sphere in half, with the core shadow separating the mass light from the mass dark.

The division between the mass light and mass dark is dictated by the light angle and position of the light source. This defines the width and angle of the elliptical plane cutting through the middle of the form.

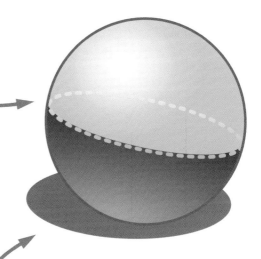

The cast shadow will be an ellipse.

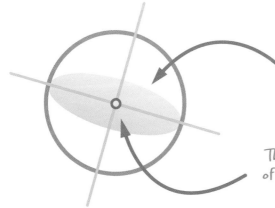

The elliptical plane defines the shape and placement of the core shadow and is always perpendicular to the light angle.

The center of the sphere and the center of the ellipse are one and the same.

The same ellipse, defined in two different ways, determines the light source for the viewer.

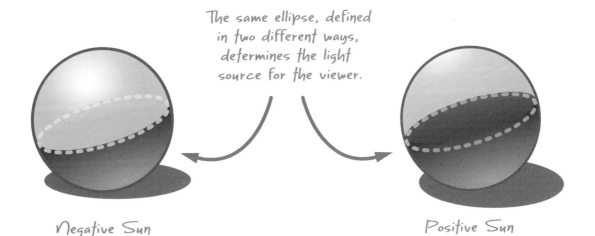

Negative Sun

Positive Sun

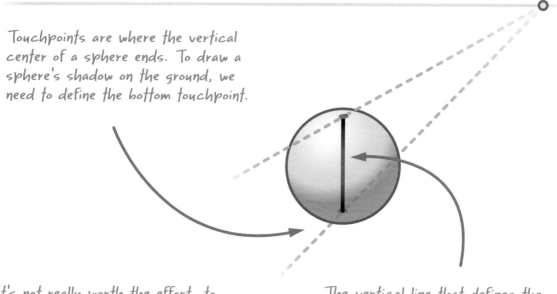

Touchpoints are where the vertical center of a sphere ends. To draw a sphere's shadow on the ground, we need to define the bottom touchpoint.

The vertical line that defines the touchpoints is always a little bit smaller than the sphere it's in.

It's not really worth the effort to accurately find the touchpoints of a sphere – an educated guess will do. What helps is paying attention to the relationship between the horizon line and the vertical center line inside the sphere. As you get closer to the horizon, the space between the touchpoint and the edge of the sphere gets smaller.

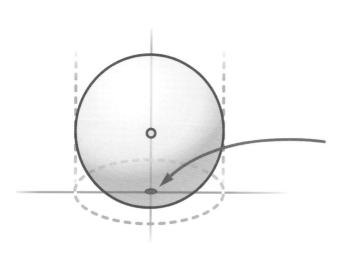

The touchpoint is also the center of the ellipse that we use as the 'footprint' of the sphere.

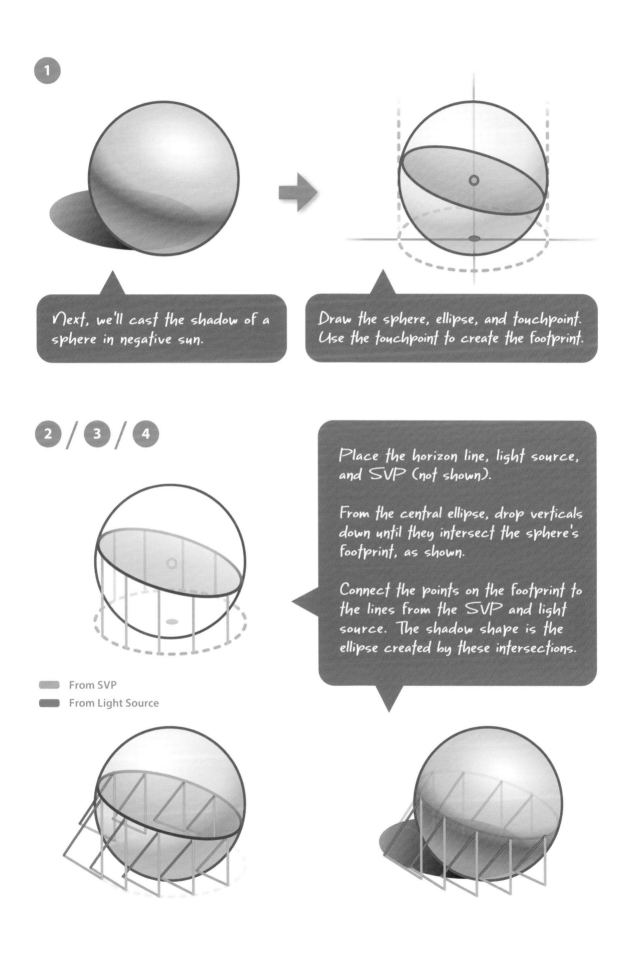

1

Next, we'll cast the shadow of a sphere in negative sun.

Draw the sphere, ellipse, and touchpoint. Use the touchpoint to create the footprint.

2 / **3** / **4**

Place the horizon line, light source, and SVP (not shown).

From the central ellipse, drop verticals down until they intersect the sphere's footprint, as shown.

Connect the points on the footprint to the lines from the SVP and light source. The shadow shape is the ellipse created by these intersections.

From SVP
From Light Source

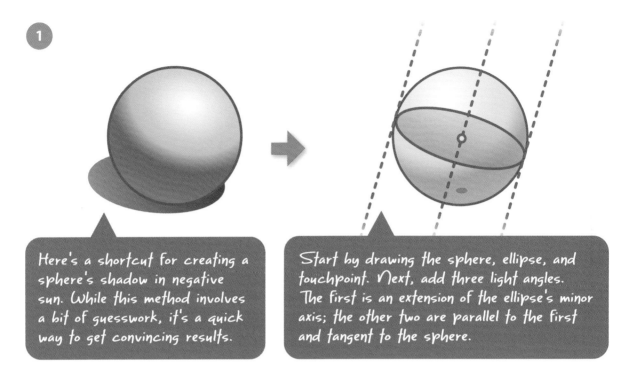

1

Here's a shortcut for creating a sphere's shadow in negative sun. While this method involves a bit of guesswork, it's a quick way to get convincing results.

Start by drawing the sphere, ellipse, and touchpoint. Next, add three light angles. The first is an extension of the ellipse's minor axis; the other two are parallel to the first and tangent to the sphere.

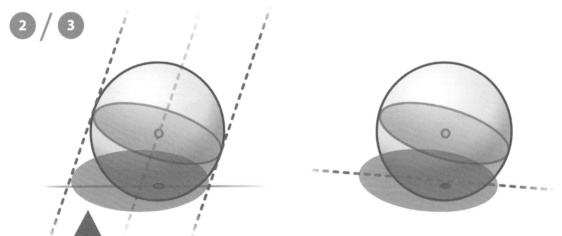

2 / 3

Decide the shape of the cast shadow — as long as the minor axis isn't too long or short, you'll be fine. Make sure the ends are tangent with the light angles on each side of the sphere. Use the touchpoint to help you place the shadow. If you're working with negative sun, make sure the touchpoint is below the ellipse's major axis, as shown above. When working with positive sun, slide the ellipse forward so the touchpoint is above the major axis. In either case, the further away the touchpoint is from the major axis, the lower the light source will seem. Keep that in mind as you commit to the width of your shadow shape.

To finish, slightly tilt the ellipse in place. As you do this, make sure it's still in contact with both outside light angles. For negative sun, the left side of the ellipse should be slightly higher than the right. In positive sun, the right side is slightly higher. Don't overdo it or the ground plane will start to look like a slope.

Chapter 13
Three-Point Perspective

Three-point perspective adds drama to everything we do. In this chapter, we'll start by discussing how three-point differs from one- and two-point perspective. Then, we'll reconfigure the setup for three-point and learn how to construct and use a three-point measuring system. We'll end the chapter with directions for creating a three-point grid.

Until now, we've concentrated mostly on two-point perspective. The mechanics are simpler and it's easier to understand because it's how we routinely experience the world. Three-point perspective is a different animal – we use it to infuse excitement and exaggeration into our work. It adds drama by changing how we draw something. It does this by positioning the viewer in an unconventional place and making him or her look up or down at our subject matter.

Working in three-point perspective can make something ordinary look more animated.

While the setup is more labor intensive when compared to one- and two-point, it's worth every bit of extra effort. When drawing in three-point, it's even more important to have a clear idea of what you want your picture to look like before you start working on the final image. This means you should transition your idea from a rough compositional sketch (where again your only concerns are size, placement, and mood) to one where your initial composition has evolved enough to show reasonably accurate space and simple, general form.

The Mechanics of Three-Point Perspective

In three-point, the viewer is either placed up high and looking down at something, or placed very low and looking up at something. The key difference here is the angle of the viewer's line of sight. Remember, the convention in one- and two-point perspective is that the viewer always looks straight ahead. Three-point perspective is defined by the opposite, and this changes everything. Think about it – because the viewer is either looking up (or down), the picture plane is no longer 90° to the ground plane. Because of this, both the center of vision and cone of vision have moved off of the horizon line. Most importantly, there are no more parallel lines – all vertical lines will now converge to their own vanishing point.

Creating the Three-Point Setup

This setup looks complicated. While it's clearly more involved than drawing a one- or two-point setup, don't let that intimidate you. Once you learn how it's done, you'll see that it all adds up to about five to ten minutes of prep work.

As we go through the setup process, it may seem puzzling that there are three horizon lines and three lines of sight. This approach is necessary so we can place the viewer in a location where each dimension can be seen and depicted in an exaggerated, dramatic way.

The foundation for a three-point drawing is a triangle. There are a few things to consider as you start – while you don't have to draw a perfect equilateral triangle, if it's too long, the dramatic effects that we get from three-point will be minimal. If the triangle is too short, three-point perspective isn't even possible. Your best bet is to start with a rough but believable sketch. Use it to get a sense of where your three vanishing points are. This will help you find the right triangle for your particular drawing.

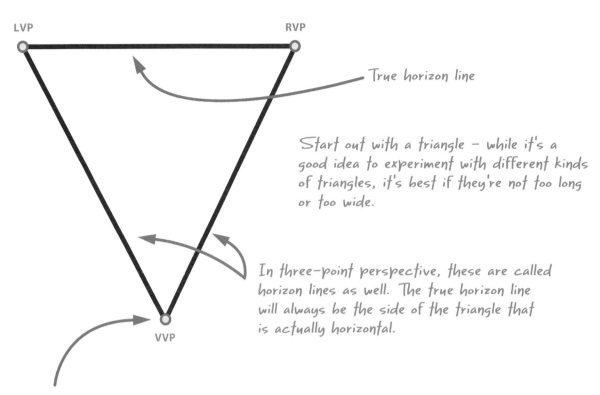

LVP RVP

True horizon line

Start out with a triangle – while it's a
good idea to experiment with different kinds
of triangles, it's best if they're not too long
or too wide.

In three-point perspective, these are called
horizon lines as well. The true horizon line
will always be the side of the triangle that
is actually horizontal.

VVP

In this example our new vanishing point is at the bottom of the triangle – it's called
the vertical vanishing point (VVP) and represents where our vertical lines converge.

How you position your triangle determines your viewer's point of view.

Viewer is Viewer is Viewer is looking
looking down... looking up... down, with head slightly
 tilted to the right.

Finding the Center of Vision

After setting up the basic triangle, we need to find the center of vision. We can do so in three simple steps, as shown below.

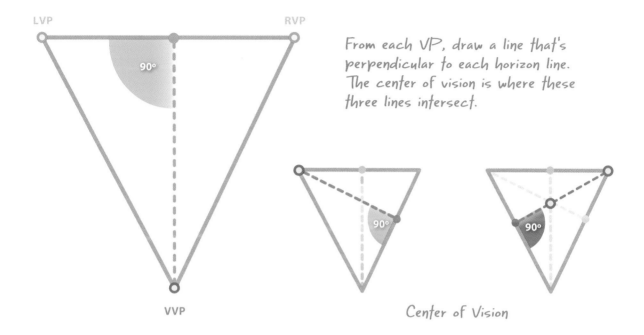

From each VP, draw a line that's perpendicular to each horizon line. The center of vision is where these three lines intersect.

Center of Vision

There's more to come, so until this becomes second nature it may help to label what's already been done. We'll call the three lines used to find the center of vision reference lines (RL) 1, 2, and 3. Label their corresponding points reference points (RP) 1, 2, and 3.

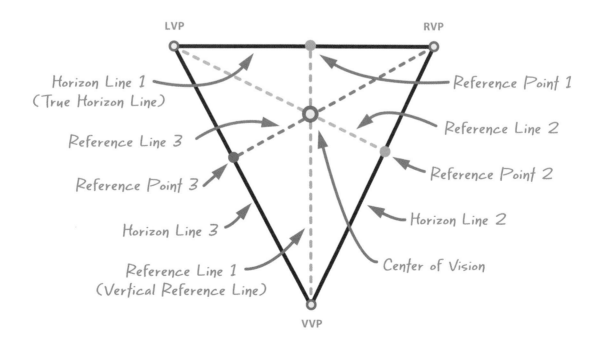

Horizon Line 1 (True Horizon Line)

Reference Point 1

Reference Line 3

Reference Line 2

Reference Point 3

Reference Point 2

Horizon Line 3

Horizon Line 2

Reference Line 1 (Vertical Reference Line)

Center of Vision

Finding the Three Lines of Sight

While it's true that the viewer only has one line of sight, we need to find three – one for each horizon line. Once that's done, we'll add the station points, cone of vision, and measuring points.

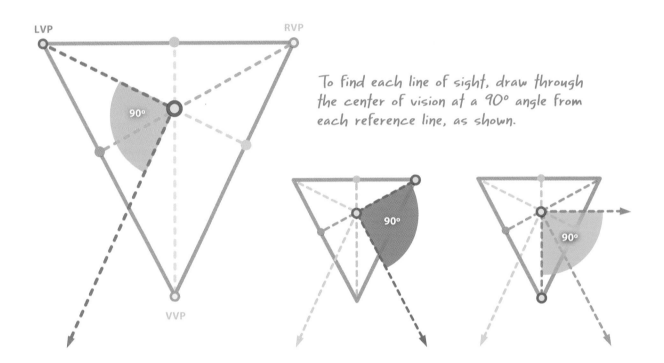

To find each line of sight, draw through the center of vision at a 90° angle from each reference line, as shown.

Establishing Station Points

A station point does a lot – it stands in for the idea of the viewer, defines the distance to the picture plane, helps us find the measuring points, and it's the starting point to the cone of vision. Since the three-point setup has three horizon lines (and three lines of sight), this means there are three different station points. They all work together to represent the same viewer. If you don't need to set up a measuring system, you'll only need one station point, which you'll use to create the cone of vision. You'll need all three to set up a measuring system. The good news is, once you've found one, the remaining two are simple. With the two-point setup, the station point is the radiating point of a 90° angle that making its way to the horizon line. In three-point, we direct that angle toward the reference lines instead. Note that in the first diagram below, the station point landed on the horizon line – that's just a coincidence. Their placement is solely determined by using points on the reference line to create a 90° angle.

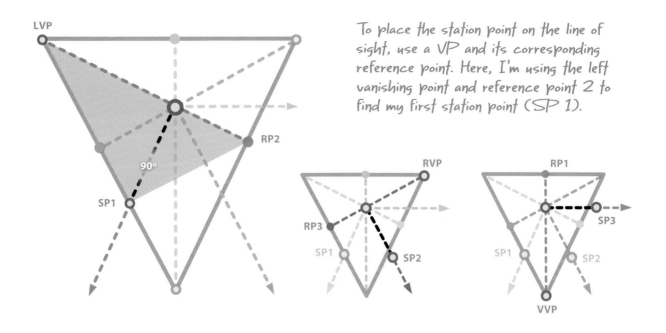

To place the station point on the line of sight, use a VP and its corresponding reference point. Here, I'm using the left vanishing point and reference point 2 to find my first station point (SP 1).

You only need to do this once — to find the other two station points, take the distance from the center of vision to your initial station point (the black dotted line) and transfer it to the other two lines of sight, measuring out from the center of vision. All three station points should be the same distance away from the center of vision. In the example above, the initial station point coincidentally landed on a horizon line. Where they land is irrelevant as long as they are placed accurately on each line of sight.

Finding the Cone of Vision

Finding the cone of vision is a simple two step-process. It can be done from any station point. While it's challenging to draw a large circle without an appropriate compass, this one doesn't have to be perfect. Do the best you can. When you're drawing, if you don't stray too far away from your imperfect boundary, you'll be fine.

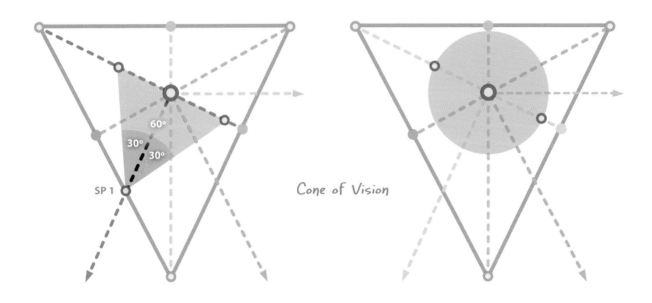

Finding the cone of vision in three-point is simple. First, pick any station point. From the station point, draw a 60° angle (30° on each side of the line of sight) out towards the corresponding reference line. Draw a circle, with the center being the center of vision and the radius cutting through the intersection at the reference line. The resulting circle is the cone of vision.

If you don't need to do any sort of measuring, congratulations! You have everything you need to get started. There's a lot you can do with a good sketch, three vanishing points and the cone of vision. On the other hand, if you feel that measuring or even setting up a grid might be useful, then we have a few things left to do before we start.

Finding the Measuring Points

If you need to measure or want to set up a grid, then you'll have to set up the measuring points. This is done from each station point. The same rule applies – the distance from the vanishing point to the station point is the same as the distance from the vanishing point to the measuring point. Place the measuring points from the right and left vanishing points on the true horizon line. Place the vertical measuring point on the horizon line opposite its station point.

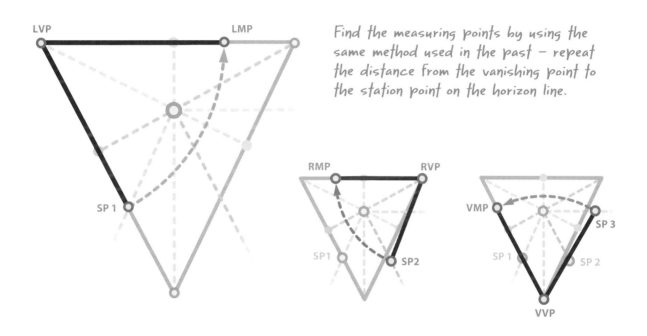

Find the measuring points by using the same method used in the past – repeat the distance from the vanishing point to the station point on the horizon line.

Place the measuring points for the right and left vanishing points on the true horizon line. The measuring point for the vertical vanishing point will be on the horizon line opposite the station point, as shown in the last diagram above.

Setting Up the Measuring System

Now it's time to set up our drawing for both horizontal and vertical measuring. This is a two-step process on pre-existing lines. We'll use two of our lines of sight to do this.

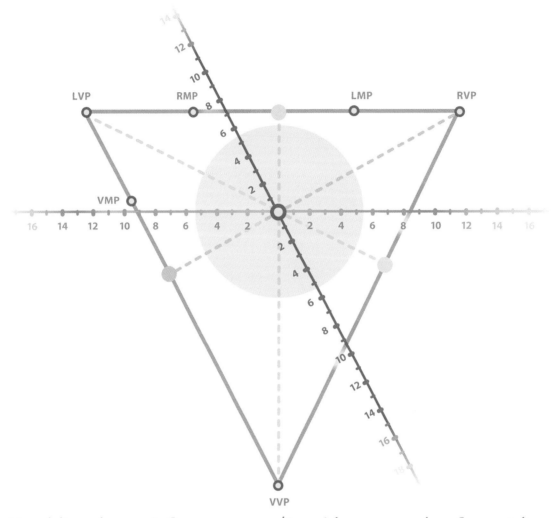

To get the setup ready for measuring, we'll need to repurpose two of our existing lines. First, we'll turn the line of sight associated with the vertical vanishing point (the solid blue line) into the horizontal measuring line. Continue the line through the center of vision, then measure out in each direction from the center of vision as shown. Next, take the line of sight associated with the right vanishing point (the solid red line) and extend it through the center of vision. This will be the vertical measuring line. Transfer your scale to this line as well, again measuring above and below the center of vision to complete the process.

Using the Measuring System – Drawing a Cube in Three-Point

We're finally ready to draw. We'll do something simple so we can practice using the three-point measuring system. There's a lot you can do in three-point once you get the hang of it.

1

Now it's time to use the setup to measure out a perfect cube in three-point perspective.

As we progress, there's one thing to be aware of. In many of the examples used throughout the book, I've started the drawing directly from the center of vision. That's not the only place to start. I've done this to keep the diagrams as simple and clear as possible — a challenge when you consider the dimensions of each page. Start your drawing wherever you like; the process will always be the same.

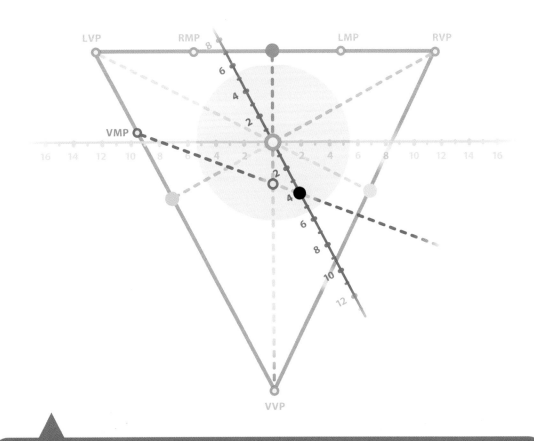

Let's create a cube that's four units in each direction. From the center of vision, we first need to measure four units down. To do so, draw a line from the vertical measuring point through the number four on the vertical measuring line. Mark where the line crosses the vertical reference line.

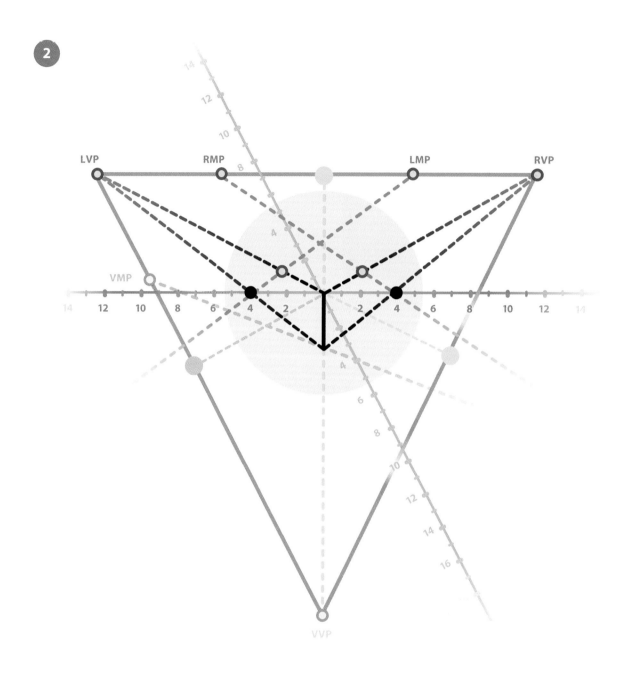

After finding and drawing in the height of the cube, indicate the front two vertical planes by going back to each vanishing point. We now need to define the depth of the vertical planes by using the right and left measuring points. Draw from each measuring point to the horizontal measuring line, as shown. Mark where each line crosses the top of each plane. These intersections represent the back part of the front planes of the cube. We're almost done.

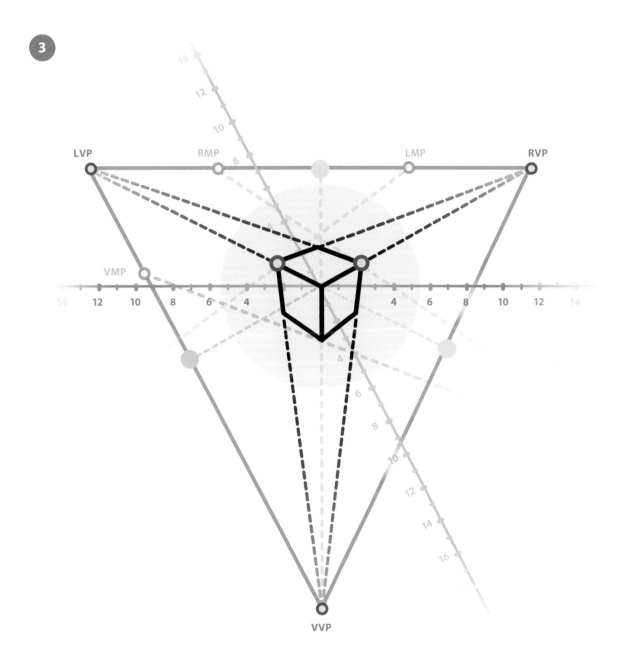

3

LVP RMP LMP RVP

14 12 10 8 6 4 4 6 8 10 12 14

VMP

14 12 10 8 6 4 4 6 8 10 12 14

16

VVP

Next, take the intersections found in the previous step and connect them to the left and right vanishing points, as shown. Finish by drawing lines from both points down to the vertical vanishing point. Draw through the form if necessary.

Setting Up a Grid in Three-Point Perspective

Depending on your subject matter, it may be easiest to create a grid before you start drawing. Once you have a measuring system in place, it's an easy thing to do. By design, it adds a fair amount of lines to the page, so if you're working traditionally, work lightly and in color. If you're working on relatively thin paper, you may want to draw the grid darkly on a separate sheet and place it under the paper that you're drawing on. If you're working digitally, you can easily construct the grid on a separate layer. Adjust the opacity of your layers as you go, so you can more easily navigate the extra lines that come with using a grid.

A note about the grid that follows. Limited space and the visual clarity needed for the sake of instruction dictate that it be kept simple. While it's always best to keep things simple, working things out on a larger scale will give you all the space you need to create the best grid for your particular drawing.

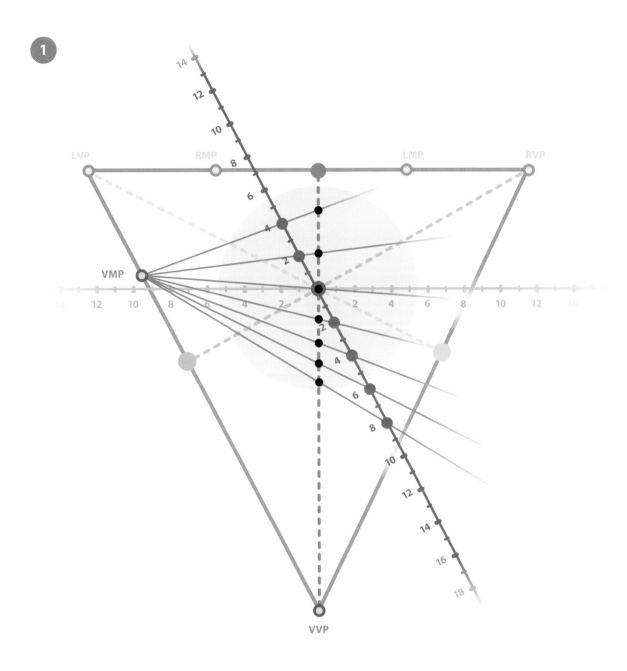

Once everything is set up, creating a three-point grid is easy. Above, I've started by drawing lines from the vertical measuring point through points on the vertical measuring line. There's little need to venture beyond the cone of vision. Mark where these lines intersect the vertical reference line, as shown. Eventually, the lines will grow too close to be accurate. The good news is that they represent things far off in the distance, where accuracy is less important.

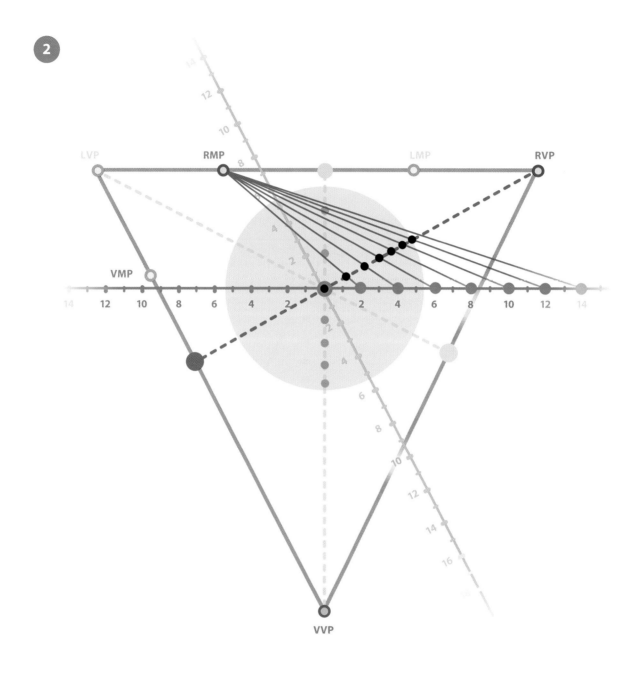

Now it's time to create the grid for our right facing planes. Draw from the right measuring point through points on the horizontal measuring line. Mark where they cross the reference line, as shown. We have one more side to go.

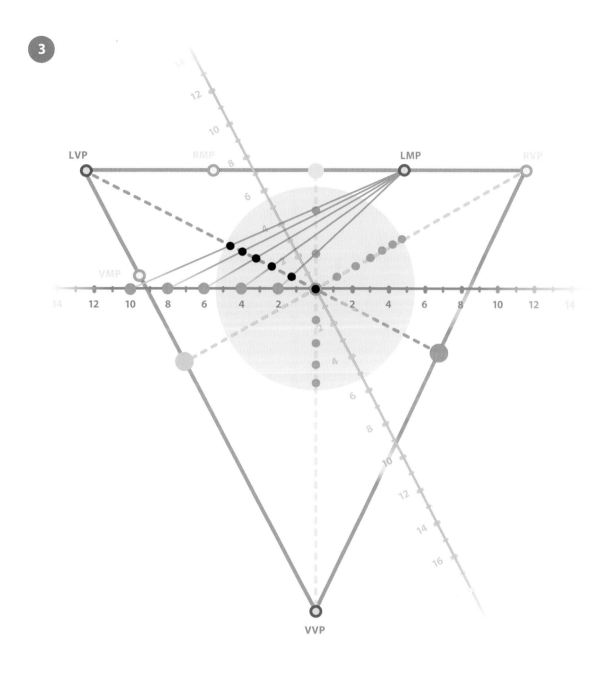

When setting things up on the left, use the same general process. Draw from the left measuring point through to the horizontal measuring line. Again mark where they cross the reference line. We're ready to draw the grid.

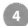

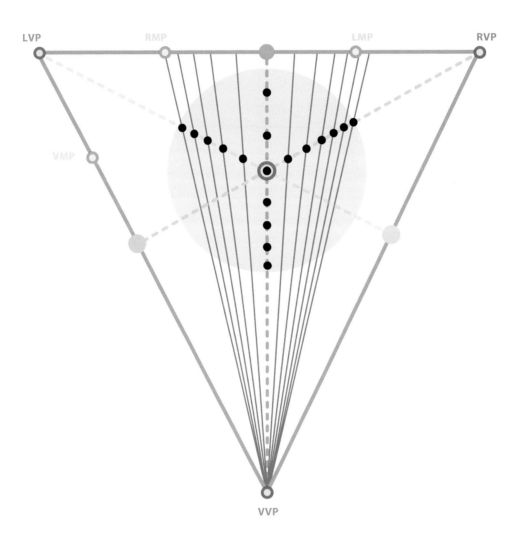

Start by drawing lines from the vertical vanishing point through each of the points placed on the reference lines. Again, you don't have to worry much about what happens outside of the cone of vision. One more step and we're done.

5

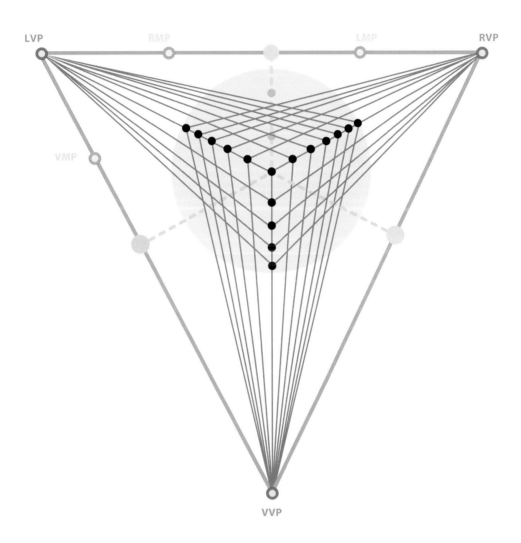

To finish creating the grid, simply take lines from each vanishing point to the points on the vertical reference line. Now you're ready to draw and measure in three-point perspective. Strive to keep things simple so your page doesn't turn into a confusing tangle of lines. With that in mind, you'll still have more room than I have here, so keep adding information until you fill up the cone of vision.

In Closing

I hope you'll soon find, as I did years ago, that a decent understanding of perspective can have a profound effect on your drawing ability. While your work will always be more than the perspective that's in it, an image built without the solid foundation perspective gives you will never live up to its potential. Getting there takes time, but it's well worth the effort. Instead of relying on software and all of its inherent limitations, understanding perspective will help you as you use the most versatile tool in all of the visual arts – your humble pencil.

With regular practice and a touch of patience, this sometimes technical information will help you visually express ideas and worlds you wouldn't have been able to otherwise, so keep drawing! Good information without regular practice makes for tediously slow progress. For inspiration and more, take a break and visit me at www.simplifyingperspective.com.

Index